THE BEST AMERICAN INFO-GRAPHICS 2016

X

THE BEST AMERICAN INFO— GRAPHICS 2016

MARINER BOOKS

HOUGHTON MIFFLIN HARCOURT

BOSTON ≠ NEW YORK 2016

INTRODUCTION BY

ROBERT KRULWICH

THE BEST AMERICAN INFO GRAPHICS 2016

Edited by
GARETH COOK

MARINER BOOKS
HOUGHTON MIFFLIN HARCOURT
NEW YORK & BOSTON 2016

The Best American Series is a registered trademark of
HOUGHTON MIFFLIN HARCOURT PUBLISHING COMPANY.

WWW.HMHCO.COM

Library of Congress Cataloging-in-Publication Data is available.

ISBN 978-0-544-55638-6

The text is set in Eames Century Modern designed by Erik van Blokland and House Industries. All three styles of Epilepsja (fill, outline, and solid) are used as the display typeface. It was designed by Mikołaj Grabowski.

Book design by Mark Robinson.

PRINTED IN CHINA

SCP 10 9 8 7 6 5 4 3 2 1

Permissions credits are located on page 174.

CONTENTS

MATERIAL WORLD

FOREWORD

The work featured in the Best American Infographics series has always appeared in many forms. There is "print," in all its varieties—the book, the magazine, the newspaper, and so on—and there is digital, from postings on a personal website to elaborate interactive pieces designed and executed by a large team. But this is the first time that one of our winning selections was designed primarily for the postcard.

Called "Dear Data," it's a sprawling and lovely project by two artists, Giorgia Lupi and Stefanie Posavec, who realized that they were living, in a sense, "parallel" lives. "We're both the same age, we're both only children, and we've both left our home countries to travel across the ocean and live in a metropolis of our chosen city," they write on their website. "We also both work with data, using a handcrafted and illustrative approach to the data visualizations we create." They had only met twice, at conferences, but as they talked, an idea emerged. Why not, they mused, send each other a weekly postcard—Lupi lives in Brooklyn, Posavec in London—with data from their week, displayed in the form of a hand-drawn infographic?

The result is a collection of 104 postcards created over the course of a year that constitute an utterly charming reminder that data doesn't have to be "big." It can be small, too. One week, for example, the two recorded their complaints. Lupi used a code of musical notation, with each note annotated to indicate the type of complaint: food, technology, her boyfriend. Posavec went for a more radial representation of her week in grumpiness, with lines, color-coded of course, sprouting out from a central point, like petals of a flower. Some of the weekly dispatches focused on the day-to-day—purchases, swearing, getting dressed, sounds, encounters with their own reflections—and others reached higher, to encompass privacy, music, and beauty. Yet these little snapshots, all hand-drawn, are anything but trivial. They feel profoundly real. "We are really just doing what artists have done for ages," they write, "which is sketch and try to capture the essence of the life happening around them."

One of the unexpected pleasures of editing this series has been watching this medium grow up, and thinking about its relationship to my own work. I am a journalist, and I work in words, not images. I originally came to this project as a fan, an enthusiast who admired the field from afar. But I've realized that there is a surprising amount of overlap between the work of a writer and the work of a designer: both are trying to tell a story. Infographics are not typically thought of as "stories," but many of the techniques are the same. Writers and designers are living, like Lupi and Posavec, parallel lives.

The Dear Data postcards work, like a good story, because of their intimacy, humanity, and directness. The choice of postcards was brilliant because it implies a strong connection between writer and reader. The postcard typically arrives from far away, "thinking of you," unguarded and playful. (From my Uncle Ricky: "The scenery is here. Wish you were beautiful.") Think of the first books that you lost yourself in—*The Lion, the Witch and the Wardrobe* was one of mine—and the sense that the printed text fell away, replaced by a feeling that there is someone there you can trust, someone who cares for you, sharing what they've seen.

What other "story qualities" does a good infographic have? Observation is key. One of the infographics featured here is an urban landscape, annotated by smell—flowers, grass, garbage, that subway stench. As every writer knows, details are the building blocks of a scene, and this infographic reminds us that smell, such a powerful sense, is often neglected. Another is the use of contrast: these pages are filled with skillful fore- and backgrounding in the service of clarity. Writers are constantly thinking about where to direct a reader's gaze, and making sure they have painted a scene well, removing any distractions. Look, for example at "How the Parties Came Apart," and how it uses red and blue for the parties, and then a gray that only catches the eye when there are many connections across the partisan divide (mostly in the early years).

And consider all the extraneous details that have been omitted. The story is strong.

Some might object that stories have a beginning, a middle, and an end. Surely, this makes them very different from a visual representation of data? But even this apparent difference brings insights. In an infographic, the eye usually lands somewhere—a "beginning" or focal point—and progresses from there. And, when you think about it, doesn't the opening of many well-told stories have something of the same feel, of landing in the middle, in medias res, and spiraling out from there?

This, the fourth volume of *Best American Infographics*, echoes the organization of previous years. In the first section, "You," we are given a periodic table of sweets, a guide for guessing the political loyalties of a stranger by their job, and an estimate of how long we can expect to live. In "Us," the lens takes in larger vistas: immigration, urban poverty, the changing lyrics of popular music, the geographic and temporal distribution of American UFO sightings. In the third and final section, "Material World," the collection changes key. There are dolphins here, and drones and hurricanes. There are baseball records and economic records. All of history's popemobiles, illustrated in chronological order? Got it. We even fly by Pluto, a dwarf planet now but not forgotten.

One change longtime fans may notice is that there is no longer a separate "interactive" section. Instead, in recognition of the field's increasingly blurry lines, these works are located in the main body, with all the others. It's also worth mentioning that you hold in your hands an infographic that is not in the book, but instead *on* the book. Take a few moments to enjoy the cover, a collaboration between our designer, Mark Robinson, who supplied a day of personal data (not to mention art direction and type work), and the illustrator Thomas Porostocky, of the TOM Agency.

All of the infographics in *The Best American Infographics 2016* were originally published for a North American audience, online or in print, during 2015. I selected all of the winners, with a lot of help from my brain trust, who have served as both scouts and cheerleaders—a big thanks to them. (Their biographies are listed in the back.) To nominate infographics for the next volume, see the rules at garethcook.net, or email me at contactgarethcook@gmail.com.

I'd like to thank Robert Krulwich for agreeing to be a part of this project, and for a delight of an introduction that takes us up a mountain for some surprising sights. I also want to thank Amy Klee, a brilliant designer in her own right, who helped manage this project, and Natalie Amend, our highly organized and enthusiastic editorial assistant. I want to thank the team at Houghton Mifflin Harcourt: designer Mark Robinson, permissions maven Mary Dalton-Hoffman, publicist Michelle Bonanno Triant, editorial assistant Jenny Xu, and my editor Deanne Urmy. The story of Best American Infographics began with a phone call from Deanne, and I'll always be grateful.

GARETH COOK

INTRODUCTION

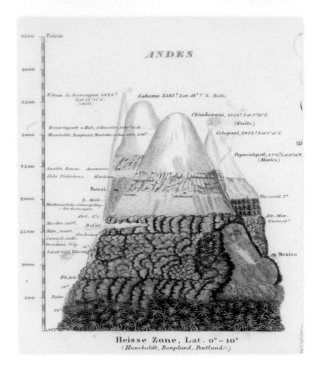

Let's start, not in 2015—you'll be up to your eyeballs in what's new as you turn these pages. No, let's go back two centuries or so to an infographic pioneer who I'm going to introduce crawling along a narrow path 15,600 feet above sea level, feet frozen, gums bleeding, dizzy with altitude sickness, steep cliffs falling left and right of him, the path he's on barely inches across—and what's he doing? He's measuring. He's taking notes. He's sketching. He's noticed something about this mountain he's on, a volcano called Chimborazo, 19,000 feet high in Peru, that reminds him of other mountains he's seen, and he wants to say what he's noticed, get it exactly right, so he hauls himself down mountain and right away draws a picture, and this picture, two feet by three feet, published in 1807, amazes the world because "with a single glance," as he later wrote, we can see what he saw.

What explorer/naturalist Alexander von Humboldt discovered is that climbing a mountain—any mountain, anywhere in the world—is like traveling north or south toward a pole. As you move higher it gets colder, and as temperatures change, so do plants. The resulting pattern is in his drawing, starting with a lush tropical palm forest at the base of the volcano, then moving up to oaks, then to shrubs, then to evergreens, each zone so sharply defined, so delicately drawn, you can almost smell the pine scent as you glide up past the tree line to the faint green of moss and lichen, and then, higher still, to empty fields of white—of snow.

Plants form distinct neighborhoods. They self-organize depending on altitude, and altitude mimics latitude. That mountains in Peru and mountains in Switzerland do the same thing was news in 1807, shocking even, but because Humboldt presented the evidence so visually, so dramatically, the lesson hit home. Thousands—tens of thousands—of people saw this drawing and "with a single glance" found a new way to think about the natural world. The essential word here is see. Not read. Humboldt made his case with pictures.

This is key. When it comes to infographics, words take second place. It's eyes you want. The best work in this field grabs those eyes, keeps them glued, and the grip is sensual—and often immediate. A good graphic says, "See what I see!" and either you do or you don't. The best ones—and you'll find some very good ones in this book—pull you right in and won't let you go.

They do this in various ways: sometimes it's in the framing, what's left in, what's left out; sometimes the images are just so gorgeous you want to linger and explore and caress them, and sometimes the more you look, the more you learn and so you stay, peeling your way down, layer by layer, detail by detail, deeper and deeper into the image until you feel, almost literally, like an explorer. When it works, it's thrilling.

Just for example (and you're going to run into it a few pages from here), we have a short history lesson from designer Mauro Martino (with Clio Andris and others) which looks like a candy-colored cloud slowly being ripped into two pieces. The cloud, it turns out, is the U.S. House of Representatives, built from red dots (Republicans) and blue dots (Democrats). Republicans who side mostly with Republicans share red lines; Democrats who hang mostly with Democrats share blue lines; and whenever a member dares—which happens—to vote more often with the other side, this dangerous act is colored blurry gray. Gray, therefore, is the hue of cooperation (or transgression), and what you see, moving from congress to congress from 1949 forward, is gray evaporating, blue getting bluer, red getting redder, and a woundingly vacant, empty white space opening between Republicans and Democrats,

a literal no man's land, because almost nobody dares go there.

Zoom in and you can meet every congressperson (or dot) by name; zoom out and you watch an institution pulling itself apart, this once cooperative body learning to un-cooperate. And, like in Alexander von Humboldt's drawing, you can see all this happening "with a single glance," a painful, beautiful, telling glance, but done—once again—without words.

Or, in a totally different vein, there's "Vaccines to the Rescue." The University of Pittsburgh took 88 million medical cases from 50 states collected over 70 years—that's a lot of sick people—and digitalized them, creating a database that lets us see what happened when vaccines came to America.

Check out the measles page, or the hepatitis A page (as designed by the *Wall Street Journal*). On the left, you see lots of sickness, represented by blue, green, and yellow boxes (some, more, many). A vaccine comes in and almost immediately those colors fade to grays, then whites (fewer, none). People don't get sick any more. The disease—and you see this in one gulp—almost disappears.

Critics, of course, hollered. Vaccines are controversial. People are suspicious. But in this case, the data is written in a computer language (called "R") that allows anyone to check the raw numbers, and, if they like, build their own graph—which is what people all over the Web did. Programmers plunged in, quarreling, comparing, duplicating, and the data, so far anyway, keeps producing roughly the same results. These graphs are not just vivid—they're transparent. You can second-guess, third-guess, even fourth-guess them.

Which brings me to where this art, this science, this journalism is going. It's going every which way: digital, searchable, musical, animated, voiced over. We are at the very beginning of a great flowering, which will take what Humboldt did up off the page not just to your eyes, but to your ears, and soon—who knows?—to your touch. We can't know how sensually

rich infographics will be one day, but in this volume I have a favorite that dazzlingly points the way.

Oddly, it's about death.

Neil Halloran's infographic essay/documentary *The Human Toll of World War II* describes how many people, first soldiers, then civilians, died from 1939 to 1945. The grand total is 70 million dead. Every thousand are represented by one human silhouette; those silhouettes are placed in rows. Rows get stacked into columns. Columns—this is an animated infographic (https://vimeo.com/128373915)—rise and fall with soft clickity-clackity sounds reminiscent of mahjong tiles. When Halloran describes a battle, an invasion, a siege, a concentration camp, the dead rise up and, on the Russian front, for example, they keep rising and rising and rising and not stopping, but rising to a height so frightening, so unspeakable that, though we see no bodies, no blood, no children, no tears, just data, the effect is—and I'm choosing this word carefully—staggering. Deaths pile, then scatter, moving to music by Andy Dollerson with occasional hints of soldiers marching, muffled footsteps, lonely gusts of wind. The thing is done so well, it's like watching a movie with no actors, or rather, with numbers playing actors, these numbers being ideographs so perfectly choreographed they made me wince, even gasp. Data here becomes drama, and surely there will be many more of these—infographics that go daringly Spielbergian.

But they don't have to. This new/old form can dare big or dare small. Some designers, like Randall Munroe (xkcd blog), Christoph Neimann ("Abstract Sunday" column), and Henry Reich (MinutePhysics YouTube channel), do their work sparely, as simply as they can. This is a game open to all players, and these days, with so many differently talented people competing, mixing it up with new tools, audiences growing, money getting more interested, I get the sense—the happy sense—that, as old as it is, the infographic biz is pushing into new territory. It's about to get even crazier. I feel it coming. Turn these pages. Look around. Maybe you'll see what I see.

ROBERT KRULWICH

THE
BEST
AMERICAN
INFOGRAPHICS
2016

DEAR DATA

Two infographics pen pals get to know each other.

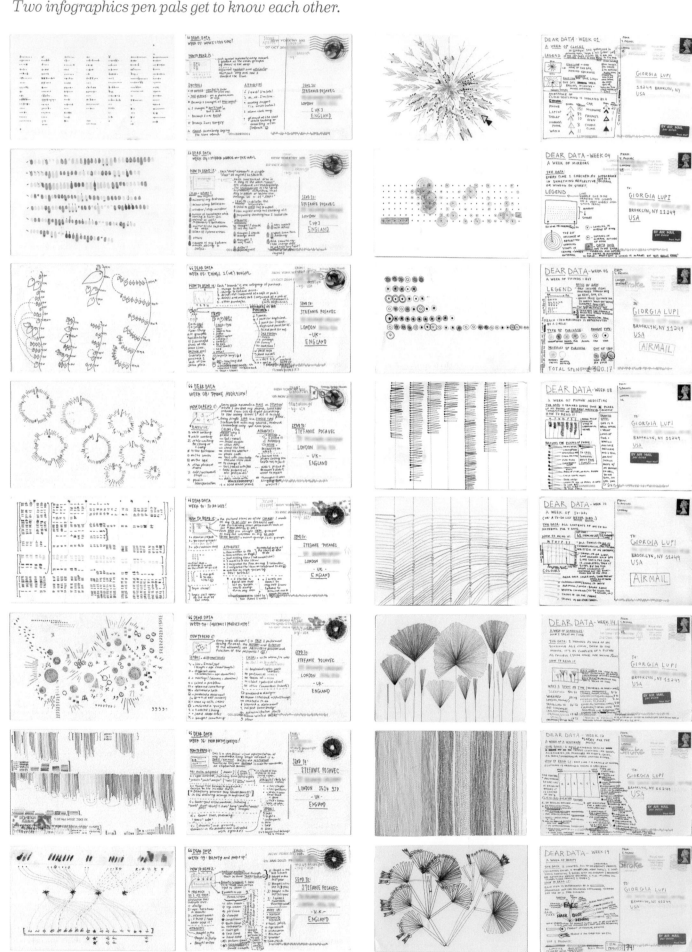

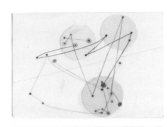
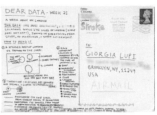

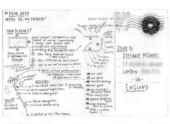
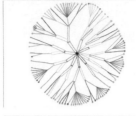
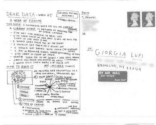

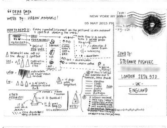
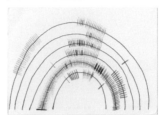
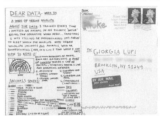

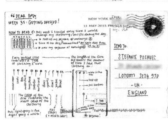
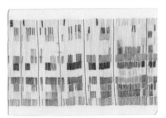
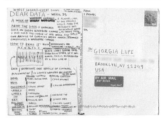

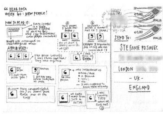

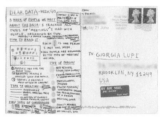

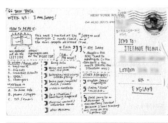

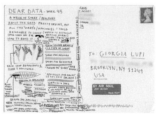

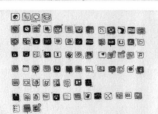
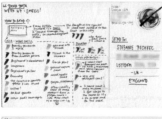
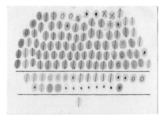

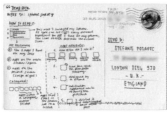

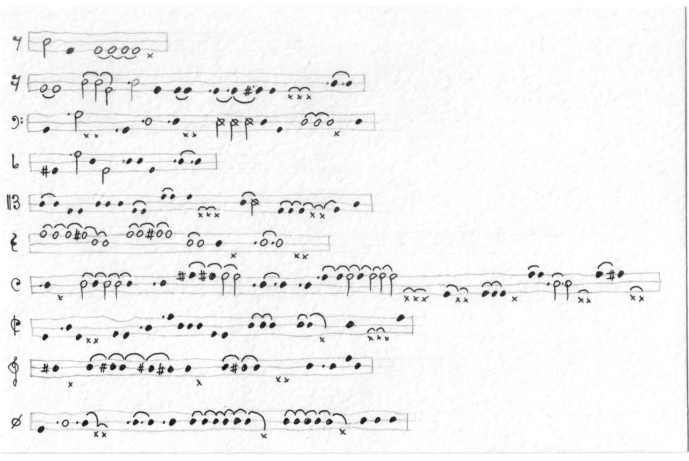

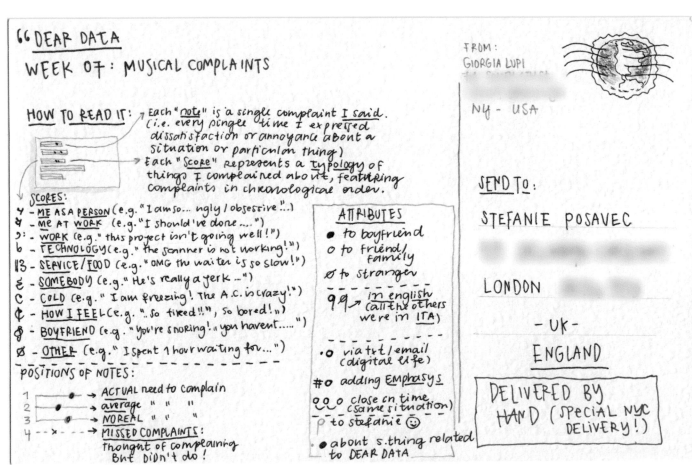

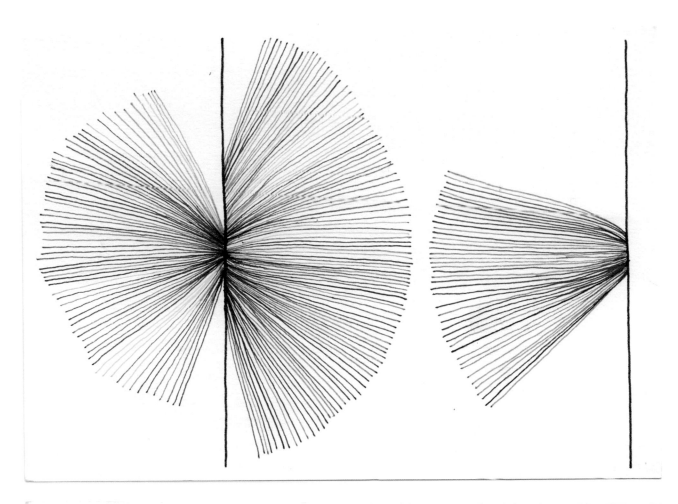

DEAR DATA - WEEK 07

A WEEK OF COMPLAINTS*
→ AND GENERAL GRUMPINESS

HOW TO READ IT: (I ~~THREW~~ THREW DOWN MY
PENS WHEN I FINISHED)
(COMPLAINT #7) WHAT IS WRONG W/ ME??

(COMPLAINT # 7) STUPID LEFT HAND SMUDGING EVERCE!

PRIVATE COMPLAINTS OUTWARD COMPLAINTS COMPLAINTS TO ME

ALL COMPLAINTS IN
CHRONOLOGICAL ORDER
EXCEPT 'COMPLAINTS TO ME'
BECAUSE (COMPLAINT #1) I
MESSED UP THE ORDER +
BY THAT TIME I HAD
ALREADY SPENT 1·5 HOURS
ON THIS... AARGH! AND
(COMPLAINT #2) THIS PART
OF THE DRAWING IS NOT
SYMMETRICAL WHICH
BOTHERS ME ↴

(COMPLAINT 6) I MESSED THIS UP TOO

TYPE OF COMPLAINT:

WEATHER HEALTH
HUSBAND HUNGER
ANIMALS MYSELF
FAMILY TECHNOLOGY/
 MEDIA
SOCIETY MONEY
THE WORLD TODAY INANIMATE
ACQUAINTANCES/ OBJECTS
STRANGERS TRANSPORT
MY APPEARANCE
FRIENDS
WORK →THIS PEN (COMPLAINT
 #3) LEAKED + SMUDGED
 MY DRAWING + GOT ALL OVER MY HANDS!

(COMPLAINT #4) MY STUPID LEFT HAND!!

MAIN STATS

PRIVATE COMPLAINTS: 67
OUTWARD COMPLAINTS: 100
COMPLAINTS TO ME: 43

OF PEOPLE WHO
COMPLAINED TO ME: 5
TOP COMPLAINER: MY DAD
OF PEOPLE I
COMPLAINED TO: 6
TOP COMPLAINEE: MY HUSBAND
I COMPLAINED MOST ABOUT MY
FAMILY (SORRY MOM + DAD)
I ♥ U XOXOX!

+ SECOND MOST COMPLAINT ABOUT
MY HUSBAND (SORRY STEVE I ♥ U XOXOX)

* AND A WEEK OF COMPLAINTS ABOUT HOW I F*CKED UP THIS DRAWING! (COMPLAINT #5)

FROM:
S POSAVEC
LONDON
UK

97P

TO:
GIORGIA LUPI

BROOKLYN, NY 11249
USA

DELIVERED BY
HAND (SPECIAL NYC
DELIVERY!)

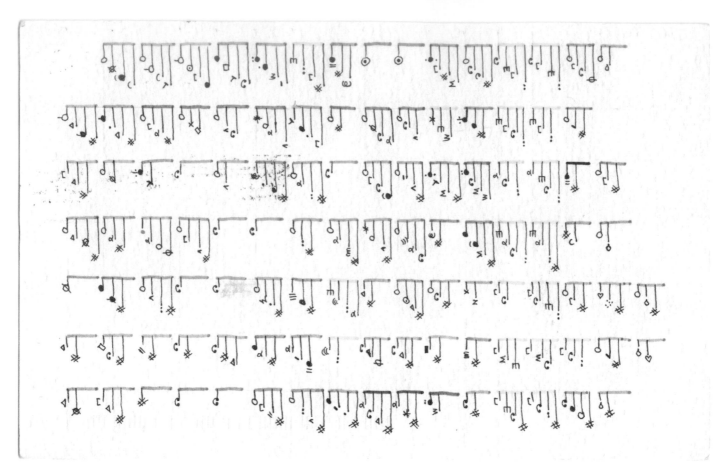

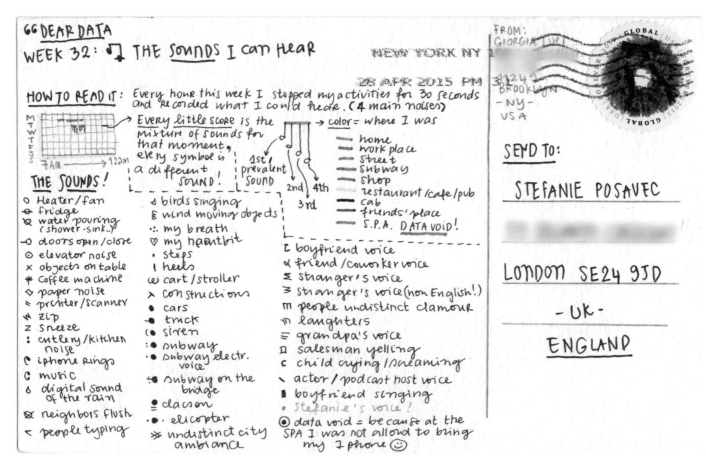

ARTISTS: Giorgia Lupi, information designer and co-founder of the firm Accurat, based in New York; Stefanie Posavec, information designer based in London.

STATEMENT: Dear Data is a year-long correspondence project in which two information designers who had met only a couple of times shared details about ourselves in the form of hand-drawn data postcards. These weekly post-

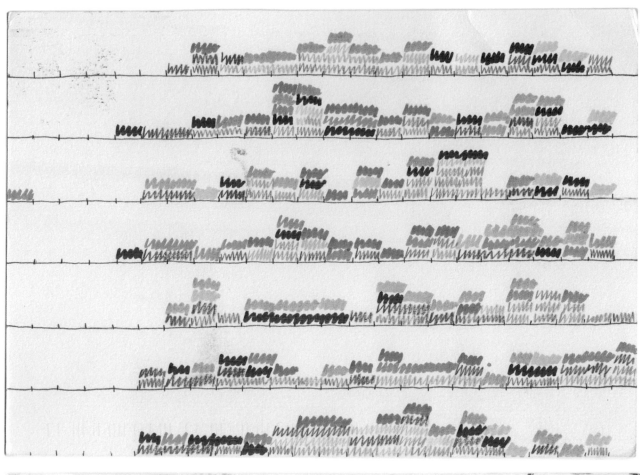

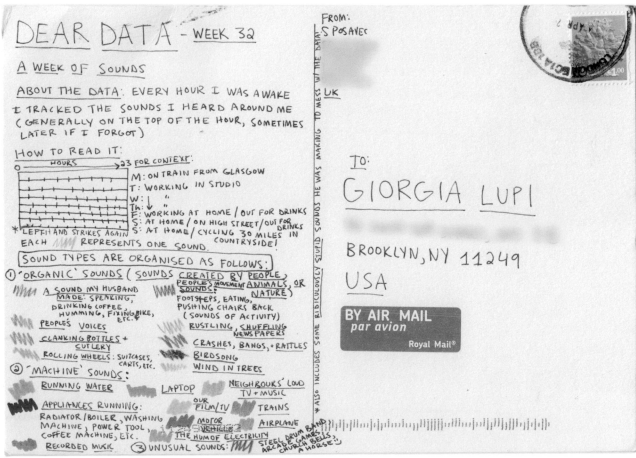

cards, sent across the ocean, gave us 52 pretexts to investigate aspects of our days. Amid the increasingly widespread assumption that "big data" is the key to decoding people's public and private lives, we wanted to explore the role that analog, hand-crafted data can have in understanding our personal experiences.

PUBLICATION: *dear-data.com* (February 2015)

Environmentalist		Oil Worker
Flight Attendant		Pilot
Bartender		Beer Wholesaler
Librarian		Logger
Taxi Driver		Truck Driver
Innkeeper		Motel Owner
Chairwoman		Chairman
Pediatrician		Urologist
Sculptor		Plastic Surgeon
Floral Designer		Exterminator
Yoga Instructor		Car Salesman
Architect		Home Builder
Bookseller		Pawnbroker
Episcopal Priest		Catholic Priest
Carpenter		Plumber
Midwife		Surgeon
Park Ranger		Sheriff
Gardener		Farmer
Chef		Cattle Feeder
Comedian		Talk Show Host
Professional Poker Player		Insurance Agent
Union Organizer		Business Owner
Environmental Scientist		Petroleum Geologist
Psychiatrist		Neurosurgeon

Restaurant & Bar
- Restaurant Manager
- Restaurateur
- Barista
- Bar Owner
- Waiter/Waitress
- Bartender

Religion
- Missionary
- Catholic Priest
- Pastor
- Reverend
- Minister
- Priest
- Chaplain
- Bishop
- Clergy
- Rabbi
- Episcopal Priest

Academia
- Professor Of Economics
- Professor Of Mathematics
- Professor Of Chemistry
- Professor Of Medicine
- Professor Of Physics
- Professor Of Law
- Professor Of History
- Professor Of English

Social & Environment
- Activist
- Environmentalist
- Social Worker
- Conservationist
- Union Organizer

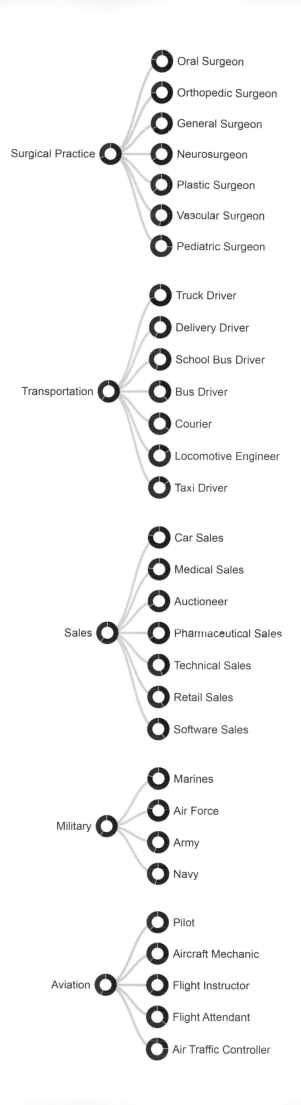

OCCUPATIONS AT THE BALLOT BOX

How do people of different professions vote?

ARTIST: Mark Edmond, software engineer and founder of Verdant Labs, a Seattle-based app company.

STATEMENT: I discovered a treasure trove of campaign contribution data published annually by the US Federal Election Commission, so I decided to see what a simple analysis of it might reveal. The circles here show the relative numbers of Democrats (blue) versus Republicans (red) in each profession. Most librarians are Democrats, it turns out, and most farmers are Republicans. As a group, doctors are in the middle, but pediatricians lean left and urologists right.

PUBLICATION: *verdantlabs.com* (June 2, 2015)

6:30am

SLOW **MEDIUM** FAST

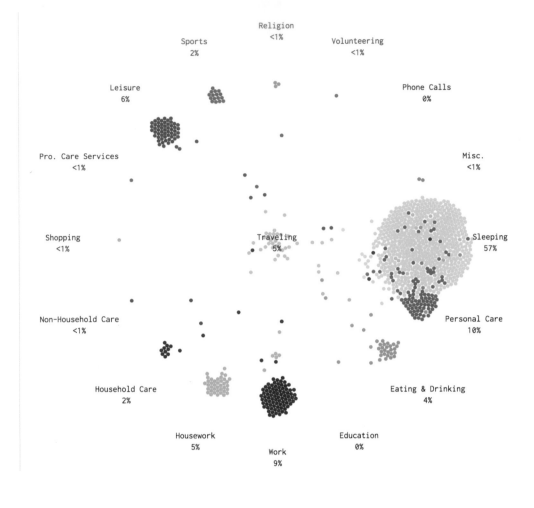

Religion
<1%

Sports
2%

Volunteering
<1%

Leisure
6%

Phone Calls
0%

Pro. Care Services
<1%

Misc.
<1%

Shopping
<1%

Traveling
5%

Sleeping
57%

Non-Household Care
<1%

Personal Care
10%

Household Care
2%

Eating & Drinking
4%

Housework
5%

Education
0%

Work
9%

8:01am

SLOW **MEDIUM** FAST

It's wake up time for most. Time to start the day with morning rituals, breakfast and a wonderful commute.

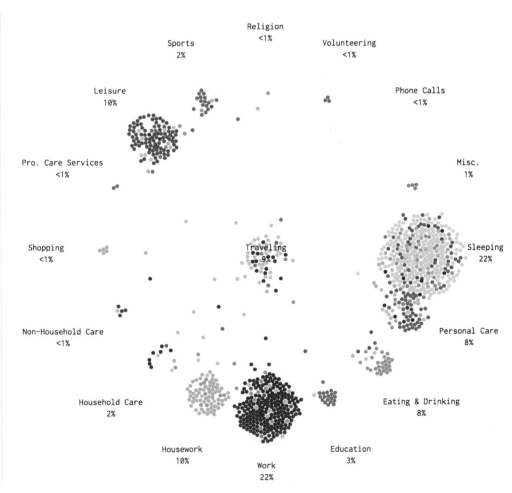

Religion
<1%

Sports
2%

Volunteering
<1%

Leisure
10%

Phone Calls
<1%

Pro. Care Services
<1%

Misc.
1%

Shopping
<1%

Traveling
9%

Sleeping
22%

Non-Household Care
<1%

Personal Care
8%

Household Care
2%

Eating & Drinking
8%

Housework
10%

Education
3%

Work
22%

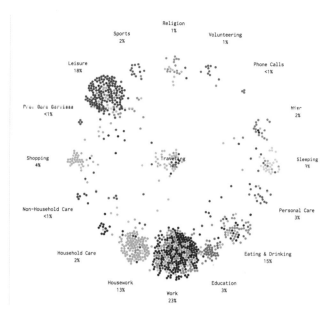

12:02pm

SLOW **MEDIUM** FAST

Lunch hour. Many go eat, but there's still activity throughout. You see a small shift at the end of the hour.

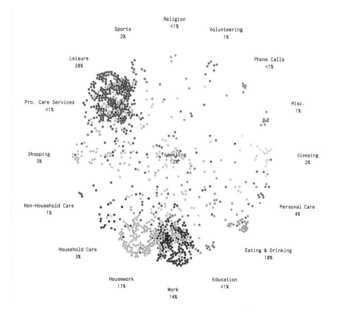

5:10pm

SLOW MEDIUM **FAST**

With the work day done, it's time to commute home and fix dinner or go out for a while.

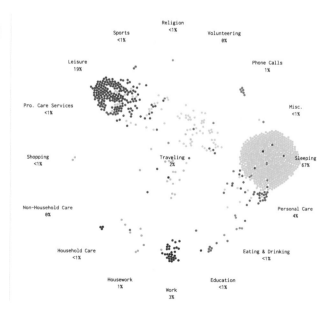

11:07pm

SLOW **MEDIUM** FAST

WHAT DO AMERICANS DO ALL DAY?

A visual answer.

ARTIST: Nathan Yau, statistician and proprietor of the website FlowingData.

STATEMENT: I'm a self-employed individual who works from home, so I tend to grow curious about what others' day-to-day lives are like. This animation is a simulation of a day in the life of 1,000 Americans based on thousands of anonymized daily schedules captured by the American Time Use Survey. Using those probabilities, I was able to simulate the lives of 1,000 people as they wake up, go to work, take breaks, eat lunch, leave work, turn in for the night, and then start the whole thing over again.

PUBLICATION: *flowingdata.com* (December 15, 2015)

Medical

Cannabis was a mainstay of healers in ancient China, India, and Greece. Today its status as an illegal drug under federal law hampers scientists who want to study its medical potential. Only two synthetic medicines have been approved by the Food and Drug Administration; a natural derivative is under review.

GLAUCOMA

Researchers are developing a drug that mimics marijuana's ability to reduce pressure in the eye but without the plant's side effects.

MULTIPLE SCLEROSIS

An extract that relieves pain and muscle spasms in MS patients has been approved in Europe and Canada, though not in the U.S.

AIDS

One of the FDA-approved synthetic versions of a substance found in marijuana helps increase appetite and treat weight loss in patients with the disease.

CANCER

The other synthetic version is used to treat nausea associated with chemotherapy.

Recreational

The primary psychoactive chemical in marijuana, tetrahydrocannabinol, or THC, acts on the brain to produce the high recreational users crave. Colors, sounds, and skin sensations can intensify, and time may seem to slow. Cannabis can also worsen the symptoms of depression and anxiety.

BRAIN

Many parts of the brain have receptors that react to marijuana. Some regulate food intake and cause cravings. Others regulate dopamine and can cause a sense of euphoria.

RESPIRATORY SYSTEM

Effects are felt seconds after inhalation and peak within 30 minutes. Unfiltered cannabis, inhaled deeply, can expose smokers to more carbon monoxide and tar than cigarettes do.

HEART

Heart rate can double, prompting panic attacks in some users. Studies also show that shortly after use, the risk of a heart attack can increase significantly.

DIGESTIVE SYSTEM

When cannabis is eaten, its effects kick in more slowly and last longer, making it hard to regulate dosage. Feelings of hunger often intensify.

Marijuana is rising in popularity...

Recreational users outnumber medical users. Despite the risk to their developing brains, a third of teens say they've used marijuana in the past month.

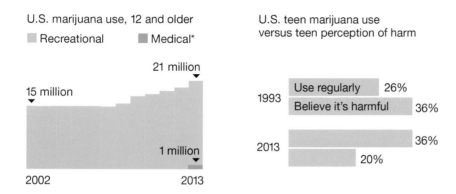

U.S. marijuana use, 12 and older

■ Recreational ■ Medical*

21 million

15 million

1 million

2002 2013

U.S. teen marijuana use
versus teen perception of harm

1993
Use regularly 26%
Believe it's harmful 36%

2013
36%
20%

and increasingly available in U.S. states...

As states loosen restrictions, one politically appealing option is cannabidiol (CBD) oil, which has some of marijuana's health effects without the high.

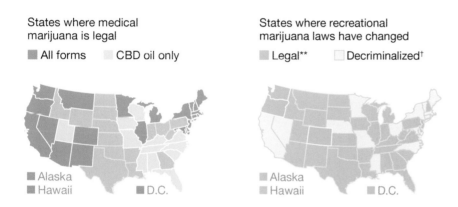

States where medical
marijuana is legal

■ All forms CBD oil only

■ Alaska
■ Hawaii ■ D.C.

States where recreational
marijuana laws have changed

■ Legal** □ Decriminalized†

■ Alaska
■ Hawaii ■ D.C.

creating a lucrative new market.

Illicit marijuana use is dwarfed by the use of other substances. As demand for legal marijuana grows, businesses are eyeing this new market.

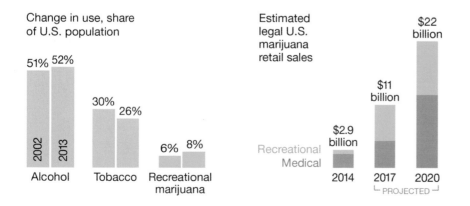

Change in use, share
of U.S. population

51% 52%

30%
26%

6% 8%

2002
2013

Alcohol Tobacco Recreational
marijuana

Estimated
legal U.S.
marijuana
retail sales

$22
billion

$11
billion

$2.9
billion

Recreational
Medical

2014 2017 2020
 └ PROJECTED ┘

THE PROSPECTS
FOR POT

The future of a controversial drug.

ARTISTS: John Tomanio, graphic editor; Bryan Christie Design, illustration; Shelley Sperry, research.

STATEMENT: In this overview of the state of cannabis in the United States, blue indicates medical marijuana (the states where it's legal; the organs where it's effective), and green indicates recreational marijuana (where it's legal; what parts of the body it affects). The charts quantify marijuana's popularity, availability, and large potential market. Medical marijuana research, an active field in several nations, is virtually nonexistent in the US because of drug laws. Our goal was to provide clear analysis of a subject that is often surrounded by unproven claims and speculation.

PUBLICATION: *National Geographic* (June 2015)

LIFE DURING WARTIME

*How much of your life has the
United States been in conflict?*

ARTIST: Philip Bump, writer at the *Washington Post*.

STATEMENT: Inspired by a college commencement address mentioning that graduates had seen the United States at war for more than half their lives, I wanted to see if I could determine that percentage for any living American. There's a surprising level of subjectivity to the analysis, since most modern wars aren't declared by Congress and don't end with surrenders.

The speaker's point was that the experience of war in modern America differs greatly from conflicts like World War II, which was all-encompassing, or Vietnam, for which there was a draft. The "war on terror," begun in the aftermath of the September 11 attacks, means that the United States has been in this new state of war for all but nine months of the twenty-first century. As a result, every living American has spent a startling percentage of his or her life in a country at war, but with very few experiencing that firsthand.

PUBLICATION: *Washington Post*
(May 18, 2015)

Composition of the population in 2014

■ PERCENT SPENT IN WAR
■ PERCENT SPENT IN PEACE

Wars, by age

TIME SPENT IN WAR ■
TIME SPENT IN PEACE ■

YEAR OF BIRTH	PERCENT OF LIFE AT WAR
1915	35.6%
1916	36
1917	36.4
1918	35.7
1919	35.1
1920	35.4
1921	35.8
1922	36.2
1923	36.6
1924	37
1925	37.4
1926	37.8
1927	38.2
1928	38.6
1929	39.1
1930	39.5
1931	40
1932	40.5
1933	41
1934	41.5
1935	42
1936	42.5
1937	43
1938	43.6
1939	44.2
1940	44.7
1941	45.3
1942	44.6
1943	43.8
1944	43.1
1945	42.3
1946	41.4
1947	42
1948	42.6
1949	43.3
1950	43.9
1951	43.1
1952	42.2
1953	41.3
1954	40.3
1955	41
1956	41.7
1957	42.4
1958	43.1
1959	43.9
1960	44.6
1961	45.5
1962	46.3
1963	47.2
1964	48.1
1965	49
1966	48
1967	46.9
1968	45.8
1969	44.7
1970	43.5
1971	42.2
1972	40.9
1973	39.5
1974	38.1
1975	39
1976	40
1977	41
1978	42.1
1979	43.2
1980	44.4
1981	45.7
1982	47.1
1983	48.5
1984	50
1985	51.6
1986	53.3
1987	55.2
1988	57.1
1989	59.3
1990	61.5
1991	64
1992	62.5
1993	65.2
1994	68.2
1995	71.4
1996	75
1997	78.9
1998	83.3
1999	88.2
2000	93.8
2001	100
2002	100
2003	100
2004	100
2005	100
2006	100
2007	100
2008	100
2009	100
2010	100
2011	100
2012	100
2013	100
2014	100

WWI WW2 KOREA V'NAM GULF TERROR

5 4 3 2 1

MILLIONS OF PEOPLE IN POPULATION

20 40 60 80 100

STATUS BY YEAR OF AGE

This table charts the wide variety of sweeteners available in the United States, either in bulk amounts or as additives in food. Not listed are super-sweet-tasting, zero-calorie proteins from several African fruits (monellin, brazzein and thaumatin), which have not been approved for use by the FDA. Also not included: banned or poisonous sweeteners, such as **lead acetate**, which ancient Romans made by cooking sour wine in lead pots.

Legend

POSITIVE ATTRIBUTES
- ✚ Diabetic-friendly
- Contains nutrients
- Prebiotic; promotes a healthy gut

NEGATIVE ATTRIBUTES
- ✖ Too much can lead to metabolic problems
- ▶ Causes tooth decay
- ❖ Unstable in heat; not suitable for cooking
- ✳ Excess amounts can have a laxative effect
- ✧ Has unpleasant aftertaste

Example cell

3
Ex
Name
Other names and trade names
Notes

CALORIES Starred sweeteners offer energy — or extra pounds.
SWEETNESS compared with table sugar, which has a sweetness value of 1
SYMBOL

Faint symbols indicate attributes that are uncertain, debatable or less strong than those of darker symbols.

NATURAL

RAW

0.97 Hn — Honey
Has antioxidants, but may contain pesticides; dangerous for infants

0.5 Yc — Yacón syrup or powder
High in fiber; daily intake might cause weight loss

300 St — Stevia leaf
Not approved as a food additive, but can be bought as a supplement

<1 Lu — Lucuma powder
Anti-inflammatory; sometimes processed with tree nuts/peanuts

300 Mk — Monk fruit, lo han
Ancient Chinese sweetener; sometimes "cut" with dextrose

COOKED

1 Ms — Maple syrup
Mostly sucrose; contains antioxidants, minerals and B vitamins

1.1 Sg — Sorghum syrup
Mostly sucrose; contains antioxidants, minerals and B vitamins

0.8 Mo — Cane sugar molasses
Mostly sucrose; contains antioxidants, minerals and B vitamins

PARTLY REFINED

1 Br — Brown sugar
Sugar in the Raw
Trace amounts of nutrients; mostly sucrose

OTHER REFINED

50 Li — Glycyrrhizin, licorice
Treats hepatitis in Japan; in excess, might cause high blood pressure

480 Re — Rebaudioside
Truvia, SweetLeaf
Not adequately tested, says one group

REFINED SUGAR

1 Su — Sucrose, table sugar
Linked to kidney disease, gout and fatty liver disease

1.7 Fr — Fructose, agave nectar
Boosts appetite; raises triglycerides and bad cholesterol

1.2 Hf — High-fructose corn syrup
Stabilizes processed foods; has been linked to mercury contamination

0.7 Gl — Glucose, corn syrup
Karo syrup
Lowers appetite; quickly raises blood-sugar levels

1.2 In — Inverted sugar
Sucrose split into glucose and fructose by an acid

0.45 Tr — Trehalose
Natural preservative for foods; fuels insect metabolism

0.5 Ma — Maltose
Brown rice syrup, Syrup arsenic levels often higher than recommended

0.3 Ga — Galactose
Harmful to people unable to digest it

0.2 Lc — Lactose, milk sugar
Glucose bonded to galactose; some adults cannot digest it

0.9 Tg — Tagatose, *Naturlose*
Lowers blood glucose levels in people with elevated blood sugar

0.8 Mt — Maltitol, *SweetPearl*
Has less of a cooling effect than other sugar alcohols

0.4 Lt — Lactitol, *NH4-Redox*
Derived from whey

SUGAR ALCOHOL

0.6 Gy — Glycerol, glycerin
Keeps foods moist; high doses cause nausea and dizziness

1 Xy — Xylitol, *Xylosweet*
Good for teeth; as sweet as sugar

0.6 Sb — Sorbitol
Prolongs food shelf life; some people allergic; not for irritable bowels

0.6 Mn — Mannitol
Hard coating for pills; very large doses can damage kidneys, heart

0.7 Er — Erythritol, *Zsweet*
Good for teeth; large doses cause nausea

SUGAR ALCOHOL

0.69 Is — Isomalt
Used to make edible decorations

ARTIFICIAL

300 Sc — Saccharin
Sweet'n Low
Once banned for causing bladder cancer in rats

600 Sr — Sucralose, *Splenda*
Keeps crystalline form even in high heat; persists in environment

200 As — Aspartame, *Equal*
Generates formaldehyde in the body; can increase waist size

200 Ac — Acesulfame potassium, *Sunett*
CSPI: "Safety tests . . . were of mediocre quality."

10,000 Ne — Neotame
"Flawed safety studies," says Center for Science in the Public Interest

20,000 Ad — Advantame
Derived from aspartame; effects on brain have not been thoroughly tested

A recent study found that these three sweeteners can upset intestinal flora, causing glucose intolerance in mice and in some humans tested.

Sources: Center for Science in the Public Interest; FDA; CDC; Ajinomoto; Life Sciences; Environmental Working Group; Mayo Clinic; Calorie Control Council; sugar.org; sugar-and-sweetener-guide.com; milkmatters.org; BMC Biology

PATTERSON CLARK AND LAZARO GAMIO/THE WASHINGTON POST

Sugars are ring-shaped molecules made of ● carbon, ● oxygen and ● hydrogen. Carbohydrates exist as simple sugars (one ring), double sugars (two linked rings) and starches (multiple linked rings). The body's cells use the simple sugar glucose as a source of fuel.

Sucrose, or table sugar, below, is a double sugar of glucose bonded to fructose. Our bodies produce an enzyme that breaks that bond.

Fructose is converted by the liver into fat.

Glucose supplies energy for brain and muscle cells.

Other sweeteners are derived from either natural sources or laboratory experiments. Although their safety is questioned by some researchers, the Food and Drug Administration regards them as safe.

Sucralose is made by removing three oxygen atoms from sucrose and substituting three chlorine atoms.

Sugar alcohols are almost as sweet as table sugar. Found naturally in small amounts in fruits, they can have a cooling effect in the mouth and don't cause tooth decay, but in excess they can cause digestive distress.

Xylitol, below, synthesized from corncobs and birch trees, can help remineralize tooth enamel.

WARNING:
Even in small amounts, xylitol, which is often found in chewing gum and candy, is poisonous to dogs.

Sorting through the sweetness

- ■ Sweetener has this characteristic
- ■ Marginal; small amounts
- ■ Has opposite effect
- ■ Some uncertainty; debatable

Low in calories

We need calories to drive our metabolism, but too many calories can lead to trouble. People seeking to reduce calories from sweeteners might turn to some of these.

Safe for diabetics

There are more natural alternatives than artificial ones for diabetics and hyperglycemics who want to satisfy a sweet tooth without raising blood glucose levels.

Good for the gut

A healthy gut is good for the whole body, so a sweetener that promotes desirable intestinal bacteria can also alleviate some of the guilt associated with enjoying dessert.

Contains nutrients

Vitamins, minerals, enzymes and other healthful compounds are more likely to be found in raw or slightly processed sweeteners, all of which are derived from plants.

May taste bad

Some compounds can trick our tongues into firing sweet signals, but in high concentrations they can yield a bitter experience.

Disrupts metabolism

Consuming too much sugar can lead to obesity, heart disease, metabolic syndrome, diabetes and high blood pressure. Some artificial sweeteners might also mess with metabolism.

Promotes tooth decay

Most natural sugars fuel bacteria, which release acid that causes tooth decay. But some sweeteners are actually good for teeth.

Unstable in heat

The last thing a baker wants is for a recipe's sweetener to break down into undesirable or dangerous substances while in the oven.

Can upset digestion

Less-digestible sweeteners might be good for some bacteria in the gut, but too much of a good thing can lead to nausea or diarrhea.

AN ELEMENTAL TABLE OF SWEETS

From advantame to yacón syrup.

ARTIST: Patterson Clark, artist and writer; Lazaro Gamio, art director, at the *Washington Post*.

STATEMENT: Today, a person with a sweet tooth can choose from dozens of different sweeteners, in many different varieties, each with benefits and drawbacks.

We divided them into categories and arranged them in the form of a periodic table, and provided a primer in sweetener chemistry as well.

PUBLICATION: *Washington Post* (March 2, 2015)

THE DEADLIEST JOBS IN AMERICA

They're not always what you expect.

Which of these workers is most likely to die on the job?

 Security guards ✕

Firefighters

 Garbage collectors

Which of these jobs is near the top of the list for fatalities but near the bottom for pay?

 Loggers

Grounds maintenance workers ✕

 Cashiers ✕

> Loggers have one of the worst job fatality-to-pay ratios. They die more often than police officers and firefighters, but are paid less.

← Higher Pay Higher Risk →

Which of these workers is most likely to die on the job?

Security guards ✕

Firefighters

Garbage collectors

← Lower Fatality Rate Higher →

Garbage collectors

These workers die on the job about four times more often than firefighters and security guards. Transportation incidents are the biggest cause, accounting for 69% of fatalities.

Fishers
Loggers
Aircraft pilots
Misc. extraction workers
Iron and steel workers
Roofers
Garbage collectors
Farmers and ranchers
Driver/sales workers and truck drivers
Power-line installers and repairers
Misc. agricultural workers
Construction laborers
Taxi drivers and chauffeurs
Police officers
Managers of construction trades
General maintenance and repairs workers
Helpers, construction trades
Grounds maintenance workers
Managers of landscaping workers
Operating engineers
Industrial machinery workers
Athletes, coaches, umpires
Electricians
Line installers and repairers
Welding, soldering, and brazing workers
Firefighters
Painters, construction and maintenance
Security guards
Bus and truck mechanics
Managers of mechanics and repairers
Hand laborers and freight/stock movers
HVAC mechanics and installers
Pipelayers, plumbers and pipefitters
Industrial truck and tractor operators
Carpenters
Automotive technicians and mechanics
Property and real estate managers
Construction managers
Managers of production workers
Managers of retail sales workers
Food service managers
Cashiers
Life, physical, and social science jobs
Managers of nonretail sales workers
Architecture and engineering jobs
Personal care and service jobs
Community and social services jobs
Retail salespersons
Food preparation and serving jobs
Office and administrative support jobs
Business and financial operations jobs

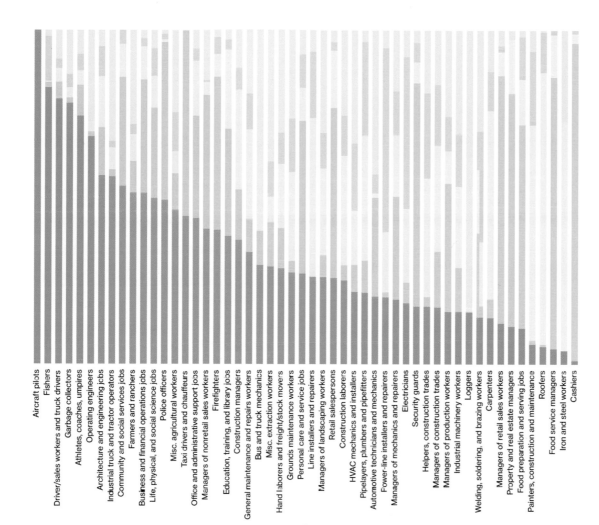

Taxi drivers are more likely to die from homicide than from a transportation accident.

Top chart (labels, left to right):

Aircraft pilots
Fishers
Driver/sales workers and truck drivers
Garbage collectors
Athletes, coaches, umpires
Operating engineers
Architecture and engineering jobs
Industrial truck and tractor operators
Community and social services jobs
Farmers and ranchers
Business and financial operations jobs
Life, physical, and social science jobs
Police officers
Misc. agricultural workers
Taxi drivers and chauffeurs
Office and administrative support jobs
Managers of nonretail sales workers
Firefighters
Education, training, and library jobs
Construction managers
General maintenance and repairs workers
Bus and truck mechanics
Misc. extraction workers
Hand laborers and freight/stock movers
Grounds maintenance workers
Personal care and service jobs
Line installers and repairers
Managers of landscaping workers
Retail salespersons
Construction laborers
HVAC mechanics and installers
Pipelayers, plumbers and pipefitters
Automotive technicians and mechanics
Power-line installers and repairers
Managers of mechanics and repairers
Electricians
Security guards
Helpers, construction trades
Managers of construction trades
Managers of production workers
Industrial machinery workers
Loggers
Welding, soldering, and brazing workers
Carpenters
Managers of retail sales workers
Property and real estate managers
Food preparation and serving jobs
Painters, construction and maintenance
Roofers
Food service managers
Iron and steel workers
Cashiers

Bottom chart (labels, left to right):

Taxi drivers and chauffeurs
Police officers
Security guards
Managers of retail sales workers
Property and real estate managers
Managers of mechanics and repairers
Misc. agricultural workers
Managers of construction trades
Food service managers
Fishers
Farmers and ranchers
Cashiers
Driver/sales workers and truck drivers
Automotive technicians and mechanics
General maintenance and repairs workers
Athletes, coaches, umpires
Managers of landscaping workers
Managers of production workers
Industrial machinery workers
Hand laborers and freight/stock movers
Personal care and service jobs
Managers of nonretail sales workers
Food preparation and serving jobs
Retail salespersons
Construction managers
Construction laborers
Grounds maintenance workers
Garbage collectors
Community and social services jobs
Pipelayers, plumbers and pipefitters
Life, physical, and social science jobs
Carpenters
Welding, soldering, and brazing workers
HVAC mechanics and installers
Electricians
Firefighters
Bus and truck mechanics
Roofers
Architecture and engineering jobs
Helpers, construction trades
Office and administrative support jobs
Business and financial operations jobs
Industrial truck and tractor operators
Education, training, and library jobs
Painters, construction and maintenance
Operating engineers
Loggers
Aircraft pilots
Misc. extraction workers
Iron and steel workers
Power-line installers and repairers
Line installers and repairers

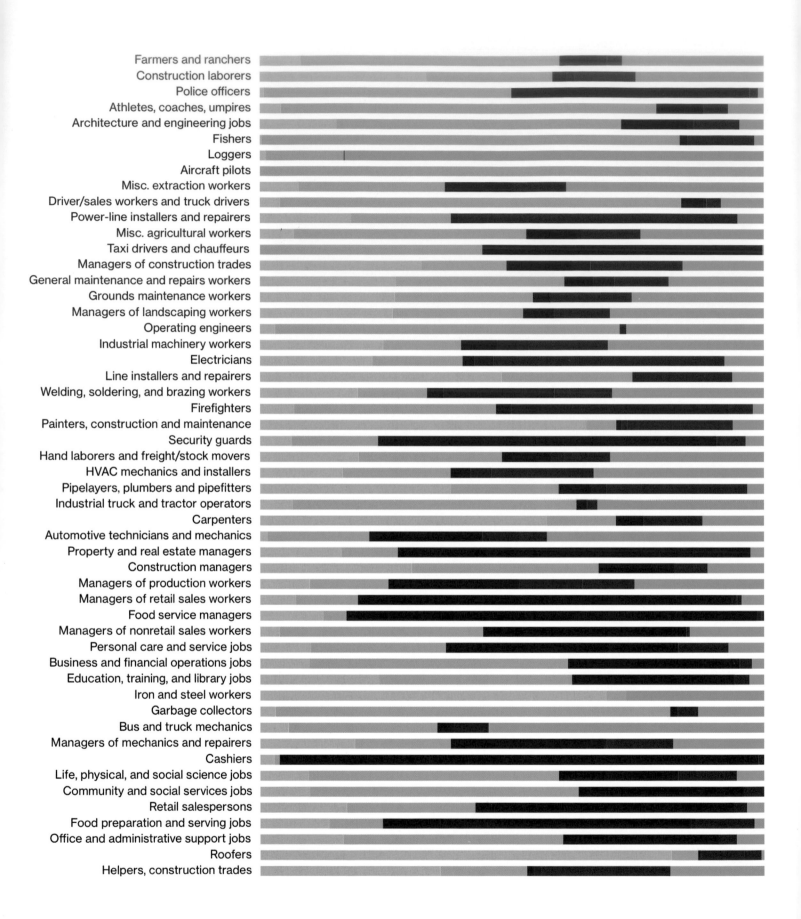

Farmers and ranchers
Construction laborers
Police officers
Athletes, coaches, umpires
Architecture and engineering jobs
Fishers
Loggers
Aircraft pilots
Misc. extraction workers
Driver/sales workers and truck drivers
Power-line installers and repairers
Misc. agricultural workers
Taxi drivers and chauffeurs
Managers of construction trades
General maintenance and repairs workers
Grounds maintenance workers
Managers of landscaping workers
Operating engineers
Industrial machinery workers
Electricians
Line installers and repairers
Welding, soldering, and brazing workers
Firefighters
Painters, construction and maintenance
Security guards
Hand laborers and freight/stock movers
HVAC mechanics and installers
Pipelayers, plumbers and pipefitters
Industrial truck and tractor operators
Carpenters
Automotive technicians and mechanics
Property and real estate managers
Construction managers
Managers of production workers
Managers of retail sales workers
Food service managers
Managers of nonretail sales workers
Personal care and service jobs
Business and financial operations jobs
Education, training, and library jobs
Iron and steel workers
Garbage collectors
Bus and truck mechanics
Managers of mechanics and repairers
Cashiers
Life, physical, and social science jobs
Community and social services jobs
Retail salespersons
Food preparation and serving jobs
Office and administrative support jobs
Roofers
Helpers, construction trades

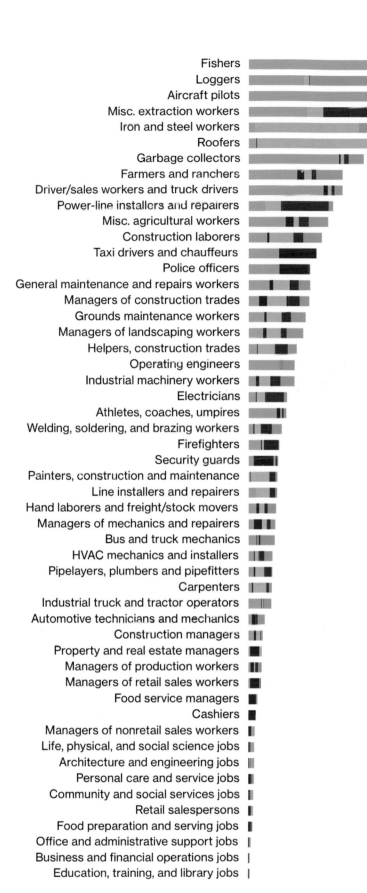

Fishers	
Loggers	
Aircraft pilots	
Misc. extraction workers	
Iron and steel workers	
Roofers	
Garbage collectors	
Farmers and ranchers	
Driver/sales workers and truck drivers	
Power-line installers and repairers	
Misc. agricultural workers	
Construction laborers	
Taxi drivers and chauffeurs	
Police officers	
General maintenance and repairs workers	
Managers of construction trades	
Grounds maintenance workers	
Managers of landscaping workers	
Helpers, construction trades	
Operating engineers	
Industrial machinery workers	
Electricians	
Athletes, coaches, umpires	
Welding, soldering, and brazing workers	
Firefighters	
Security guards	
Painters, construction and maintenance	
Line installers and repairers	
Hand laborers and freight/stock movers	
Managers of mechanics and repairers	
Bus and truck mechanics	
HVAC mechanics and installers	
Pipelayers, plumbers and pipefitters	
Carpenters	
Industrial truck and tractor operators	
Automotive technicians and mechanics	
Construction managers	
Property and real estate managers	
Managers of production workers	
Managers of retail sales workers	
Food service managers	
Cashiers	
Managers of nonretail sales workers	
Life, physical, and social science jobs	
Architecture and engineering jobs	
Personal care and service jobs	
Community and social services jobs	
Retail salespersons	
Food preparation and serving jobs	
Office and administrative support jobs	
Business and financial operations jobs	
Education, training, and library jobs	

ARTISTS: Christopher Cannon, visual and information designer, data journalist; Adam Pearce, developer, data journalist; Alex McIntyre, data analyst, reporter, at Bloomberg Graphics.

STATEMENT: The Bureau of Labor Statistics releases data annually about on-the-job fatalities, which include some surprises. Taxi drivers suffer more deaths from violence than from traffic accidents; truck drivers are less likely to die in a transportation incident than are athletes, coaches, and umpires. We asked readers three simple quiz questions that highlighted unexpected answers, and used them to lead off sections on fatality rates, the correlation of risk to reward, and all the different ways workers die on the job.

PUBLICATION: Bloomberg.com (May 13, 2015)

SMELL THE CITY

What the geographical aromas of urban life can tell us.

ARTISTS: Data science by Rossano Schifanella, computer scientist at the University of Turin, Italy; Daniele Quercia, head of the Social Dynamics group at Bell Labs in Cambridge, UK; and Luca Aiello, research scientist at Yahoo Labs in London. Design by Schifanella.

STATEMENT: Humans are able to discriminate among several thousands of different odors, but city officials and urban planners deal only with the management of a few bad ones. The Smelly Maps project explores the olfactory footprint of an entire city by collecting smell reports from

social media. By analyzing the metadata (mainly tags) associated with geo-located photos shared on social media platforms (e.g., Flickr, Instagram), Smelly Maps is able to determine the odors present in each street segment. The goal of Smelly Maps is to open up a new stream of research celebrating the complex smells of our cities, and to contribute to critical thinking about the roles smell has to play in urban design.

PUBLICATION: *goodcitylife.org* (2015)

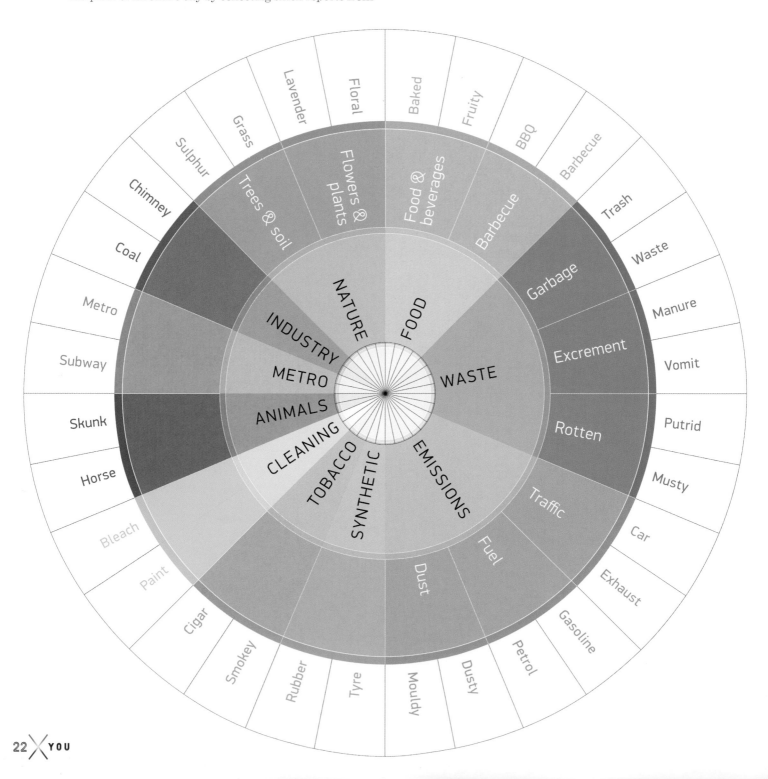

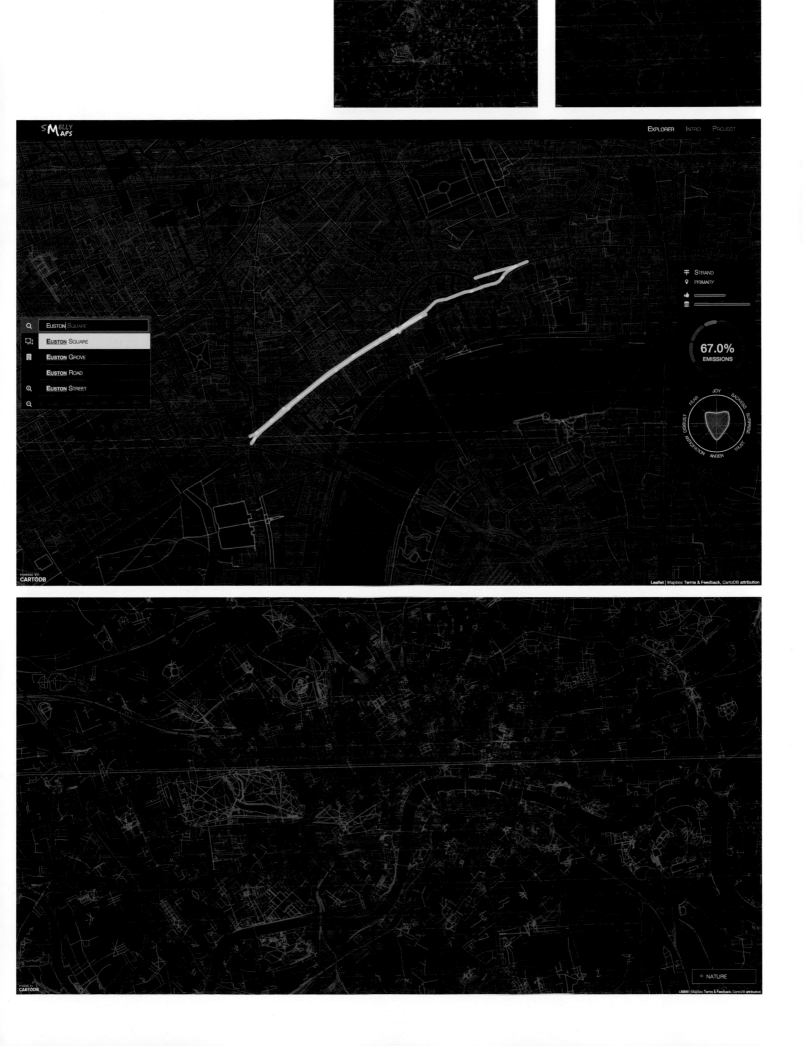

HOW LONG YOU HAVE LEFT TO LIVE (ON AVERAGE)

Counting down the years.

ARTIST: Nathan Yau, statistician and proprietor of the website FlowingData.

STATEMENT: Maybe it's that I'm a dad now or maybe I'm just getting older, but I got to thinking about how long I'm going to live. We know about life expectancy, yet just because a female at birth in the United States lives to 79 on average doesn't mean every woman lives to this age. I wanted to let people see how long they were likely to live, given what "average" really means. So I looked at data from the Social Security Administration, which provides the probabilities that one will die within the next year by age and sex based on deaths in previous years. The older you get, the higher the probability you will die. Makes sense.

PUBLICATION: *flowingdata.com*
(September 23, 2015)

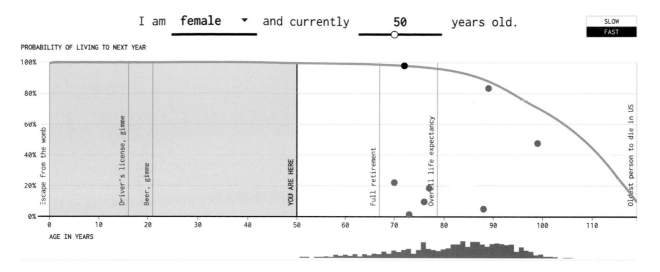

I am **female** ▼ and currently **50** years old.

SLOW
FAST

PROBABILITY OF LIVING TO NEXT YEAR

Escape from the womb · Driver's license, gimme · Beer, gimme · YOU ARE HERE · Full retirement · Overall life expectancy · Oldest person to die in US

AGE IN YEARS

Probabilities For Years Left to Live

0 to 9	10 to 19	20 to 29	30 to 39	40 to 49	50 or more
3%	9%	21%	34%	30%	3%
(19)	(63)	(149)	(234)	(208)	(23)

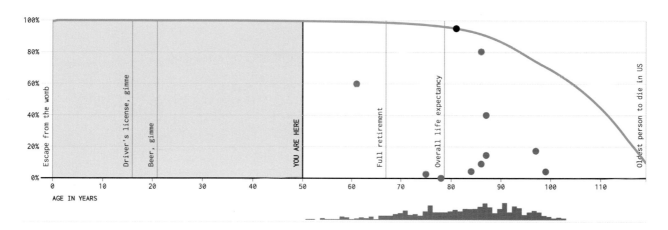

Escape from the womb · Driver's license, gimme · Beer, gimme · YOU ARE HERE · Full retirement · Overall life expectancy · Oldest person to die in US

AGE IN YEARS

Probabilities For Years Left to Live

0 to 9	10 to 19	20 to 29	30 to 39	40 to 49	50 or more
3%	8%	23%	33%	29%	4%
(11)	(31)	(89)	(131)	(115)	(16)

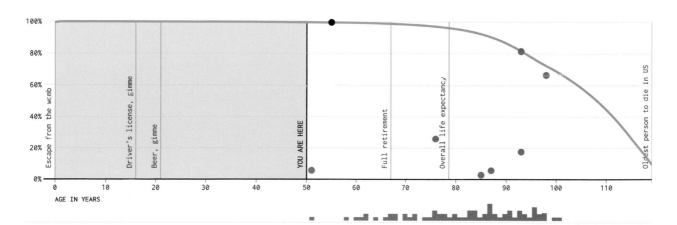

Escape from the womb · Driver's license, gimme · Beer, gimme · YOU ARE HERE · Full retirement · Overall life expectancy · Oldest person to die in US

AGE IN YEARS

Probabilities For Years Left to Live

0 to 9	10 to 19	20 to 29	30 to 39	40 to 49	50 or more
3%	14%	19%	29%	32%	3%
(2)	(10)	(14)	(21)	(23)	(2)

A TAX BRACKET HISTORY

Behind "simplicity" hides a system that's become much less progressive.

ARTIST: Alvin Chang, graphics reporter at Vox.com.

STATEMENT: This graphic uses simple bars to show three things: what tax brackets are, how they've changed in the past 100 years, and why "simplifying" them has caused a growth in inequality. In 2014, there are just seven lines to represent the marginal tax rates. I hope readers' first thought is: I get it. But I hope their next thoughts are: Wow, there used to be a lot of brackets. And wow, Ronald Reagan cut it down to two. And some people's marginal tax rate was greater than 90 percent under John F. Kennedy? What did these systems mean for wealth distribution? This graphic offers a way to consider whether it's true that having fewer tax brackets is better, merely because it's simpler.

PUBLICATION: *Vox* (October 26, 2015)

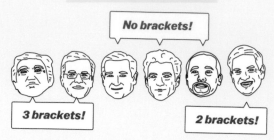

Presidential candidates have been talking about reducing the number of tax brackets. But what does that mean?

No brackets!

3 brackets!

2 brackets!

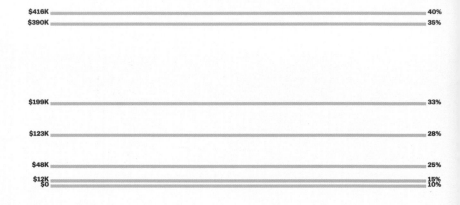

Here are the 2013 income tax brackets*. As your income rises, you usually have to pay a higher percentage to the government.

** For heads of household.*

$416K	40%
$390K	35%
$199K	33%
$123K	28%
$48K	25%
$12K	15%
$0	10%

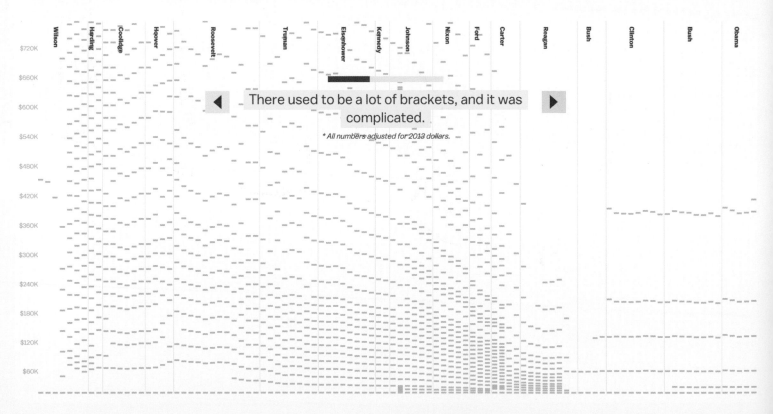

There used to be a lot of brackets, and it was complicated.

** All numbers adjusted for 2013 dollars.*

Wilson · Harding · Coolidge · Hoover · Roosevelt · Truman · Eisenhower · Kennedy · Johnson · Nixon · Ford · Carter · Reagan · Bush · Clinton · Bush · Obama

$720K · $660K · $600K · $540K · $480K · $420K · $360K · $300K · $240K · $180K · $120K · $60K

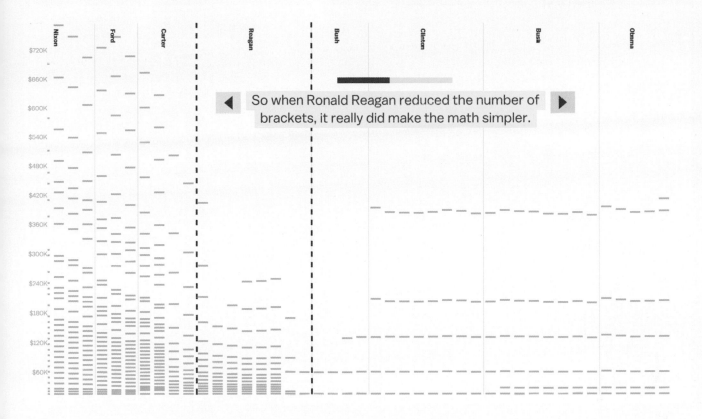

So when Ronald Reagan reduced the number of brackets, it really did make the math simpler.

For example, during Kennedy's presidency, the top rate for someone earning $210,000 was 54 percent; the top rate for someone earning $1.5 million was 90 percent.

Data from the Tax Foundation

Winners and Losers: Job Gains and Losses Jump to National Unemployment

Track the number of sectors gaining or losing jobs each month. Boxes are shaded based on percentage change from the previous month in each sector's payrolls.

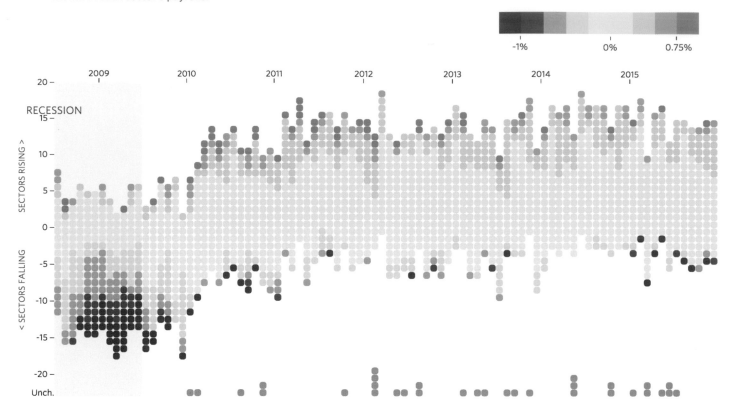

Detailed View: Job Gains and Losses for January 2016

Click on *any column header* to re-order both charts, first by sectors that gained jobs that month, then by sectors that lost them.

Sector name	Sector size	Monthly change (total jobs)	Monthly change (pct.) ⌄	Months rising	Months falling
Construction	6,597,000	48,000	+0.73%	65	52
Transportation and warehousing	4,889,300	17,000	+0.35%	84	35
Restaurants and bars	11,221,100	36,600	+0.33%	93	26
Professional and business services	19,981,000	60,000	+0.30%	95	24
Information	2,761,000	8,000	+0.29%	43	71
Federal government	2,766,000	8,000	+0.29%	60	49
Education	3,495,100	9,500	+0.27%	83	36
Nondurable goods manufacturing	4,593,000	12,000	+0.26%	46	70
Health care and social assistance	18,874,100	44,800	+0.24%	116	3
Other services	5,660,000	12,000	+0.21%	77	39
Financial activities	8,192,000	10,000	+0.12%	69	48
Utilities	563,400	600	+0.11%	65	52
Wholesale trade	5,902,400	5,100	+0.09%	82	37
Local government	14,164,000	4,000	+0.03%	58	58
Durable goods manufacturing	7,734,000	1,000	+0.01%	61	57
Retail trade	15,753,400	-800	-0.01%	74	44
State government	5,109,000	-1,000	-0.02%	60	55
Accommodation	1,925,900	-500	-0.03%	73	45
Arts, entertainment and rec.	2,191,300	-4,700	-0.21%	78	40
Mining and logging	764,000	-7,000	-0.91%	76	39

WATCHING JOBS AS THEY FALL AND RISE

An interactive graphic keeps pace with unemployment.

ARTISTS: Andrew Van Dam, data visualization reporter, and Renee Lightner, graphics editor, at the *Wall Street Journal*.

STATEMENT: There are two main surveys of the US labor market—payroll information from businesses, and employment-status and demographic information from house-holds—expressed here in two heat maps. Though a version of this graphic appeared in print, the interactive version allowed us to reflect a high level of detail as well as ongoing changes. The data updates automatically each month when the jobs report comes out.

PUBLICATION: *Wall Street Journal* (February 5, 2015)

Jobs Come, Jobs Go: National Unemployment Jump to Job Gains/Losses

Track various national unemployment rates month by month since their earliest year with official data, seasonally adjusted

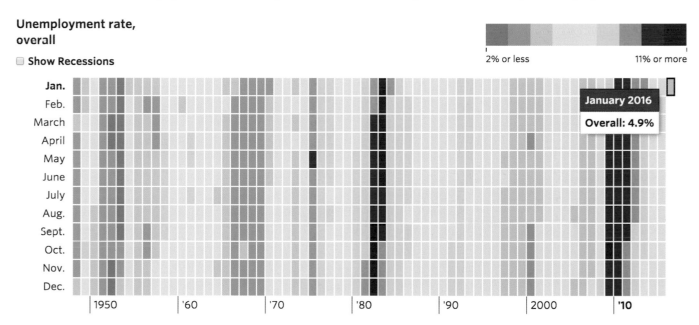

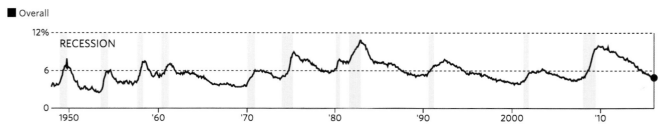

A YEAR IN THE LIFE OF THE DATA ARTIST

A designer tracks his own behavior—and maps it.

ARTIST: Nicholas Felton, information designer in New York.

STATEMENT: Since 2005, the Feltron Annual Report has gathered ethereal personal data to document the life of its author. This is the tenth and final Feltron Annual Report, based entirely on an array of commercially available applications and devices that logged information about my car, computer, location, environment, media consumption, sleep, activity, and physiology. The final document incorporated nearly 600,000 data points, including photographs, and took nearly a year to complete.

PUBLICATION: *feltron.com*
(October 15, 2015)

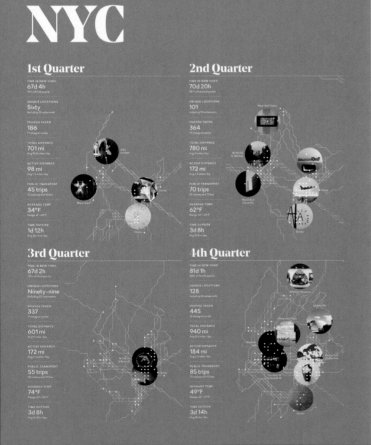

NYC

1st Quarter

TIME IN NEW YORK
67d 4h
75% of first quarter

UNIQUE LOCATIONS
Sixty
Including 13 restaurants

PHOTOS TAKEN
186
7 Instagram weeks

TOTAL DISTANCE
701 mi
Avg 10.4 miles/day

ACTIVE DISTANCE
98 mi
Avg 1.5 miles/day

PUBLIC TRANSPORT
45 trips
32 subway and 13 taxi

AVERAGE TEMP
34°F
Range 4°–60°F

TIME OUTSIDE
1d 12h
Avg 32 mins/day

2nd Quarter

TIME IN NEW YORK
70d 20h
78% of second quarter

UNIQUE LOCATIONS
101
Including 14 restaurants

PHOTOS TAKEN
364
13 Instagram posts

TOTAL DISTANCE
780 mi
Avg 7 miles/day

ACTIVE DISTANCE
172 mi
Avg 2.4 miles/day

PUBLIC TRANSPORT
70 trips
57 subway and 13 taxi

AVERAGE TEMP
62°F
Range 37°–21°F

TIME OUTSIDE
3d 8h
Avg 51 hrs/day

3rd Quarter

TIME IN NEW YORK
67d 2h
78% of third quarter

UNIQUE LOCATIONS
Ninety-nine
Including 32 restaurants

PHOTOS TAKEN
337
7 Instagram posts

TOTAL DISTANCE
601 mi
Avg 9 miles/day

ACTIVE DISTANCE
172 mi
Avg 2 miles/day

PUBLIC TRANSPORT
55 trips
39 subway and 12 taxi

AVERAGE TEMP
74°F
Range 61°–90°F

TIME OUTSIDE
3d 8h
Avg 1h 00m/day

4th Quarter

TIME IN NEW YORK
81d 1h
88% of fourth quarter

UNIQUE LOCATIONS
128
Including 24 restaurants

PHOTOS TAKEN
445
12 Instagram posts

TOTAL DISTANCE
940 mi
Avg 10 miles/day

ACTIVE DISTANCE
184 mi
Avg 2 miles/day

PUBLIC TRANSPORT
85 trips
71 subway and 10 taxi

AVERAGE TEMP
49°F
Range 27°–77°F

TIME OUTSIDE
3d 14h
Avg 56 min/day

Sources

Locations FROM MOVES APP

COMPLETENESS
99%
360 DAYS AND 9 HOURS RECORDED

TOTAL VISITS
2,367
23% to Home

PLACE CATEGORIES
168
Top category: Airport gate

Photos FROM IPHONE PHOTOS & INSTAGRAM

DAYS PHOTOGRAPHED
84%
305 DAYS WITH PHOTOS

TOTAL PHOTOS
2,758
Avg 8 photos/day

CAMERAS USED
Two
Apple iPhone 5s & 6

Music FROM RDIO AND ITUNES VIA LAST.FM

DAYS PLAYING MUSIC
88%
322 DAYS WITH MUSIC

TOTAL LISTENS
16,857
94% of listens from Rdio

NOT INCLUDED
SoundCloud
699 listens

Videos FROM NETFLIX

DAYS WATCHING VIDEO
27%
97 DAYS WITH VIDEO

TOTAL VIDEOS
282
Avg 1 video/day

NOT INCLUDED
Cinema
Flights, iTunes & Amazon

Computing FROM RESCUETIME

DAYS USING COMPUTER
98%
358 DAYS WITH COMPUTER

ALL RECORDS
60,313
7,578 apps & websites

CATEGORIES
Sixty-five
Top activity: Graphic design

Sleep FROM BASIS B1 WATCH

COMPLETENESS
93%
340 DAYS RECORDED

ALL RECORDS
435
Avg 5.3 records/day

DEVICES BROKEN
One
Snorkeling in Virgin Gorda

Transit FROM MOVES APP

COMPLETENESS
99%
360 DAYS AND 9 HOURS RECORDED

ALL RECORDS
48,296
Avg 2.5 transits/day

TRANSIT TYPES
Six
Top transit: Car

Activity FROM MOVES AND SKI TRACKS APPS

COMPLETENESS
99%
360 DAYS AND 9 HOURS RECORDED

ALL RECORDS
66,629
Avg 6.3 activities/day

MISSING ACTIVITY
Snorkeling
In Virgin Gorda

Heart Rate FROM BASIS B1 WATCH

COMPLETENESS
75%
273 DAYS AND 6 HOURS RECORDED

ALL RECORDS
393,435
Avg 1,076 records/day

UNMEASURED DAYS
Ten
Longest gap: Dec 1–6

Weight FROM WITHINGS SMART BODY ANALYZER

DAYS USING SCALE
79%
289 DAYS RECORDED

ALL RECORDS
329
Avg 1.1 records/day

MAX MEASUREMENTS
9:05 am
8 measurements

Drinking FROM LAPKA BAM

DAYS USING BREATHALYZER
87%
319 DAYS RECORDED

ALL RECORDS
758
24% with no alcohol found

MAX MEASUREMENTS
7:35 pm
6 measurements

Driving FROM AUTOMATIC APP

DAYS USING CAR
37%
134 DAYS RECORDED

ALL RECORDS
396
Avg 3.3 records/day

NOT INCLUDED
Mom's Car
Virgin Gorda & Hobbit Tesla

Elsewhere

Bay Area
TIME IN REGION
14d 13h
1 visit totaling 4% of year

TOTAL DISTANCE
703 mi
Active distance 41 miles

UNIQUE LOCATIONS
Fifty-seven
34 visits to Moni's House

PHOTOS TAKEN
Ninety-five
5 Instagram posts

AVERAGE TEMP
60°F
Range 43°-90°F

Virgin Gorda
TIME ON ISLAND
8d 4h
1 visit totaling 2% of year

TOTAL DISTANCE
110 mi
Active distance 8 miles

UNIQUE LOCATIONS
Twenty-two
14 visits to Blue Creek

PHOTOS TAKEN
288
3 Instagram posts

AVERAGE TEMP
80°F
Range 72°-86°F

Chicago
TIME IN CITY
4d 7h
2 visits totaling 1% of year

TOTAL DISTANCE
89 mi
Active distance 48 miles

UNIQUE LOCATIONS
Twenty-four
10 visits to The Jones

PHOTOS TAKEN
232
9 Instagram posts

AVERAGE TEMP
70°F
Range 43°-83°F

Madison
TIME IN CITY
3d 18h
1 visit totaling 1% of year

TOTAL DISTANCE
55 mi
Active distance 28 miles

UNIQUE LOCATIONS
Seven
6 visits to Graduate Hotel

PHOTOS TAKEN
Sixty-six
1 Instagram post

AVERAGE TEMP
67°F
Range 56°-80°F

Southern California
TIME IN REGION
7d 10h
1 visit totaling 2% of year

TOTAL DISTANCE
745 mi
Active distance 42 miles

UNIQUE LOCATIONS
Nineteen
6 visits to Mammoth Lodge

PHOTOS TAKEN
114
2 Instagram posts

AVERAGE TEMP
42°F
Range 12°-79°F

Netherlands
TIME IN COUNTRY
5d 5h
1 visit totaling 1% of year

TOTAL DISTANCE
134 mi
Active distance 9 miles

UNIQUE LOCATIONS
Thirteen
6 visits to Lloyd Hotel

PHOTOS TAKEN
Sixty-one
2 Instagram posts

AVERAGE TEMP
46°F
Range 37°-56°F

Rhode Island
TIME IN STATE
3d 18h
1 visit totaling 1% of year

TOTAL DISTANCE
70 mi
Active distance 8 miles

UNIQUE LOCATIONS
Nine
5 visits to The Dean

PHOTOS TAKEN
Forty-six
1 Instagram post

AVERAGE TEMP
43°F
Range 32°-56°F

Vail
TIME IN REGION
3d 13h
1 visit totaling 1% of year

TOTAL DISTANCE
359 mi
Active distance 8 miles

UNIQUE LOCATIONS
Nine
7 visits to The Lodge at Vail

PHOTOS TAKEN
Fifty-five
2 Instagram posts

AVERAGE TEMP
30°F
Range 18°-70°F

Minneapolis
TIME IN CITY
5d 4h
2 visits totaling 1% of year

TOTAL DISTANCE
39 mi
Active distance 12 miles

UNIQUE LOCATIONS
Eleven
6 visits to Hyatt Regency

PHOTOS TAKEN
Fifty-eight
2 Instagram posts

AVERAGE TEMP
43°F
Range 31°-53°F

Belgrade
TIME IN CITY
4d 19h
1 visit totaling 1% of year

TOTAL DISTANCE
49 mi
Active distance 21 miles

UNIQUE LOCATIONS
23
5 visits to LifeDesign Home

PHOTOS TAKEN
Sixty-four
2 Instagram posts

AVERAGE TEMP
47°F
Range 32°-64°F

Helsinki
TIME IN CITY
3d 1h
1 visit totaling 1% of year

TOTAL DISTANCE
42 mi
Active distance 14 miles

UNIQUE LOCATIONS
Seventeen
5 visits to Torsdio Hotel

PHOTOS TAKEN
Ninety
3 Instagram posts

AVERAGE TEMP
46°F
Range 30°-55°F

Dublin
TIME IN CITY
3d
1 visit totaling 1% of year

TOTAL DISTANCE
39 mi
Active distance 10 miles

UNIQUE LOCATIONS
Nine
5 visits to Ormonde Quay

PHOTOS TAKEN
Thirty-six
2 Instagram posts

AVERAGE TEMP
59°F
Range 53°-69°F

Elsewhere

Bay Area
TIME IN REGION
14d 13h
703 mi
Fifty-seven
Ninety-five
60°F

Virgin Gorda
TIME ON ISLAND
8d 4h
110 mi
Twenty-two
288
80°F

Chicago
TIME IN CITY
4d 7h
89 mi
Twenty-four
232
70°F

Madison
TIME IN CITY
3d 18h
55 mi
Seven
Sixty-six
67°F

Southern California
7d 10h
745 mi
Nineteen
114
42°F

Netherlands
5d 5h
134 mi
Thirteen
Sixty-one
46°F

Rhode Island
3d 18h
70 mi
Nine
Forty-six
43°F

Vail
3d 13h
359 mi
Nine
Fifty-five
30°F

Minneapolis
5d 4h
39 mi
Eleven
Fifty-eight
43°F

Belgrade
4d 19h
49 mi
23
Sixty-four
47°F

Helsinki
3d 1h
42 mi
Seventeen
Ninety
46°F

Dublin
3d
39 mi
Nine
Thirty-six
59°F

The Feltron Annual Report Tenth Edition

THIS IS THE TENTH AND FINAL FELTRON ANNUAL REPORT. THE WORLD OF PERSONAL DATA HAS
CHANGED CONSIDERABLY SINCE THE PROJECT BEGAN IN 2005 AND THIS EDITION ATTEMPTS TO
CAPTURE ITS CURRENT STATE. WHILE PREVIOUS EDITIONS HAVE RELIED ON CUSTOM SOLUTIONS
TO GATHER ETHEREAL PERSONAL DATA, THIS EDITION IS BASED ENTIRELY ON COMMERCIALLY
AVAILABLE APPLICATIONS AND DEVICES. USING AN ARRAY OF PRODUCTS AND SOFTWARE, THE
AUTHOR'S CAR, COMPUTER, LOCATION, ENVIRONMENT, MEDIA CONSUMPTION, SLEEP, ACTIVITY
AND PHYSIOLOGY WERE INSTRUMENTED AND LOGGED.

NICHOLAS FELTON IS AN INFORMATION DESIGNER BASED IN NEW YORK. HE IS THE CO-CREATOR
OF THE SELF-TRACKING APPLICATIONS REPORTER AND DAYTUM. PREVIOUS ANNUAL REPORTS
CAN BE VIEWED AT FELTRON.COM. THIS EDITION IS TYPESET IN NOE DISPLAY BY SCHICK TOIKKA
AND FIRME BY DSTYPE.

NO.

NICHOLAS FELTON OF 3,000

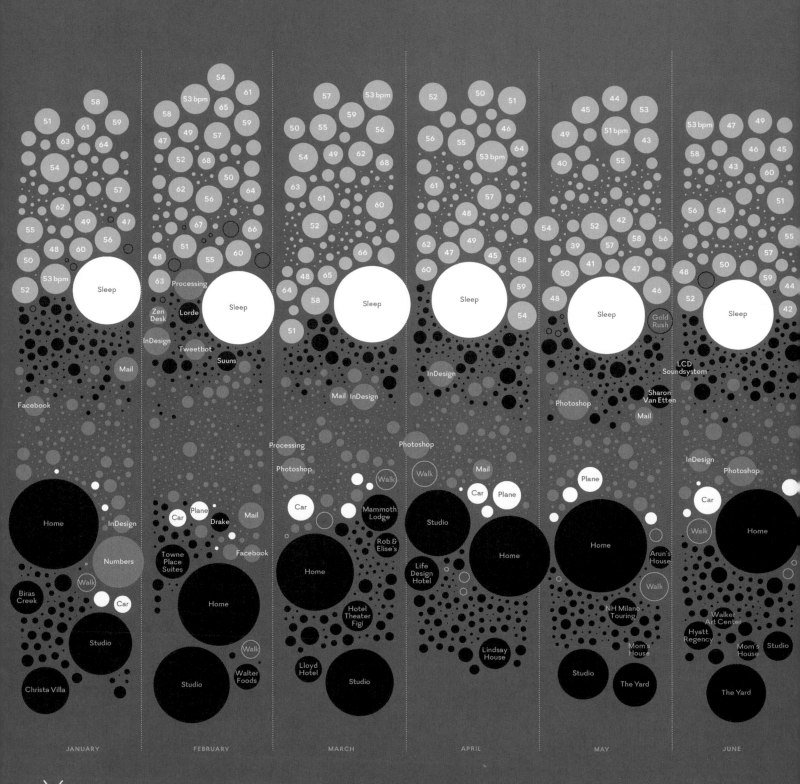

JANUARY FEBRUARY MARCH APRIL MAY JUNE

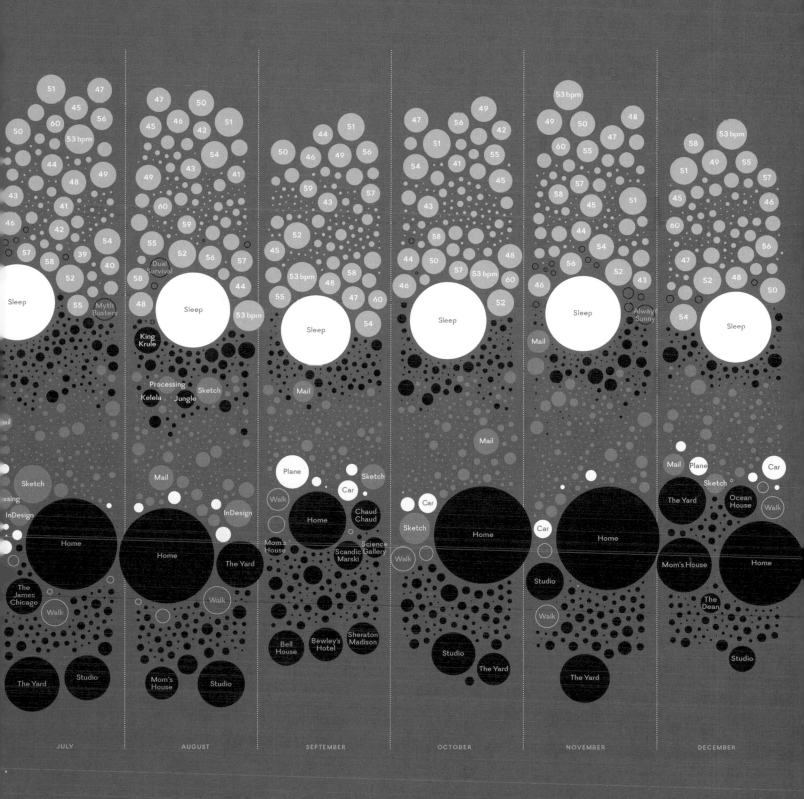

HOW THE PARTIES CAME APART

Does gerrymandering create unexpected cross-party allies? Nope.

ARTISTS: Mauro Martino (IBM Watson), artist; Clio Andris (Penn State) and David Lee (flux.io), analysts.

STATEMENT: As gerrymandering has emerged as a tool to protect incumbents and political parties, the boundaries between districts have become increasingly serpentine. With more entangled geographies, we wondered, would a Republican and Democratic duo of congressional representatives vote similarly? The answer, based on roll call votes from 2009, was just the opposite. Single-party pairs agreed (D-D or R-R) and cross-party pairs (D-R) disagreed. It was that simple. There were no secret district-neighbor partnerships. And once we reviewed the data from 1949 to 2011, we found party loyalty has grown over time.

PUBLICATION: *PLOS ONE* (April 21, 2015)

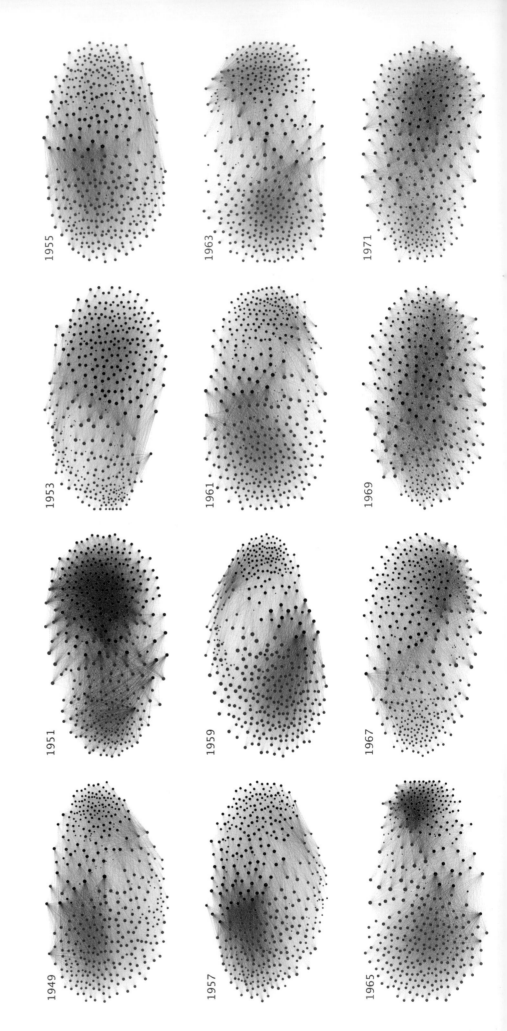

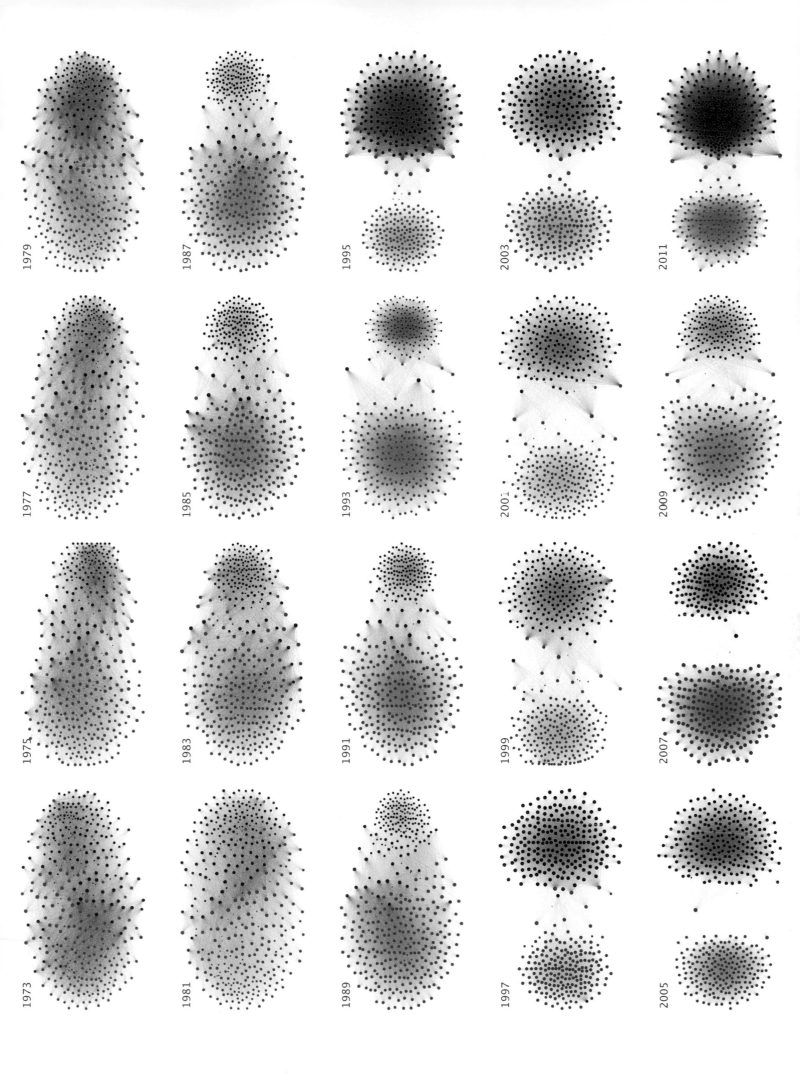

BUYING POWER

Here are 120 million Monopoly pieces, roughly one for every household in the United States.

WHO'S BUYING AMERICAN ELECTIONS

As a pile of Monopoly houses makes clear, it's a tiny fraction of households.

Mostly Backing Republicans

Republicans 138

Democrats 20

Tend to Be Self-Made

Self-made wealth 119

Inherited wealth 37

Just 158 families have provided nearly half of the early money for efforts to capture the White House.

Mainly in Finance and Energy

Finance 64
Majority in hedge funds, private equity or venture capital.

Energy and natural resources 17
Mostly oil and gas.

Real estate and construction 15

Transportation 9
Trucking, autos, cruise ships.

Media and entertainment 12
Hollywood moguls like Steven Spielberg, J.J. Abrams and Jeffrey Katzenberg.

Health 12
Woody Johnson, owner of the New York Jets, whose family founded Johnson & Johnson.

Technology 10

ARTISTS: Wilson Andrews, graphics editor; Amanda Cox, assistant editor; Evan Grothjan, graphics editor; Yuliya Parshina-Kottas, graphics editor; Graham Roberts, senior graphics editor; Karen Yourish, graphics editor, at the *New York Times*.

STATEMENT: A huge pile of green Monopoly houses in front of the White House represent all of American households, while a tiny sprinkling of red houses represents the 158 families that provided nearly half of the early money in the 2016 presidential race. We used 3-D software to model the image, calculating the volume 120 million Monopoly houses would take up in front of the White House. To determine the list of 158 families, reporters scrubbed the names of every donor who gave at least $10,000, then matched addresses and names to find possible additional family members. We were inspired by Of All the People in All the World, an art installation by Stan's Cafe, an experimental theater company in Birmingham, England, which used grains of rice to represent population statistics.

PUBLICATION: *New York Times* (October 10, 2015)

QUEEN VICTORIA

b. ALEXANDRINA VICTORIA, May 24, 1819; fifth in the line of succession.

m. PRINCE ALBERT of Saxe-Coburg and Gotha, 1840.

DURING HER REIGN

❦❦ Charles Dickens's *A Tale of Two Cities*, the best-selling novel in British history, is published (1859) • Launch of the longest ship in the world, the *Great Eastern* (1858) • **The Cleveland Street scandal**, in which a male brothel in London is raided and rumors circulate that the queen's grandson Prince Albert Victor is a client (1889) • Britain effectively annexes Egypt after **buying up Suez Canal shares** (1875).

ASSASSINATION ATTEMPTS

❦❦ Edward Oxford **fires two shots at Victoria** as she rides out of Buckingham Palace, and misses (1840) • John Francis runs at the queen and **fires a pistol** one Sunday morning; misses and escapes, then tries again the next day and is caught (1842) • Retired army officer Robert Pate runs up and **beats her with his cane** (1850) • Roderick MacLean **fires a shot** at her and misses (1882).

YEAR 30

1867: Grants Canada semi-independence (it can govern itself, but is still part of the empire), amid fears that America is about to invade.

1861: Albert dies of typhoid fever. Victoria, in mourning, stays out of public view for several years, and wears black for the next 40.

1858: The government grinds to a halt because the Thames smells so bad. Victoria and Albert try a boat ride but quit within minutes.

1853: National Association for the Vindication of Scottish Rights, the first group campaigning for Scotland's independence, founded.

1868: William Gladstone's first of four terms as prime minister. Victoria can't stand him; calls him "arrogant, tyrannical and obstinate."

1870: Near the peak of its industrial power, England produces one-third of all global output.

1877: Adds a new title, Empress of India. (Queen Elizabeth's father, George VI, cedes the imperial title in 1948.)

YEAR 15

1852: Albert buys Balmoral Castle. Unlike other royal properties, it's purchased with personal funds. (Today, Queen Elizabeth II summers there.)

YEAR 45

1896: Surpasses George III to become the longest-reigning British monarch. The next year, marks her Diamond Jubilee.

1842–44: The queen is photographed and travels by train, each a royal first.

1900: Victoria's son Alfred dies. "It is a horrible year," Victoria writes, "nothing but sadness & horrors."

1841: The first of several incidents involving "Boy" Jones, a weirdo who snuck into the queen's dressing room and stole her underwear.

1901: Dies on the Isle of Wight at 81. Albert Edward (Queen Elizabeth's great-grandfather) becomes King Edward VII.

1838: The first of several incidents involving "Boy" Jones, a weirdo...

1837: Awakens to learn that William IV, her uncle, has died. At her coronation, wears the newly rebuilt Imperial State Crown.

YEAR 1

YEAR 64

CHILDREN

Victoria (b. 1840) • Albert Edward (b. 1841) • Alice (b. 1843) • Alfred (b. 1844) • Helena (b. 1846) • Louise (b. 1848) • Arthur (b. 1850) • Leopold (b. 1853) • Beatrice (b. 1857). **42 grandchildren, 87 great-grandchildren.**

PETS

A **King Charles spaniel** named Dash • a **greyhound**, Nero • a **deerhound**, Hector • a **parrot**, Lory • a **collie**, Noble ("guardian of the queen's gloves").

TWO LONGTIME QUEENS, COMPARED

How does Queen Elizabeth II stack up to Victoria?

ARTISTS: Karishma Sheth, designer; Thomas Alberty, design director; Marvin Orellana, photo editor; Jody Quon, photography director; Ian Epstein, writer; Christopher Bonanos, editor; Adam Moss, editor in chief, at *New York* magazine.

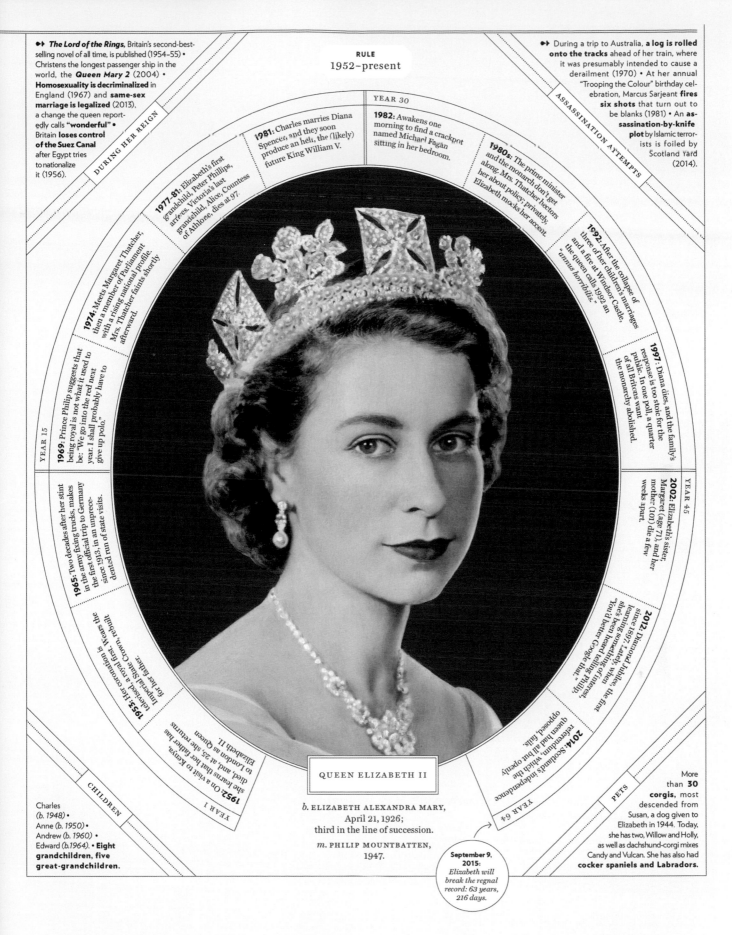

RULE
1952–present

QUEEN ELIZABETH II

b. ELIZABETH ALEXANDRA MARY, April 21, 1926; third in the line of succession.

m. PHILIP MOUNTBATTEN, 1947.

September 9, 2015: *Elizabeth will break the regnal record: 63 years, 216 days.*

DURING HER REIGN

➔ *The Lord of the Rings*, Britain's second-best-selling novel of all time, is published (1954–55) • Christens the longest passenger ship in the world, the *Queen Mary 2* (2004) • **Homosexuality is decriminalized** in England (1967) and **same-sex marriage is legalized** (2013), a change the queen reportedly calls **"wonderful"** • Britain **loses control of the Suez Canal** after Egypt tries to nationalize it (1956).

ASSASSINATION ATTEMPTS

➔ During a trip to Australia, **a log is rolled onto the tracks** ahead of her train, where it was presumably intended to cause a derailment (1970) • At her annual "Trooping the Colour" birthday celebration, Marcus Sarjeant **fires six shots** that turn out to be blanks (1981) • An **assassination-by-knife plot** by Islamic terrorists is foiled by Scotland Yard (2014).

YEAR 30

1981: Charles marries Diana Spencer, and they soon produce an heir, the (likely) future King William V.

1982: Awakens one morning to find a crackpot named Michael Fagan sitting in her bedroom.

1980s: The prime minister and the monarch don't get along: Mrs. Thatcher hectors her about policy; privately, Elizabeth mocks her accent.

1977–81: Elizabeth's first grandchild, Peter Phillips, arrives. Victoria's last grandchild, Alice, Countess of Athlone, dies at 97.

1974: Meets Margaret Thatcher, then a member of Parliament with a rising national profile. Mrs. Thatcher faints shortly afterward.

1992: After the collapse of three of her children's marriages and a fire at Windsor Castle, the queen calls 1992 an *"annus horribilis."*

1997: Diana dies, and the family's response is too stoic for the public. In one poll, a quarter of all Britons want the monarchy abolished.

YEAR 15

1969: Prince Philip suggests that being royal is not what it used to be: "We go into the red next year. I shall probably have to give up polo."

1965: Two decades after her stint in the army fixing trucks, makes the first official trip to Germany since 1913, in an unprecedented run of state visits.

YEAR 45

2002: Elizabeth's sister, Margaret (age 71), and her mother (101) die a few weeks apart.

2012: Diamond Jubilee, since 1897. Lately, leaning somewhat on Prince Philip: "You'd better Google that." "Is that a mint or are you pleased to see me?" She's been telling off-color jokes since 1897.

1953: Her coronation is the first televised State funeral. Wears the Imperial State Crown, rebuilt for her father.

1952: On a visit to Kenya, she learns that her father has died, and, at 25, she returns to London as Queen Elizabeth II.

2014: Scotland's independence referendum, which the queen had all but openly opposed, fails.

YEAR 1

YEAR 64

CHILDREN

Charles (b. 1948) • Anne (b. 1950) • Andrew (b. 1960) • Edward (b.1964). • **Eight grandchildren, five great-grandchildren.**

PETS

More than **30 corgis**, most descended from Susan, a dog given to Elizabeth in 1944. Today, she has two, Willow and Holly, as well as dachshund-corgi mixes Candy and Vulcan. She has also had **cocker spaniels and Labradors.**

STATEMENT: In September 2015, Queen Elizabeth II became the longest-reigning monarch in British history, surpassing Queen Victoria's 63-plus years. Our side-by-side comparison of their reigns, 114 years apart, is part timeline, part almanac, and it accommodates a lot of data—notable events during their respective rules, news and cultural events, children, pets, even assassination attempts. Inspired by royal souvenirs from the Victorian era, we used the dates and information to frame the two queens' portraits.

PUBLICATION: *New York* (September 7–20, 2015)

A LIVE VIEW OF SUPER BOWL ODDS

The chance of victory swings dramatically.

The **New England Patriots** have won the Super Bowl

The probability of each team winning is plotted below over the course of the game, based on 50,000 simulations run after every play.

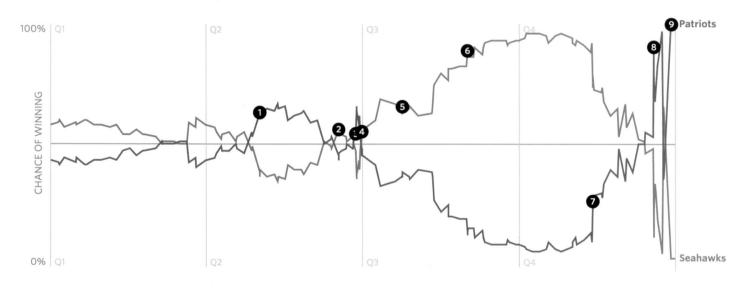

CHANCE OF WINNING

100% Q1 Q2 Q3 Q4 **9** Patriots

0% Q1 Q2 Q3 Q4 Seahawks

How the Game Unfolded

How it works

PredictionMachine.com's simulation engine attempts to account for all the statistical interactions of the players (playing or not playing/injured), coaches, officials, fans (home-field advantage) and weather.

The data comes from a real-time play-by-play feed. After each play, the simulator plays the remainder of the game 50,000 times to predict the odds of one team beating the other. The simulation accounts for players on the field at any given time, instead of estimating win-chance based on historical situations.

1. Patriots' Brandon LaFell makes 11-yard touchdown catch

2nd Quarter with 9:47 remaining

After a scoreless first quarter, the Patriots broke through with a nine-play, 65-yard TD drive.

2. Seahawks' Marshawn Lynch makes 3-yard touchdown run

2nd Quarter with 2:16 remaining

The Seahawks offense gets on the scoreboard with an eight-play, 70-yard TD drive. A huge play during the possession is a 44-yard catch by Chris Matthews.

3. Patriots' Rob Gronkowski makes 22-yard touchdown catch

2nd Quarter with 36 seconds remaining

The Patriots drive 80 yards in 1:45 to score with 31 seconds left in the half. The Seahawks tried to defend Gronkowski with linebacker K.J. Wright.

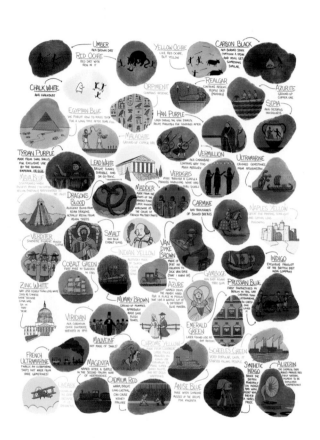

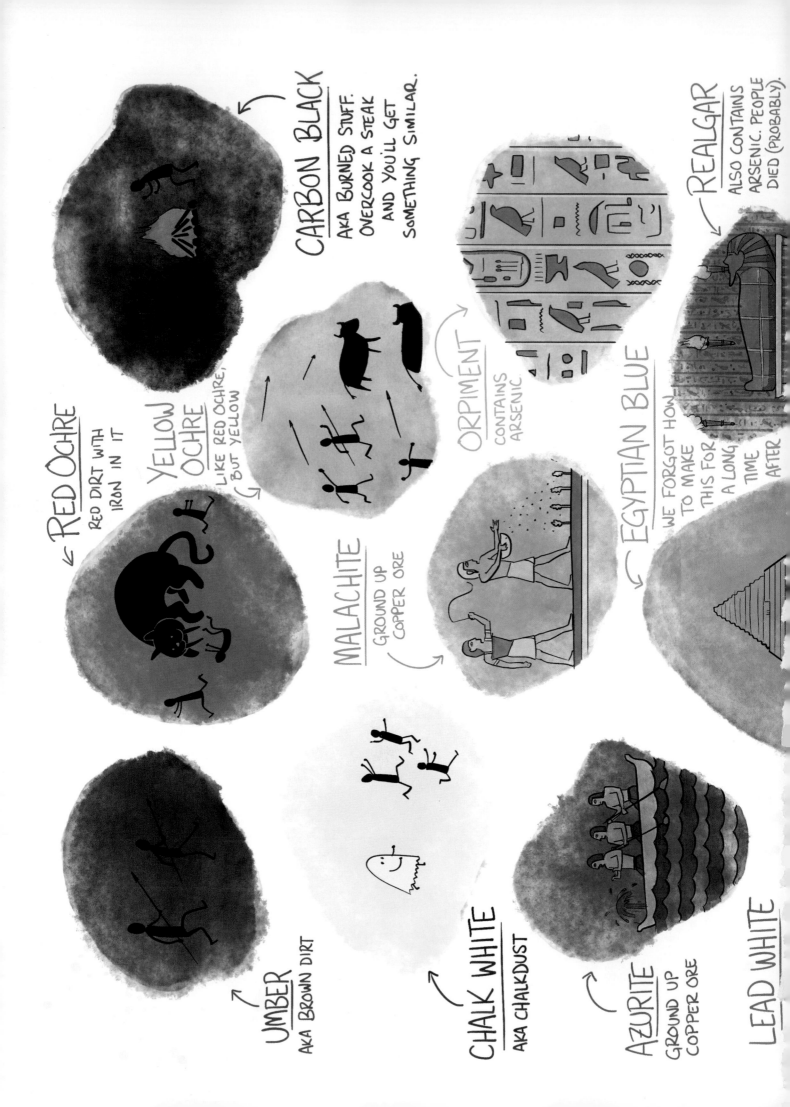

← RED OCHRE
RED DIRT WITH
IRON IN IT

CARBON BLACK
AKA BURNED STUFF.
OVERCOOK A STEAK
AND YOU'LL GET
SOMETHING SIMILAR.

YELLOW OCHRE
LIKE RED OCHRE,
BUT YELLOW

ORPIMENT
CONTAINS
ARSENIC

REALGAR
ALSO CONTAINS
ARSENIC. PEOPLE
DIED (PROBABLY).

MALACHITE
GROUND UP
COPPER ORE

EGYPTIAN BLUE
WE FORGOT HOW
TO MAKE
THIS FOR
A LONG
TIME
AFTER

UMBER
AKA BROWN DIRT

CHALK WHITE
AKA CHALKDUST

AZURITE
GROUND UP
COPPER ORE

LEAD WHITE

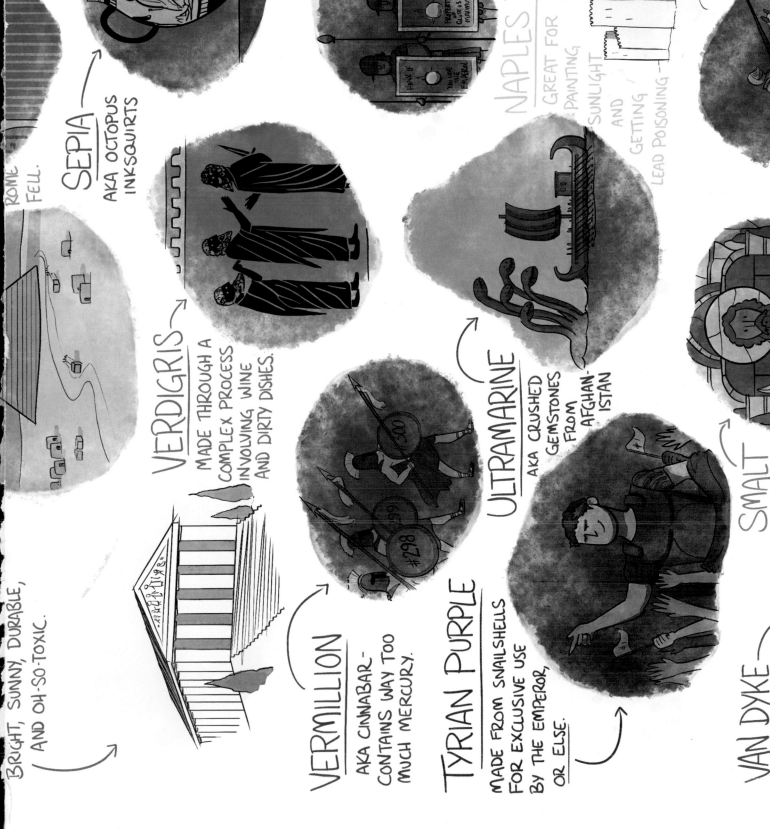

ROME FELL.

BRIGHT, SUNNY, DURABLE, AND OH-SO-TOXIC.

MADDER
MADE FROM THE ROOTS OF THE MADDER PLANT. LATER KNOWN WORLD-WIDE AS THE COLOR OF FRENCH MILITARY PANTS.

SEPIA
AKA OCTOPUS INKSQUIRTS

NAPLES YELLOW
GREAT FOR PAINTING SUNLIGHT AND GETTING LEAD POISONING

VERDIGRIS
MADE THROUGH A COMPLEX PROCESS INVOLVING WINE AND DIRTY DISHES.

ULTRAMARINE
AKA CRUSHED GEMSTONES FROM AFGHAN-ISTAN

SMALT
AKA BLUE

VERMILLION
AKA CINNABAR- CONTAINS WAY TOO MUCH MERCURY.

TYRIAN PURPLE
MADE FROM SNAILSHELLS FOR EXCLUSIVE USE BY THE EMPEROR, OR ELSE.

VAN DYKE BROWN

CARMINE

4. Seahawks' Chris Matthews makes 11-yard touchdown catch

2nd Quarter with 2 seconds remaining

After a 19-yard Robert Turbin run, Seattle goes 80 yards in 29 seconds. Seahawks coach Pete Carroll gambles and goes for the TD with only six seconds on the clock.

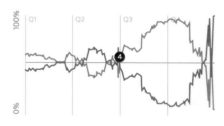

5. Seahawks' Steven Hauschka makes 27-yard field goal

3rd Quarter with 11:09 remaining

After Katy Perry roars at halftime, the Seahawks get three points in their opening drive of the second half.

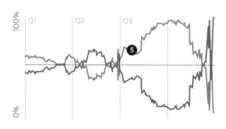

6. Doug Baldwin 3-yard TD catch

3rd Quarter with 4:54 remaining

A Bobby Wagner interception sets Seattle up at midfield, where they score six plays later. A 15-yard scramble by Russell Wilson is a key play in the drive. Seattle's win probability peaks at 97%.

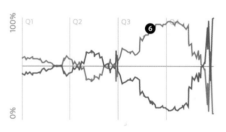

7. Patriots' Danny Amendola 4-yard touchdown catch

4th Quarter with 7:55 remaining

The Patriots convert on two big third-down plays to stay alive. Tom Brady caps the nine-play, 68-yard drive with a touchdown pass over the middle to Danny Amendola. New England cuts Seattle's win probability to 74%.

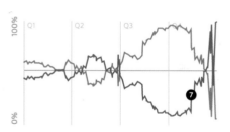

8. Patriots' Julien Edelman 3-yard TD catch

4th Quarter with 2:02 remaining

The drive begins with Seattle's probability in the 60% range. After Tom Brady drives the Patriots offense 64 yards in 10 plays, New England's win probability shoots up to 87%.

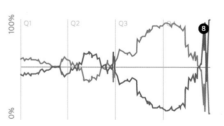

9. Patriots' Malcolm Butler catches interception

4th Quarter with 20 seconds remaining

Has there ever been a bigger swing in win probability in the Super Bowl in a span of three plays? The Seahawks drive the ball down to the 1-yard line. With 20 seconds left, Malcolm Butler intercepts a Russell Wilson pass, sealing the game and the Lombardi Trophy for the Patriots.

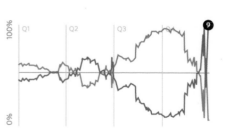

Journal's homepage and above a live blog during the Super Bowl. There were technical challenges to ingesting a live data feed, but we also learned how a staggered approach can keep interest high even once an event has ended. We started with only the main chart, and added annotations as the game progressed. After the game, we recast the project into a retrospective, expanding on these annotations to help readers understand how the game had unfolded.

PUBLICATION: *Wall Street Journal* (January 30, 2015)

ARTISTS: Stuart A. Thompson, director of enterprise visuals and interactive graphics; Palani Kumanan, application architect; Jim Chairusmi, sports editor, at the *Wall Street Journal*.

STATEMENT: Using data from PredictionMachine.com, this chart showed the likelihood of each team winning Super Bowl XLIX in real time, based on the score, players on the field, and injuries. Editors added annotations during the game to help explain key moments that affected the model. The project appeared live on the *Wall Street*

WHERE THE UFOS WERE

A century of mysterious sights in the skies.

SHAPE TRENDING

AS A PROPORTION OF OTHER REPORTED SHAPES THAT YEAR.
TREND LINES BEGIN IN 1964.

PREVALENCE

SYMBOLS REPRESENT 100 SIGHTINGS

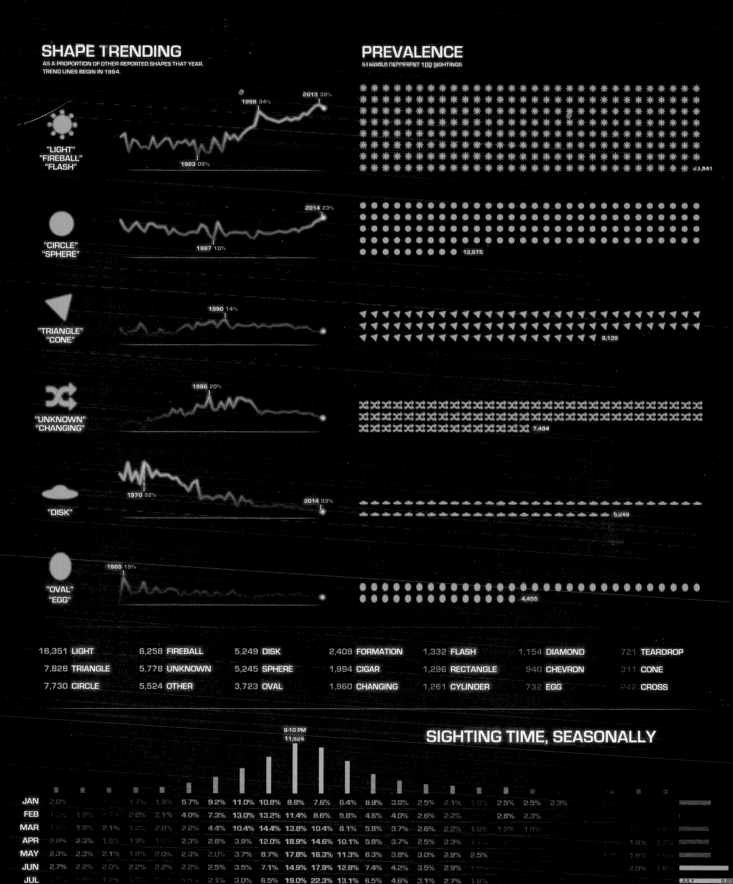

"LIGHT" "FIREBALL" "FLASH" — 1998 34%, 2013 38%, 1983 09% — 23,841

"CIRCLE" "SPHERE" — 2014 23%, 1987 10% — 12,975

"TRIANGLE" "CONE" — 1990 14% — 8,139

"UNKNOWN" "CHANGING" — 1986 20% — 7,484

"DISK" — 1970 32%, 2014 03% — 5,249

"OVAL" "EGG" — 1965 15% — 4,455

16,351 LIGHT	6,258 FIREBALL	5,249 DISK	2,409 FORMATION	1,332 FLASH	1,154 DIAMOND	721 TEARDROP
7,828 TRIANGLE	5,778 UNKNOWN	5,245 SPHERE	1,994 CIGAR	1,296 RECTANGLE	940 CHEVRON	311 CONE
7,730 CIRCLE	5,524 OTHER	3,723 OVAL	1,960 CHANGING	1,261 CYLINDER	732 EGG	242 CROSS

SIGHTING TIME, SEASONALLY

9-10 PM 11,524

	12 NOON	01	02	03	04	05	06	07	08	09	10	11	12 MIDNIGHT	01	02	03	04	05	06	07	08	09	10	11	12 NOON
JAN	2.0%			1.7%	1.9%	5.7%	9.2%	11.0%	10.8%	9.8%	7.6%	6.4%	8.9%	3.0%	2.5%	2.1%	1.9%	2.5%	2.5%	2.3%					
FEB	1.7%	1.9%	1.7%	2.0%	2.1%	4.0%	7.3%	13.0%	13.2%	11.4%	8.6%	5.8%	4.6%	4.0%	2.6%	2.2%		2.8%	2.3%	1.8%					
MAR	1.8%	1.9%	2.1%	1.2%	2.0%	2.2%	4.4%	10.4%	14.4%	13.8%	10.4%	8.1%	5.8%	3.7%	2.6%	2.2%	1.9%	1.9%	1.8%					1.6%	
APR	2.0%	2.3%	1.8%	1.9%	1.6%	2.3%	2.6%	3.9%	12.0%	18.9%	14.6%	10.1%	5.8%	3.7%	2.5%	2.3%	1.7%					1.9%	1.7%		
MAY	2.3%	2.3%	2.1%	1.8%	2.0%	2.3%	2.0%	3.7%	8.7%	17.8%	16.3%	11.3%	6.3%	3.8%	3.0%	2.9%	2.5%					1.7%	1.9%		
JUN	2.7%	2.2%	2.0%	2.2%	2.2%	2.2%	2.5%	3.5%	7.1%	14.9%	17.9%	12.8%	7.4%	4.2%	3.5%	2.9%						2.0%	1.6%		
JUL	1.6%		1.7%	2.2%	1.6%	1.5%	2.1%	3.0%	6.5%	19.0%	22.3%	13.1%	6.5%	4.6%	3.1%	2.7%	1.8%					1.5%	1.5%		
AUG	1.7%	1.5%	1.7%	1.5%		1.8%	2.2%	3.8%	9.8%	17.9%	17.1%	11.8%	6.4%	4.4%	3.1%	2.8%	2.2%	2.3%				1.5%	1.5%		
SEP	1.8%			1.7%	1.6%	2.4%	3.5%	8.5%	15.2%	16.5%	11.7%	8.6%	4.6%	3.6%	2.5%	2.6%	2.2%	2.6%	1.5%						
OCT			1.6%	1.8%	2.4%	3.0%	5.9%	11.6%	14.6%	12.2%	9.9%	7.4%	4.4%	3.8%	2.8%	2.1%	1.8%	2.0%	2.5%	1.9%					
NOV				1.9%	2.9%	6.4%	11.8%	12.3%	11.0%	10.1%	8.5%	7.1%	4.3%	3.2%	2.5%	2.0%	1.9%	3.2%	2.2%						
DEC			1.7%	3.0%	6.4%	9.7%	10.8%	10.8%	10.1%	9.2%	8.4%	4.6%	3.2%	2.3%	2.0%	1.9%	2.9%	2.9%	2.0%						

JULY 9,892

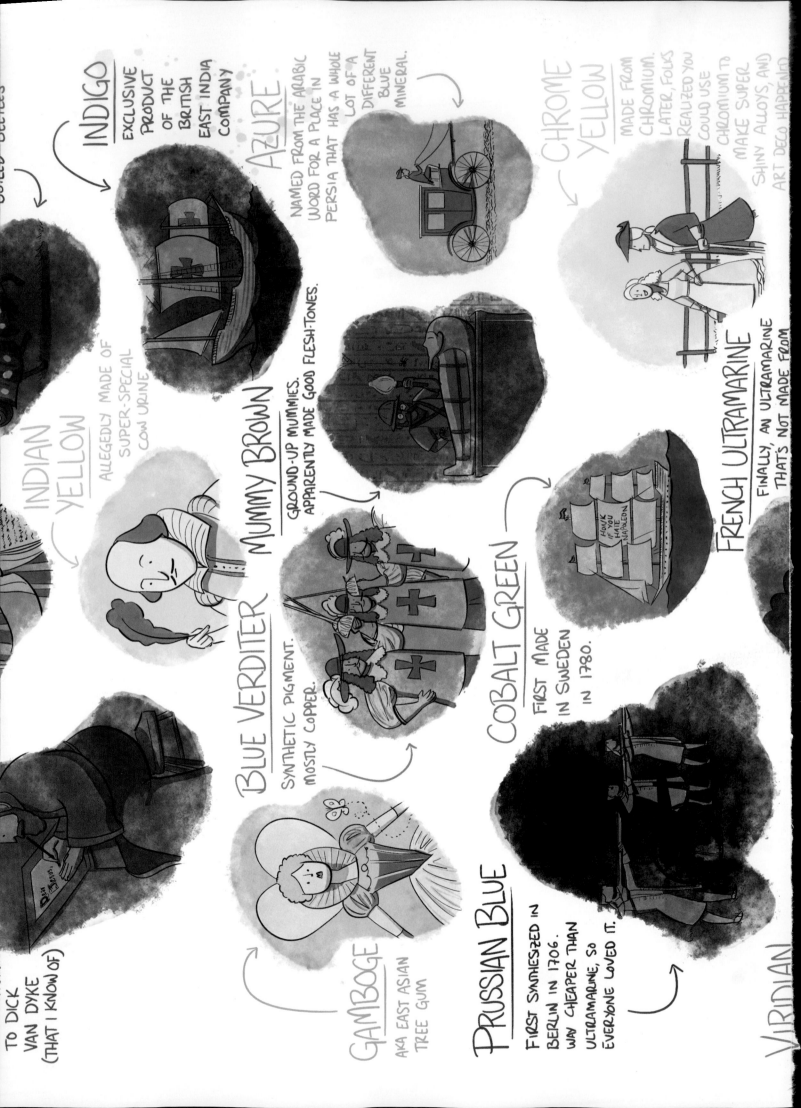

INDIGO

EXCLUSIVE PRODUCT OF THE BRITISH EAST INDIA COMPANY

AZURE

NAMED FROM THE ARABIC WORD FOR A PLACE IN PERSIA THAT HAS A WHOLE LOT OF A DIFFERENT BLUE

CHROME YELLOW

MADE FROM CHROMIUM. LATER, FOLKS REALIZED YOU COULD USE CHROMIUM TO MAKE SUPER-SHINY ALLOYS, AND ART DECO HAPPENED.

TO DICK VAN DYKE (THAT I KNOW OF)

INDIAN YELLOW

ALLEGEDLY MADE OF SUPER-SPECIAL COW URINE

MUMMY BROWN

GROUND-UP MUMMIES. APPARENTLY MADE GOOD FLESH-TONES.

BLUE VERDITER

SYNTHETIC PIGMENT. MOSTLY COPPER.

COBALT GREEN

FIRST MADE IN SWEDEN IN 1780.

FRENCH ULTRAMARINE

FINALLY, AN ULTRAMARINE THAT'S NOT MADE FROM

HONK IF YOU HATE NAPOLEON

GAMBOGE

AKA EAST ASIAN TREE GUM

PRUSSIAN BLUE

FIRST SYNTHESIZED IN BERLIN IN 1706. WAY CHEAPER THAN ULTRAMARINE, SO EVERYONE LOVED IT.

VIRIDIAN

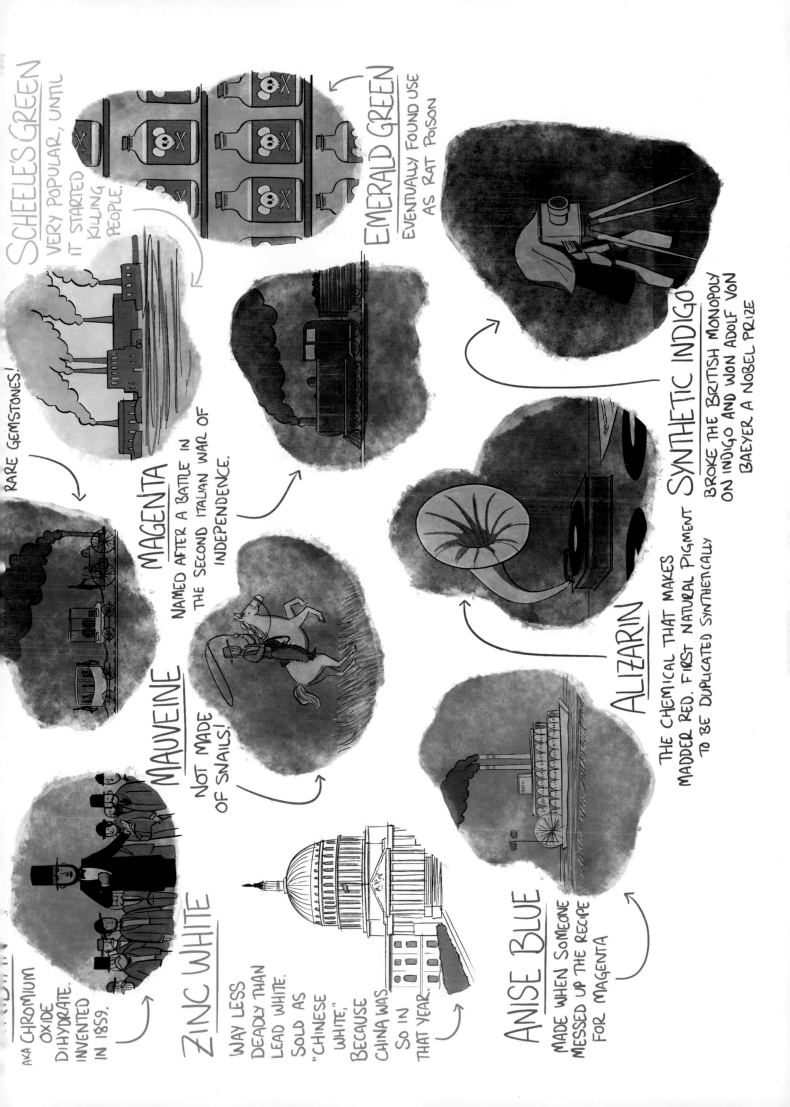

SCHEELE'S GREEN
VERY POPULAR, UNTIL IT STARTED KILLING PEOPLE.

EMERALD GREEN
EVENTUALLY FOUND USE AS RAT POISON

RARE GEMSTONES!

MAGENTA
NAMED AFTER A BATTLE IN THE SECOND ITALIAN WAR OF INDEPENDENCE.

MAUVEINE
NOT MADE OF SNAILS!

AKA CHROMIUM OXIDE DIHYDRATE. INVENTED IN 1859.

ZINC WHITE
WAY LESS DEADLY THAN LEAD WHITE. SOLD AS "CHINESE WHITE", BECAUSE CHINA WAS SO IN THAT YEAR.

ANISE BLUE
MADE WHEN SOMEONE MESSED UP THE RECIPE FOR MAGENTA

ALIZARIN
THE CHEMICAL THAT MAKES MADDER RED. FIRST NATURAL PIGMENT TO BE DUPLICATED SYNTHETICALLY

SYNTHETIC INDIGO
BROKE THE BRITISH MONOPOLY ON INDIGO AND WON ADOLF VON BAEYER A NOBEL PRIZE

THE QUEST FOR COLOR

A timeline of the vivid, noxious, surprising evolution of artists' pigments.

ARTIST: Korwin Briggs, an illustrator and history enthusiast who runs the blog *Veritable Hokum*.

STATEMENT: These are a bunch of historical colors, arranged by date (sort of). While I considered buying, using, and scanning all of these colors, I didn't because a good chunk of them are expensive, toxic, and/or no longer exist. So what you see here is my best digital approximation.

My takeaways: (a) Colors are very toxic. I regret being so careless with paints when I was in art school. (b) This could probably be re-titled "The Quest for a Good, Cheap, Nontoxic Blue." (c) I think it's easy to assume nowadays that colors are just varieties of paint. But you're not just mixing colors—you're mixing chemicals, some toxic, some not. No matter when we're talking about, the ultimate limit of the artist's palette is the ability of a chemist to invent it.

PUBLICATION: *veritablehokum.com* (September 8, 2015)

ARTIST: John Nelson, product engineer for Esri, cartography and design.

STATEMENT: This visualization covers almost 100 years of reported UFO sightings. I took care to account for underlying population, so that the result was not just a reproduction of a population map. A per capita map gives us an impression of where any given person was more likely to spot a UFO; a second map accounts for variable populations and area sizes, since people may be more likely to notice something unidentifiable in a sky that is vast, dark, and clear. Crowd-sourced data tends to reflect how we see ourselves and the world around us, even for something as otherworldly as UFOs..

PUBLICATION: *uxblog.idvsolutions.com* (June 9, 2015)

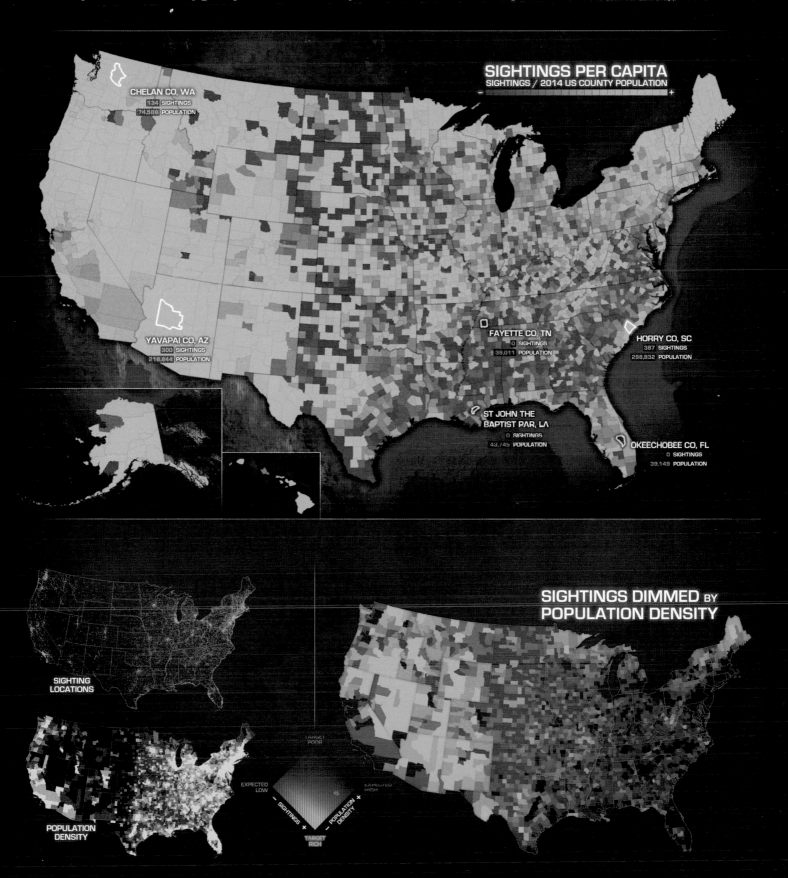

SIGHTINGS PER CAPITA
SIGHTINGS / 2014 US COUNTY POPULATION

CHELAN CO, WA
134 SIGHTINGS
74,588 POPULATION

YAVAPAI CO, AZ
300 SIGHTINGS
218,844 POPULATION

FAYETTE CO, TN
0 SIGHTINGS
39,011 POPULATION

HORRY CO, SC
387 SIGHTINGS
298,832 POPULATION

ST JOHN THE BAPTIST PAR, LA
0 SIGHTINGS
43,745 POPULATION

OKEECHOBEE CO, FL
0 SIGHTINGS
39,149 POPULATION

SIGHTINGS DIMMED BY POPULATION DENSITY

SIGHTING LOCATIONS

POPULATION DENSITY

EXPECTED LOW

EXPECTED HIGH

TARGET POOR

TARGET RICH

SIGHTINGS

POPULATION DENSITY

Mumps

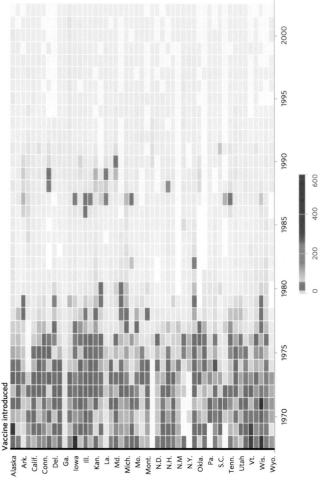

Vaccine introduced

Pertussis (Whooping Cough)

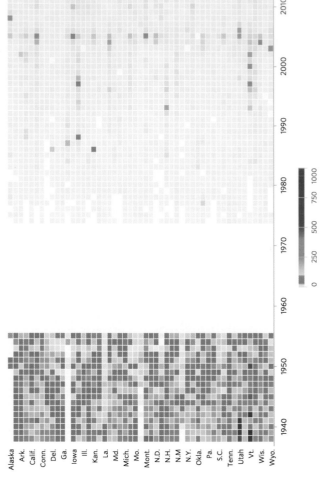

Note: The CDC did not report any weekly, state level data for pertussis between 1955 and 1974. The vaccine was introduced in 1914.

Measles

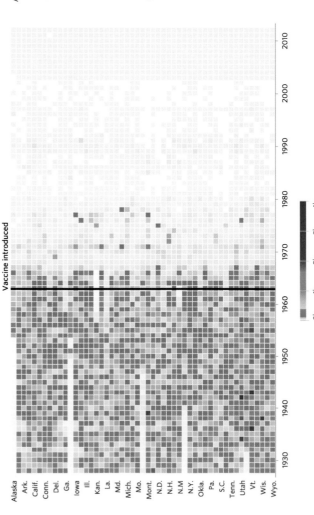

Vaccine introduced

Note: CDC data from 2003-2012 comes from its Summary of Notifiable Diseases, which publishes yearly rather than weekly and counts confirmed cases as opposed to provisional ones.

Hepatitis A

Vaccine introduced

Polio

Rubella

VACCINES TO THE RESCUE

Infectious diseases, brought to their knees.

ARTISTS: Tynan DeBold, graphics editor; Dov Friedman, technical director, visuals, at the *Wall Street Journal.*

STATEMENT: For a state-by-state, year-by-year breakdown of eight infectious diseases, we presented heat maps depicting incident rates per 100,000 people in each state for each year, colored by severity. We added a label and corresponding vertical line when the vaccine was introduced. Those dates show a clear falloff of the disease.

PUBLICATION: *Wall Street Journal* (February 11, 2015)

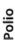

THE REAL NEW LANDSCAPE OF DETROIT

Behind the hard-luck headlines, a more nuanced picture.

ARTISTS: Martin Gamache, cartographer; Kelsey Nowakowski and Heidi Schultz, researchers/writers; David Whitmore, designer, all at *National Geographic*; Noah Urban, Data Driven Detroit, GIS data and analysis.

STATEMENT: Fortunes in the crisis-stricken city of Detroit are more complicated than you might gather; some of the city is doing well and some of it isn't. This graphic explores the health of De-

troit's diverse neighborhoods through metrics like population loss, abandonment, and vacant land. Photos illustrate what the range of categories on the key look like on the ground, in areas that are healthy, rebounding, or depopulating and reverting to nature. We worked with a local data provider, Data Driven Detroit, to build a thoughtful, layered picture of the Motor City's current state.

PUBLICATION: *National Geographic* (May 2015)

Traditional
residential

Urban
prairie

Full key and neighborhood map on previous page

Rethinking Detroit

In less than five decades the once vibrant Motor City lost more than half its population and gained a reputation as a failed metropolis of abandoned buildings, widespread poverty, and rampant crime. But photos of derelict homes and empty lots can create a misleading impression. The city ranks 69th in population density—people per square mile—among U.S. cities with more than a hundred thousand people, ahead of Las Vegas, Denver, Phoenix, and Portland, Oregon, to name just a few. Detroit is still losing inhabitants, but neighborhoods such as Woodbridge are rebounding.

1 Hamtramck and Highland Park are incorporated cities completely surrounded by Detroit. Historically Polish Hamtramck has the third largest Bangladeshi population in the U.S.

2 Construction is starting on the privately and publicly funded 3.3-mile M-1 Rail streetcar project. It will connect downtown Detroit to the bustling Midtown commercial district.

3 Investor interest in Detroit's downtown is growing. Residential occupancy rates are high, and two local investors have bought and are developing more than 130 properties here.

Open space

Mixed-use and nonresidential parcels

21%
Urban prairie/naturescape

Least densely populated
Most vacant lots
Most abandoned buildings

71%
Traditional neighborhood

Most densely populated
Fewer vacant lots
Least blight

City area (in square miles)
20 —
10 —
0 —

Percentage of Detroit's residential area

Block by Block

Many neighborhoods along Detroit's perimeter are as densely populated as the city's wealthier suburbs. This analysis is at the block level shows the range from neighborhoods that are thriving to those that have more vacant lots—and to areas reverting to nature, known as "urban prairie."

Approximate neighborhood boundary

MARTIN GAMACHE AND KELSEY NOWAKOWSKI, NGM STAFF

SOURCES: NOAH URBAN, DATA DRIVEN DETROIT; LOVELAND TECHNOLOGIES; DETROIT LAND BANK AUTHORITY; SOUTHEAST MICHIGAN COUNCIL OF GOVERNMENTS; COMMUNITY DEVELOPMENT ADVOCATES OF DETROIT; MOTOR CITY MAPPING/OPENSTREETMAP/ U.S. CENSUS BUREAU; CITY OF DETROIT ASSESSMENT DIVISION AND PLANNING AND DEVELOPMENT DEPARTMENT; NOAA

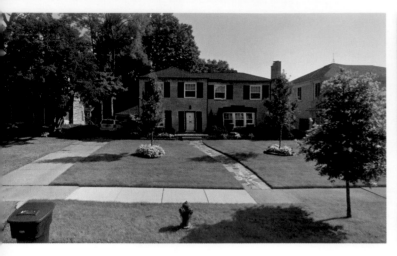

Sherwood Forest

This northern neighborhood has long been stable. It's near a university and golf course and abuts other strong neighborhoods. The more than 500 brick homes in this predominantly middle-class, black

Woodbridge

Many affluent residents left for the suburbs after World War II, but this community of mostly Victorian homes has seen an influx of young professionals since housing incentives began in 2011. City organizations have

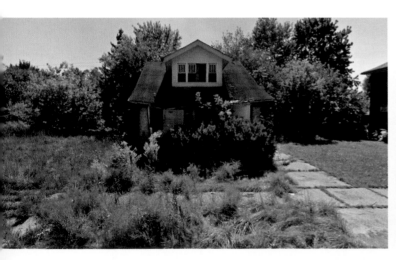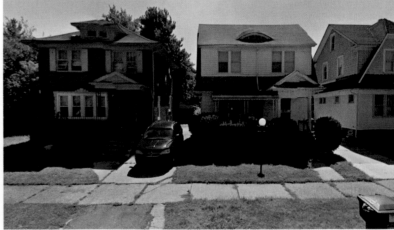

Burbank

Population loss in this part of the city has been staggering. Hit hard by the mortgage crisis, Burbank lost 41 percent of its residents from 2000 to 2010. Of the neighborhood's 7,300 properties, only 3,000 are occupied and

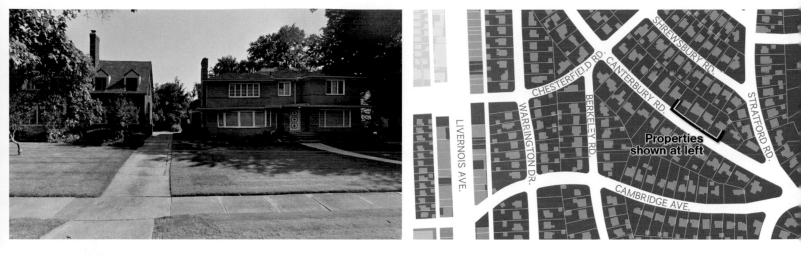

community are in good condition. Eight homes are unoccupied, and 33 lots are vacant. Sherwood Forest has not suffered the exodus other neighborhoods have faced in recent decades.

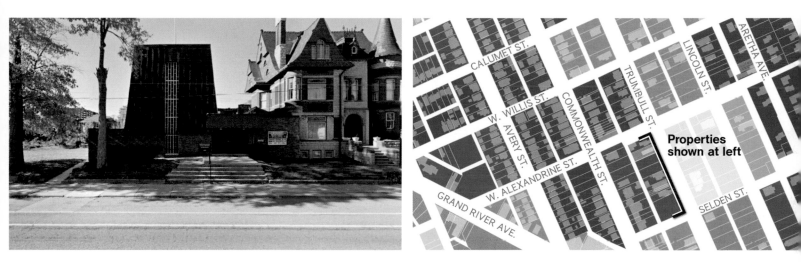

targeted the neighborhood, within walking distance of downtown and the future M-1 streetcar, for improvement. More than half its 1,200 properties are vacant lots. About 60 houses were unoccupied, but that number continues to decline.

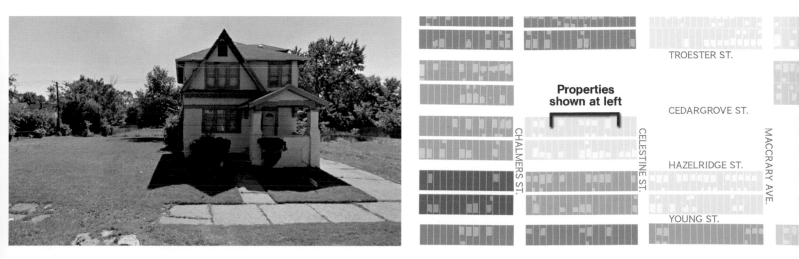

2,350 are vacant lots. Nearly 200 of its mostly postwar, lower quality homes have been recommended for demolition, and 340 homes have fire damage, mostly likely related to high rates of arson and vandalism in Detroit.

ALL DATA AS OF JANUARY 2015

A CENTENNIAL LOOK AT RELATIVITY'S INFLUENCE

Where Einstein's theory had the most impact in 2015.

ARTISTS: Jer Thorp, creative direction; Noa Younse, technology and development; Genevieve Hoffman, research and design; Ellery Royston, data acquisition and wrangling, at the Office for Creative Research, a design studio based in Brooklyn, New York. Jen Christiansen, design and layout; Gary Stix, introduction; Clara Moskowitz, captions and science advising, at *Scientific American*.

STATEMENT: The data set consists of papers uploaded to arXiv.org in 2014, and the aesthetics of the visualization, which shows where his theories are still most influential, were inspired by the material Einstein was trying to describe—space and the effect of gravity on celestial bodies.

PUBLICATION: Commemorative Einstein issue, *Scientific American* (September 1, 2015)

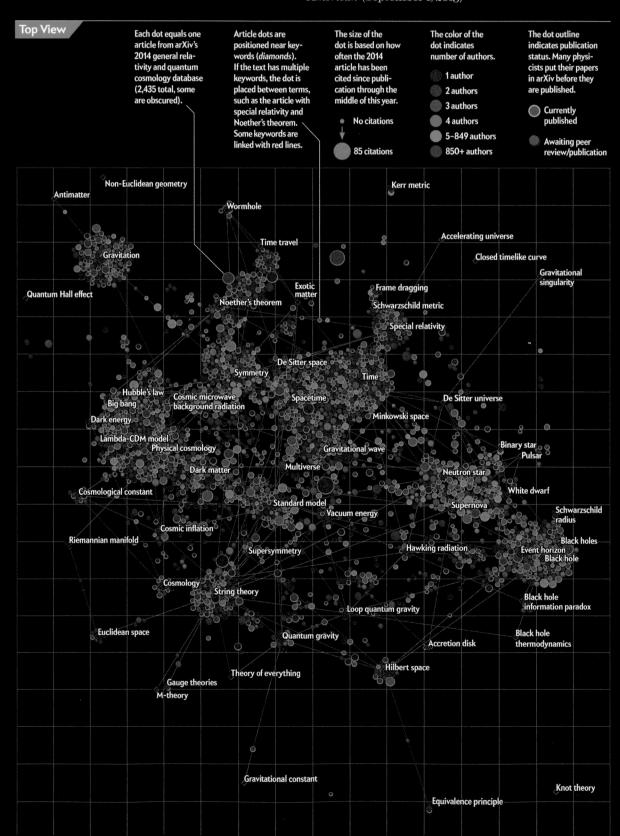

Top View

Each dot equals one article from arXiv's 2014 general relativity and quantum cosmology database (2,435 total, some are obscured).

Article dots are positioned near keywords (*diamonds*). If the text has multiple keywords, the dot is placed between terms, such as the article with special relativity and Noether's theorem. Some keywords are linked with red lines.

The size of the dot is based on how often the 2014 article has been cited since publication through the middle of this year.

No citations

85 citations

The color of the dot indicates number of authors.

1 author
2 authors
3 authors
4 authors
5–849 authors
850+ authors

The dot outline indicates publication status. Many physicists put their papers in arXiv before they are published.

Currently published

Awaiting peer review/publication

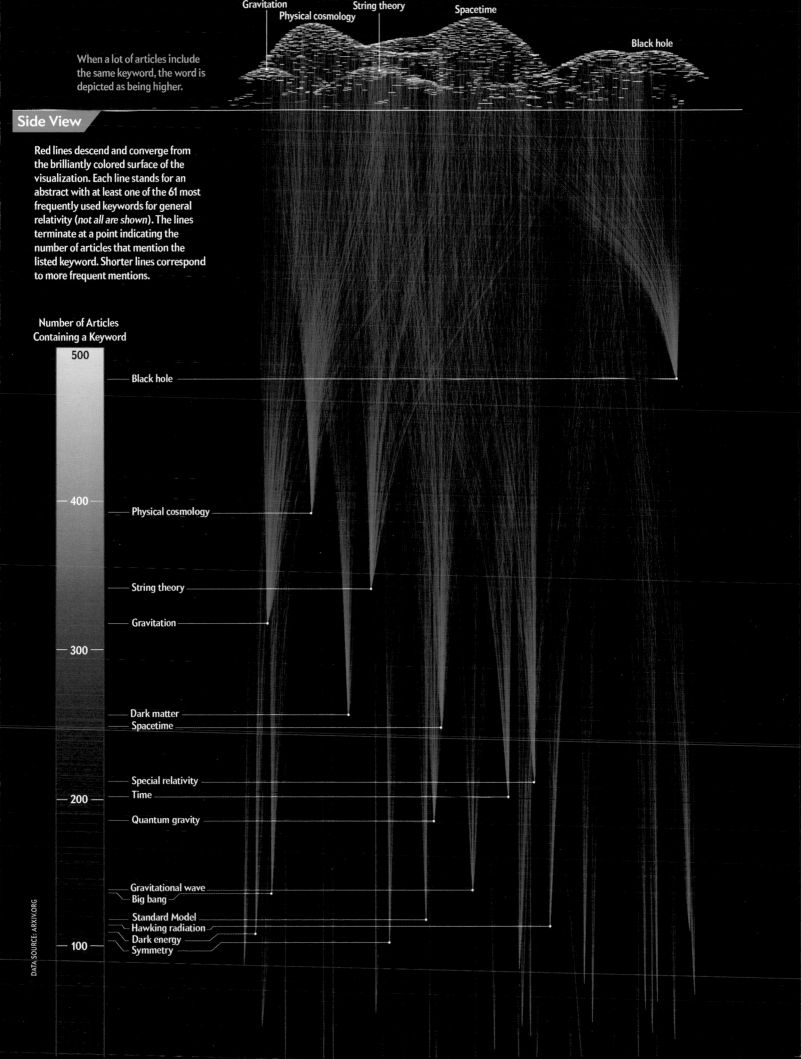

When a lot of articles include the same keyword, the word is depicted as being higher.

Gravitation
Physical cosmology
String theory
Spacetime
Black hole

Side View

Red lines descend and converge from the brilliantly colored surface of the visualization. Each line stands for an abstract with at least one of the 61 most frequently used keywords for general relativity (*not all are shown*). The lines terminate at a point indicating the number of articles that mention the listed keyword. Shorter lines correspond to more frequent mentions.

Number of Articles
Containing a Keyword

500

Black hole

400

Physical cosmology

String theory

Gravitation

300

Dark matter
Spacetime

Special relativity
Time

200

Quantum gravity

Gravitational wave
Big bang

Standard Model
Hawking radiation
Dark energy
Symmetry

100

POSITIVE WORDS

COMPLEX WORDS

NEGATIVE WORDS

SIMPLE WORDS

An analysis of the presidential candidates' speaking styles, measuring the complexity of their speech and the positivity (or negativity) of their message. For context, they are presented alongside 72 works of literature, using the same analysis.

No candidate uses simpler language than Mr. Trump, whose average sentence is just 12 words. Examples:

"I wrote 'The Art of the Deal.'"

"Obviously, I'm doing pretty well."

"I'm No. 1 in every poll by a lot."

John Kasich

The Divine Comedy: Paradise

Hillary Rodham Clinton

Persuasion

The Canterbury Tales

The Kama Sutra

Don Quixote

Barack Obama (2008)

Ted Cruz

Beowulf

Martin O'Malley

Honeybee: Lessons From an Accidental Beekeeper

Mike Huckabee

Mansfield Park

Plato's Republic

The Romance of Lust

The Pursuit of God

Jeb Bush

Encyclopedia of Needlework

Eve's Diary

Ben Carson

Marco Rubio

The Life-Changing Magic of Tidying Up

Hans Christian Andersen's Fairy Tales

Donald J. Trump

The Legends of King Arthur

Adventures of Huckleberry Finn

Les Misérables

Life on the Mississippi

The Moonstone

Ulysses

A Tale of Two Cities

The Double Helix

Sense and Sensibility

Pride and Prejudice

The Arabian Nights

The Last of the Mohicans

Meditations

Middlemarch

Northanger Abbey

Anna Karenina

Walden

The Confessions of St. Augustine

Around the World in 80 Days

Journey to the Center of the Earth

Great Expectations

The Wind in the Willows

Emma

Twenty Thousand Leagues Under The Sea

Bernie Sanders

Rendezvous With Rama

Candide

Siddhartha

The Odyssey

The Trial

Tess of the D'Urbervilles

Bird by Bird

Bossypants

A Christmas Carol

Chris Christie

Carly Fiorina

Oliver Twist

Master and Commander

Anne of Green Gables

The Return of Sherlock Holmes

Dracula

The Sign of the Four

A Room With a View

Treasure Island

The Wonderful Wizard of Oz

Just So Stories

The Sirens of Titan

The Forever War

The Adventures of Sherlock Holmes

1Q84

Dubliners

The Fault in Our Stars

The Martian

Youth

The Yellow Wallpaper

Rand Paul

The Aeneid

Three Men in a Boat

The Importance of Being Earnest

Ender's Game

Peter Pan

Sources: Debate transcripts from Federal News Service; book texts from Project Gutenberg and other sources.

EVERY PRESIDENTIAL CANDIDATE TALKS LIKE A BOOK

But which one?

ARTIST: Josh Katz, graphics editor at the *New York Times.*

STATEMENT: We wanted to look at the speaking styles of the 2016 presidential candidates by plotting the complexity of their speech and the positivity or negativity of their message. To help make this concrete, we compared them with a range of books, drawn from the most commonly downloaded titles on Project Gutenberg and selections from our personal libraries. We used a formula for language complexity developed in the 1960s that is based on the number of three-plus-syllable words per sentence—which generates a higher score for those who use either longer sentences or a lot of very big words.

PUBLICATION: *New York Times* (October 28, 2015)

REFUGEE FLOWS

Where asylum seekers come from, and where they go.

WHO GOES WHERE?

Citizens from Syria and Kosovo comprised nearly 40 percent of asylum applicants during the first four months of 2015; Syrian claims were up 80 percent from the same period last year, whereas those from Kosovo exploded, seeing a 17-fold jump.

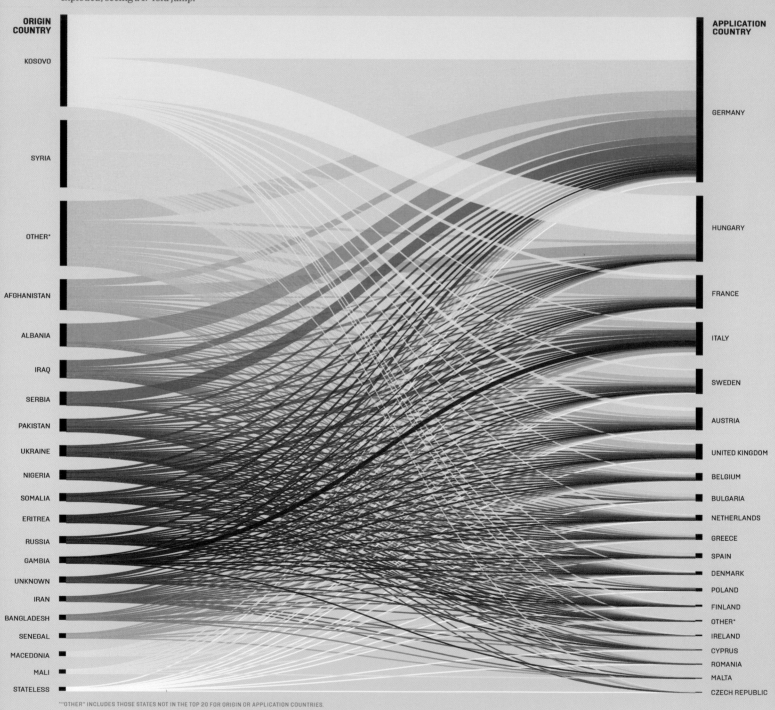

ORIGIN COUNTRY

KOSOVO
SYRIA
OTHER*
AFGHANISTAN
ALBANIA
IRAQ
SERBIA
PAKISTAN
UKRAINE
NIGERIA
SOMALIA
ERITREA
RUSSIA
GAMBIA
UNKNOWN
IRAN
BANGLADESH
SENEGAL
MACEDONIA
MALI
STATELESS

APPLICATION COUNTRY

GERMANY
HUNGARY
FRANCE
ITALY
SWEDEN
AUSTRIA
UNITED KINGDOM
BELGIUM
BULGARIA
NETHERLANDS
GREECE
SPAIN
DENMARK
POLAND
FINLAND
OTHER*
IRELAND
CYPRUS
ROMANIA
MALTA
CZECH REPUBLIC

*"OTHER" INCLUDES THOSE STATES NOT IN THE TOP 20 FOR ORIGIN OR APPLICATION COUNTRIES.

WHAT ARE THEIR FAVORED DESTINATIONS?

Germany received 40 percent of asylum applications during the first third of 2015, while Hungary, France, Italy, and Sweden combined received another 39 percent.

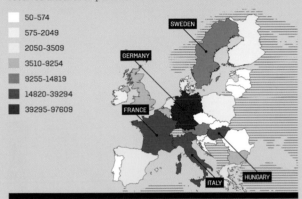

- 50–574
- 575–2049
- 2050–3509
- 3510–9254
- 9255–14819
- 14820–39294
- 39295–97609

SWEDEN · GERMANY · FRANCE · ITALY · HUNGARY

WHO ARE THEY?

The vast majority of asylum applicants are men ages 18 to 34, but the proportion of minors grew significantly during 2014. Those with unknown age or gender (only 0.1 percent of applicants) are not shown.

■ FEMALE 18+ □ MALE 18+ ■ UNDER-18 FEMALE □ UNDER-18 MALE

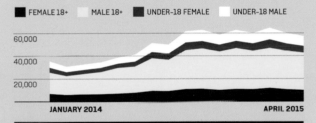

60,000
40,000
20,000

JANUARY 2014 · APRIL 2015

HOW DO THEY GET THERE?

In 2014, nearly 78 percent of detections of asylum-seekers and undocumented migrants occurred at sea—the most common being Syrians attempting to traverse the eastern and central Mediterranean (two of the most congested border crossings). Eritreans were one of the most frequently found populations along the central Mediterranean, while Afghans, Somalis, and Iraqis contributed to heavy volume along the eastern Mediterranean. And in late 2014, a spike occurred along the route through the Western Balkans, the third-most-popular land or sea route.

■ CENTRAL MEDIT. ■ EASTERN MEDIT. □ WEST. BALKANS □ OTHER
■ LAND BORDERS SEA BORDERS

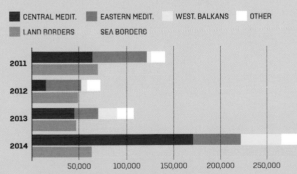

2011
2012
2013
2014

50,000 · 100,000 · 150,000 · 200,000 · 250,000

"WHO GOES WHERE?" AND "WHAT ARE THEIR FAVORED DESTINATIONS?": EUROSTAT, JANUARY–APRIL 2015; "WHO ARE THEY?": EUROSTAT; "HOW DO THEY GET THERE?": FRONTEX.

ARTISTS: Ed Johnson, designer and art director; Elaine Ayo, writer and researcher; Amanda Silverman, story editor; Josef Reyes, creative director; Mindy Kay Bricker, executive editor, at *Foreign Policy*.

STATEMENT: Personal narratives from the migrant crisis in Europe have inundated the news media, but we wanted to give a graphic overview that would help readers quickly see and begin to understand the flow of this conflict-driven migration over a few months in 2015. The central challenge was to figure out which approach was best for showing the flows between countries. This alluvial diagram won out.

PUBLICATION: *Foreign Policy* (September/October 2015)

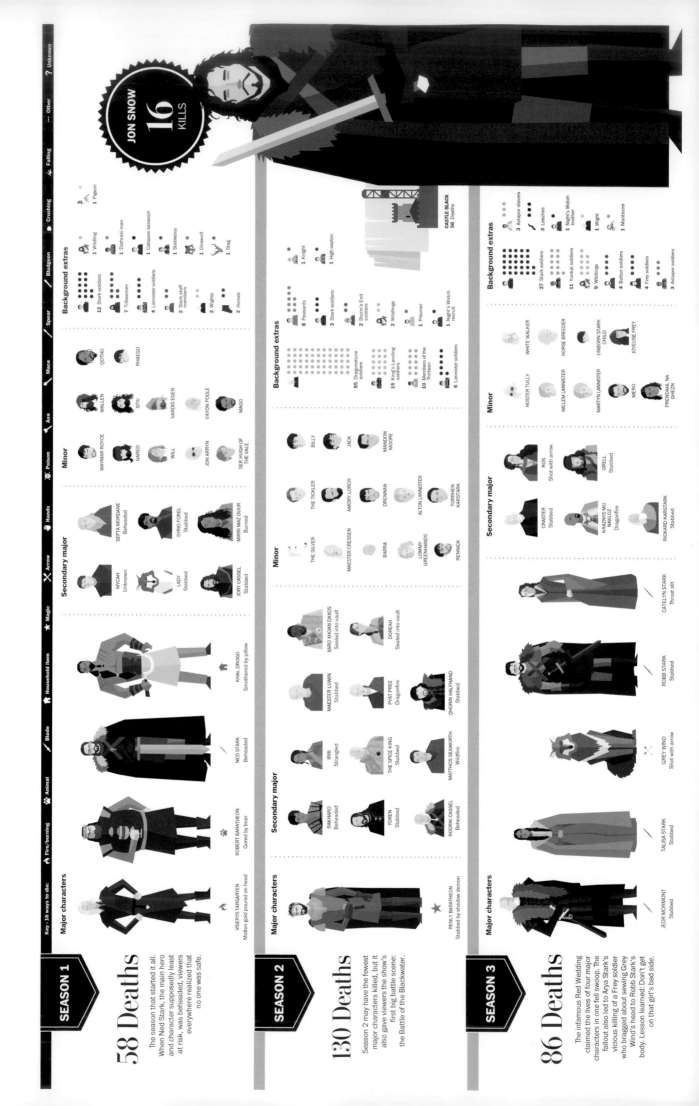

Key – 16 ways to die: ⚡ Fire/burning ✴ Animal 🗡 Blade 🏠 Household Item ★ Magic ☠ Poison ✋ Hands ✕ Arrow 🪓 Axe ⚔ Mace ⚡ Spear ⁄ Bludgeon 🔨 Crushing ✦ Falling ⋯ Other ? Unknown

JON SNOW 16 KILLS

SEASON 1
58 Deaths
The season that started it all. When Ned Stark, the main hero and character supposedly least at risk, was beheaded, viewers everywhere realized that no one was safe.

Major characters
- VISERYS TARGARYEN — Molten gold poured on head
- ROBERT BARATHEON — Gored by boar
- NED STARK — Beheaded
- KHAL DROGO — Smothered by pillow

Secondary major
- RODRIK CASSEL — Beheaded
- YOREN — Stabbed
- RAKHARO — Beheaded
- MYCAH — Unknown
- LADY — Stabbed
- JORY CASSEL — Stabbed
- SEPTA MORDANE — Beheaded
- SYRIO FOREL — Stabbed
- MIRRI MAZ DUUR — Burned

Minor
- WAYMAR ROYCE
- GARED
- WILL
- JON ARRYN
- SER HUGH OF THE VALE
- WALLEN
- STIV
- VARDIS EGEN
- VAYON POOLE
- MAGO
- QOTHO
- RHAEGO

Background extras
- 12 Stark soldiers
- 7 Tribesmen
- 4 Lannister soldiers
- 2 Stark staff members
- 2 Wights
- 2 Horses
- 1 Wildling
- 1 Dothraki man
- 1 Catspaw assassin
- 1 Stableboy
- 1 Direwolf
- 1 Stag
- 1 Pigeon

SEASON 2
130 Deaths
Season 2 may have the fewest major characters killed, but it also gave viewers the show's first big battle scene: the Battle of the Blackwater.

Major characters
- RENLY BARATHEON — Stabbed by shadow demon

Secondary major
- MATTHOS SEAWORTH — Wildfire
- THE SPICE KING — Stabbed
- IRRI — Strangled
- MAESTER LUWIN — Stabbed
- PYAT PREE — Dragonfire
- QHORIN HALFHAND — Stabbed
- XARO XHOAN DAXOS — Sealed into vault
- DOREAH — Sealed into vault

Minor
- LOMMY GREENHANDS
- RENNICK
- MAESTER CRESSEN
- BARRA
- THE SILVER
- THE TICKLER
- AMORY LORCH
- DRENNAN
- BILLY
- JACK
- MANDON MOORE
- ALTON LANNISTER
- TORRHEN KARSTARK

Background extras
- 55 Dragonstone soldiers
- 15 King's Landing soldiers
- 10 Members of the Thirteen
- 6 Lannister soldiers
- 8 Peasants
- 3 Stark soldiers
- 2 Storm's End soldiers
- 2 Wildlings
- 1 Prisoner
- 1 Night's Watch recruit
- 1 Knight
- 1 High septon

CASTLE BLACK 56 Deaths

SEASON 3
86 Deaths
The infamous Red Wedding claimed the lives of four major characters in one fell swoop. The fallout also led to Arya Stark's vicious killing of a Frey soldier who bragged about sewing Grey Wind's head to Robb Stark's body. Lesson learned: Don't get on that girl's bad side.

Major characters
- JEOR MORMONT — Stabbed
- TALISA STARK — Stabbed
- GREY WIND — Shot with arrow
- ROBB STARK — Stabbed
- CATELYN STARK — Throat slit

Secondary major
- CRASTER — Stabbed
- KRAZNYS MO NAKLOZ — Dragonfire
- RICKARD KARSTARK — Stabbed
- ROS — Shot with arrow
- ORELL — Stabbed

Minor
- HOSTER TULLY
- WILLEM LANNISTER
- MERO
- WHITE WALKER
- MARTYN LANNISTER
- PRENDAHL NA GHEZN
- HORSE BREEDER
- UNBORN STARK CHILD
- JOYEUSE FREY

Background extras
- 27 Stark soldiers
- 11 Yunkai soldiers
- 9 Wildlings
- 4 Bolton soldiers
- 4 Frey soldiers
- 3 Astapor soldiers
- 3 Astapor slavers
- 3 Leeches
- 1 Night's Watch brother
- 1 Wight
- 1 Manticore

ARTIST: Elliott Ramos, mobile editor, *Wall Street Journal.*

STATEMENT: I'm always curious to see if obscure things such as parking or restaurant data could stand in for broader trends in interactions within a community. For example, what would music selections on e-jukeboxes in public venues reveal about us locally, regionally, and nationally? Using data provided exclusively by TouchTunes, I mapped jukebox selections and was surprised by how much these listening choices followed both ethnic and socioeconomic data for a region. Popular music selections turned out to highlight Latino and African-American communities, and cities behaved in interesting ways. Centralized business and tourist districts often showed a mix of pop and rock selections, while quieter residential parts would reveal the eccentricities of a neighborhood. In some cases, you can even spot a neighborhood in the middle of gentrification, given away by a mashup of Latin and '90s alt-rock artists.

PUBLICATION: *Wall Street Journal* (September 29, 2015)

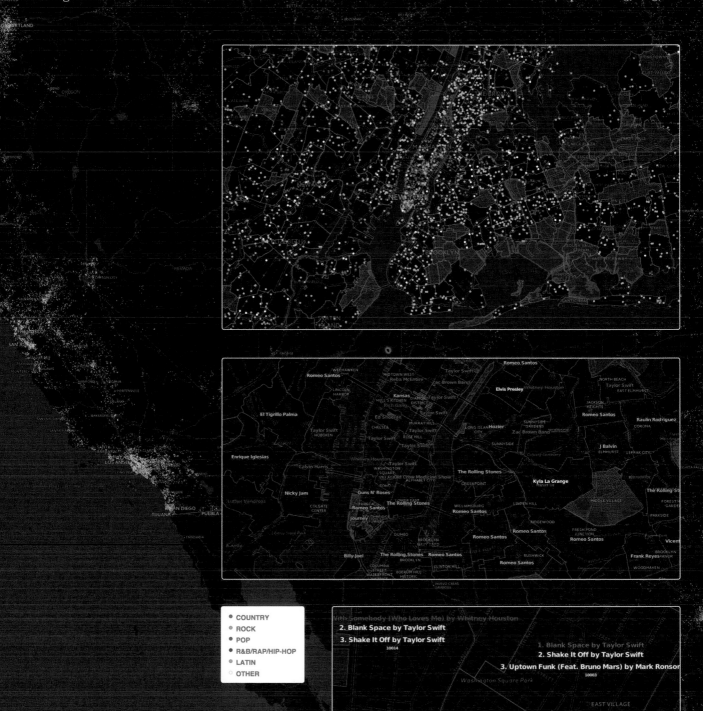

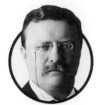

THEODORE ROOSEVELT

BARACK OBAMA

RUTHERFORD B. HAYES

RONALD REAGAN

DWIGHT D. EISENHOWER

Blitt: This recalls Edward Lear, who was never president, I don't think.

Cavna: Worth noting: Only doodle in the whole bunch that shows people in actual conflict.

Sorensen: Best portrait of an unhappy FLOTUS.

These drawings came from Roosevelt's "picture letters" to his family.

Sorensen: Most artistic talent [of the bunch]. Shows a natural ability at caricature. Is that Dianne Feinstein?

Then-Sen. Obama drew this for the Doodle4NF auction benefitting neurofibromatosis research. It depicts, from the bottom, Senators Charles Schumer, Edward Kennedy, Harry Reid — and yes, Dianne Feinstein.

Blitt: Very nice. Someone's been answering those "Draw Me" ads at the back of magazines. (I'll bet he draws a mean pirate.)

Bell: This is both a beautiful young lady and a mushroom cloud.

Cavna: It feels personal, almost intimate, as if sketching a loved one. ... This doodler is a person capable of significant compassion — a feel increased by the imperfect line, which has the look of an old-fashioned dip pen or fountain pen.

Blitt: The Great Cartoonicator.

Sorensen: A couple great stylized retro cartoon characters. I suspect this president might have been looking at a cartoon himself when he drew those. I'm getting a serious Reagan vibe.

Blitt: There's a skilled bit of draftsmanship. The subject matter is mildly disturbing. I bet he was a goth.

Cavna: Talk about a preoccupation with all things uber-masculine. ... The knife-on-knife action looks as if the doodler's drawing from real-life weaponry.

STATEMENT: Inspired by *Cabinet* magazine's 2006 book *Presidential Doodles: Two Centuries of Scribbles, Scratches, Squiggles, and Scrawls from the Oval Office,* and with an assist from in-house cartoonist Michael Cavna, we decided to ask politically minded cartoonists for their thoughts on a few presidential works without telling them which POTUS did the doodling. The result was part art critique, part comic riff, and part armchair psychoanalysis. The editing was excruciating: so many clever comments just didn't fit.

PUBLICATION: *Washington Post* (April 17, 2015)

Like many people trapped in endless meetings, U.S. presidents tend to doodle. Their sketches and scribbles on documents such as memos and White House stationery have long been fodder for analysts seeking deeper meaning. But what would artists say? We asked four cartoonists to critique some presidential doodles — without knowing which POTUS was behind the pen.

Darrin Bell
Post Writers Group political cartoonist and "Candorville" strip creator

Barry Blitt
cartoonist and illustrator best known for his more than 80 New Yorker covers

Michael Cavna
cartoonist, creator of the "Comic Riffs" column and graphic-novel reviewer for The Post's Book World

Jen Sorensen
political cartoonist, winner of the 2014 Herblock Prize and comics editor for Fusion.net

← +abstract —

RICHARD NIXON **HERBERT HOOVER** **WARREN G. HARDING** **LYNDON JOHNSON**

 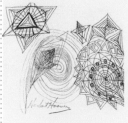

Bell: This is one image composed of eight different sets of perspective lines. Clearly, this is a man who prefers to hear all perspectives, even diametrically opposed ones.

Blitt: Looks like a sketch for a large, polished-metal sculpture that would find a nice home in a cold industrial park somewhere.

Blitt: Looks like it was penned unconsciously while on the telephone, negotiating the country's way out of a nuclear standoff.

Bell: The work of someone who is working very hard at not paying attention.

Blitt: Love the severed fingers. Looks like this was inked by a 13-year-old child of a bitter divorce.

Bell: This is just crazy.

Cavna: Like toppled art deco.

Sorensen: That last panel would make a great indie album cover.

Cavna: This may give me (long national) nightmares!

SKETCH ARTISTS IN CHIEF

Cartoonists go to town on presidents' doodle skills.

ARTISTS: Various US presidents, art; various cartoonists, commentary. Samuel Granados, concept and design; Bonnie Berkowitz, writing, editing, and curation, at the *Washington Post*.

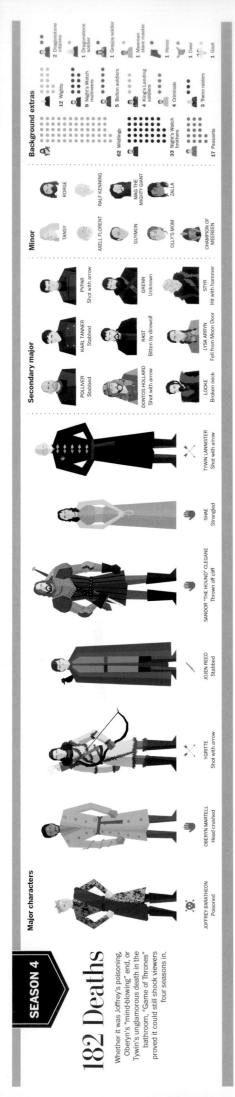

GAME OF THRONES OF DOOM

An illustrated guide to all 456 deaths in HBO's murderous hit show.

ARTISTS: Shelly Tan, graphics editor at the *Washington Post*; Alberto Cuadra, former senior graphics editor at the *Post* and current graphics managing editor at *Science* magazine.

STATEMENT: *Game of Thrones* is notorious for both its high death count and its willingness to kill off major characters. Curious about exactly how people and animals died, Shelly Tan decided to rewatch the first four seasons and mark down every single death, including why, how, when, and more. The result was an illustrated guide to all 456 deaths to date in *Game of Thrones*, including background extras and animals. Want to know exactly how many pigeons died? This graphic can tell you.

Bonus discovery: In battle scenes, loud noises often cover up surprisingly little fighting. Many times, fighters are just jostling each other or standing their ground while sound effects make it seem like someone is dying.

PUBLICATION: *Washington Post* (April 6, 2015)

SEASON 4

182 Deaths

Whether it was Joffrey's poisoning, Oberyn's "mind-blowing" end, or Tywin's unglamorous death in the bathroom, "Game of Thrones" proved it could still shock viewers four seasons in.

Major characters

- JOFFREY BARATHEON — Poisoned
- OBERYN MARTELL — Head crushed
- YGRITTE — Shot with arrow
- JOJEN REED — Stabbed
- SANDOR "THE HOUND" CLEGANE — Thrown off cliff
- SHAE — Strangled
- TYWIN LANNISTER — Shot with arrow

Secondary major

- POLLIVER — Stabbed
- KARL TANNER — Stabbed
- PYPAR — Shot with arrow
- DONTOS HOLLARD — Shot with arrow
- RAST — Bitten by direwolf
- GRENN — Unknown
- LOCKE — Broken neck
- LYSA ARRYN — Fell from Moon Door
- STYR — Hit with hammer

Minor

- TANSY
- RORGE
- AXELL FLORENT
- RALF KENNING
- GUYMON
- MAG THE MIGHTY GIANT
- OLLY'S MOM
- ZALLA
- CHAMPION OF MEEREEN

Background extras

- 62 Wildlings
- 12 Wights
- 9 Night's Watch mutineers
- 5 Bolton soldiers
- 4 King's Landing soldiers
- 33 Night's Watch brothers
- 4 Criminals
- 3 Thenn raiders
- 17 Peasants
- 2 Dragonstone citizens
- 1 Dragonstone soldier
- 1 Greyjoy soldier
- 1 Meereen slave master
- 1 Horse
- 1 Deer
- 1 Goat

METHODOLOGY
A death is only counted if:

1. The character is killed on-screen.

2. The character dies off-screen, but the death is confirmed or assumed due to imminent death while on screen.

3. Only prominent off-screen deaths are listed. (Prominence is determined mainly by importance to the plot.)

See the interactive version at **WAPO.ST/THRONES**

Source: Data compiled by Shelly Tan/The Washington Post. Episode information from "Game of Thrones" HBO television show, "Game of Thrones" wiki.

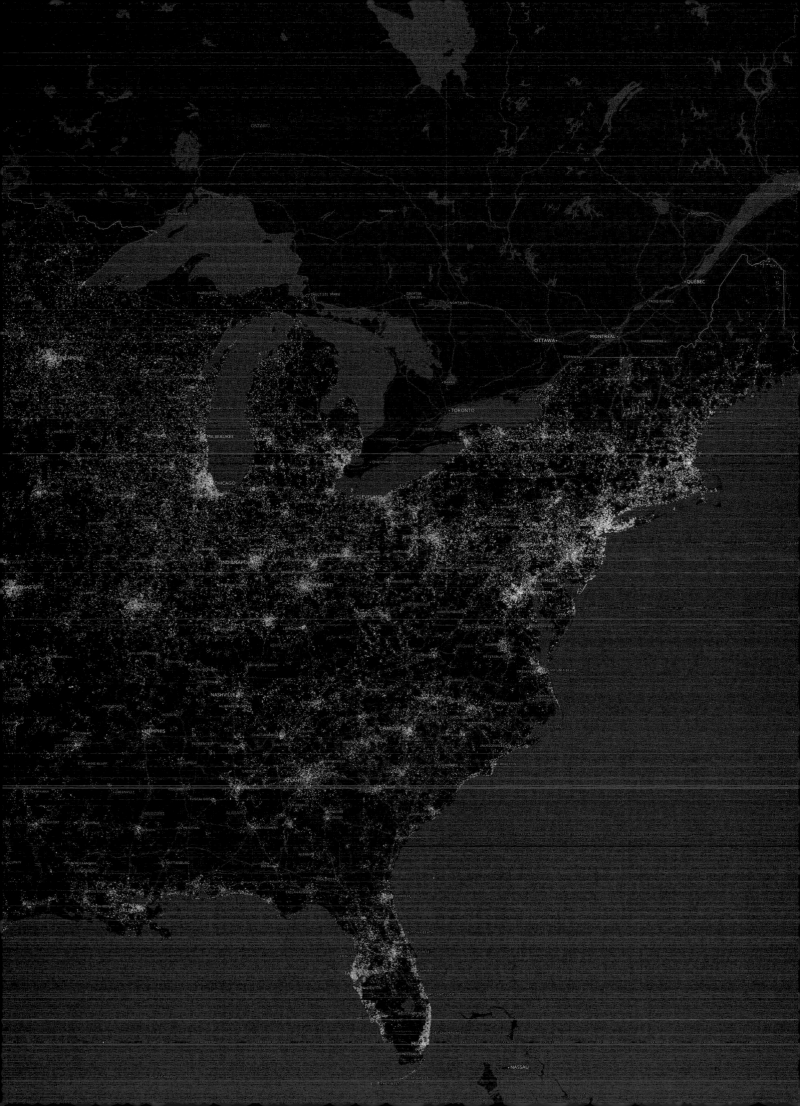

WHO POLLUTES AND WHO SUFFERS MOST

Occasionally it's the same countries—but not very often.

ARTISTS: Valerio Pellegrini, a communication designer based in Milan, information design; Emily Newhook, content, at 2U Inc., for the Milken Institute School of Public Health at the George Washington University.

STATEMENT: The artwork juxtaposes the 50 nations that emit the most CO2 with the 50 countries most vulnerable to climate change. The central map reveals the few countries that are either in both groups (both top emitters and most vulnerable) or in neither.

PUBLICATION: *mha.gwu.edu/climate-change-emissions-data/* (September 8, 2015)

CO2 EMISSION VS. VULNERABILITY TO CLIMATE CHANGE, BY NATION (2010)

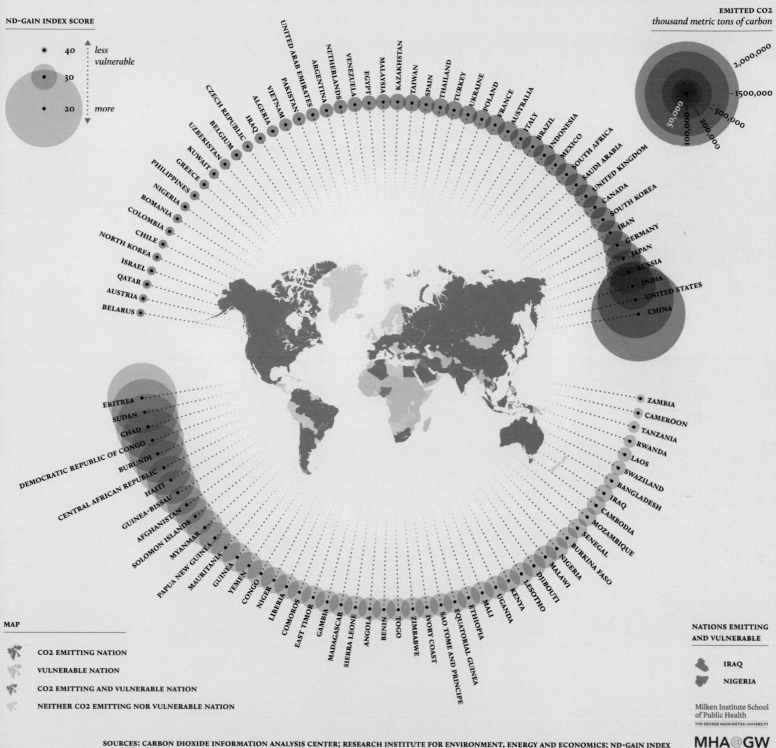

ND-GAIN INDEX SCORE

- 40 · less vulnerable
- 30 ·
- 20 · more

EMITTED CO2
thousand metric tons of carbon

2,000,000
1,500,000
500,000
200,000
100,000
50,000

MAP

- CO2 EMITTING NATION
- VULNERABLE NATION
- CO2 EMITTING AND VULNERABLE NATION
- NEITHER CO2 EMITTING NOR VULNERABLE NATION

NATIONS EMITTING AND VULNERABLE

- IRAQ
- NIGERIA

Milken Institute School
of Public Health
THE GEORGE WASHINGTON UNIVERSITY

MHA@GW

SOURCES: CARBON DIOXIDE INFORMATION ANALYSIS CENTER; RESEARCH INSTITUTE FOR ENVIRONMENT, ENERGY AND ECONOMICS; ND-GAIN INDEX

WHO CAME TO AMERICA WHEN

A vivid map of immigration gates swinging open and closed.

Country of last residence not specified
Oceania
Africa
Mexico
Carribean and other America
South America
Central America
Canada
Other Asia
India
China
Other Europe
United Kingdom
Russia
Norway-Sweden
Italy
Ireland
Philippines
Germany
Austria-Hungary

1829 1839 1849 1859 1869 1879 1889 1899 1909

ARTIST: Natalia Bronshtein, currently researcher and interactives editor at STAT.

STATEMENT: As a recent immigrant observing the fervid debate about US immigration policy, I was interested in seeing as much of the big picture as government data permitted. In this interactive data visualization, each country or region of last residence is represented by color, in a stream whose thickness represents the number of people arriving from that area in a given year. Two things stand out: the diversity of immigrants after World War II, and the immigration rate fluctuations. The major bottleneck occurs after the 1924 Immigration Act was passed, which sharply restricted or prohibited immigration from many regions. After the Immigration and Naturalization Act of 1965 eliminated the national origins quota system, we see the flowering of a completely new range of colors.

PUBLICATION: *insightfulinteraction.com* (March 2015)

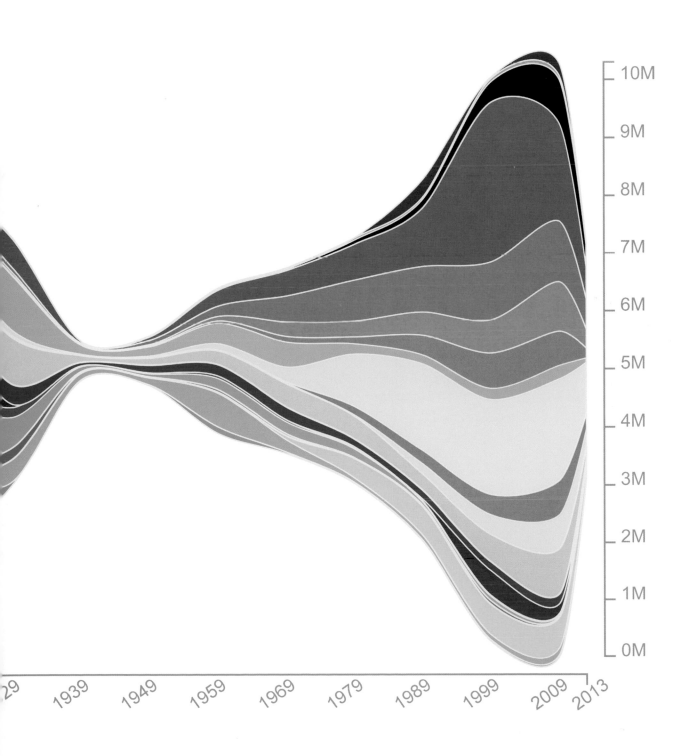

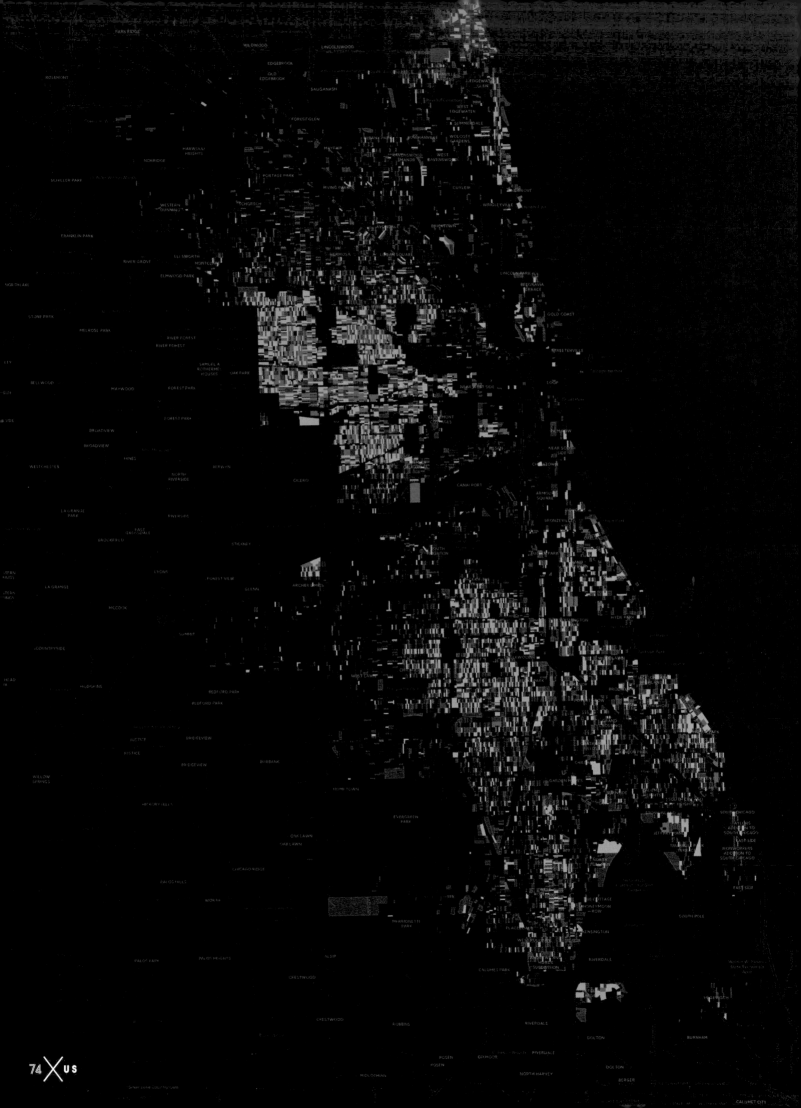

WHAT INCARCERATION COSTS CHICAGO CITY BLOCKS

The striking price of American incarceration policy.

ARTISTS: Forest Gregg, strategist, developer, data cruncher, content; Cathy Deng, designer, developer, content; Derek Eder, strategist, designer, developer, content; Eric van Zanten, developer, GIS data merging, at DataMade, a civic technology company. Daniel Cooper (Adler University) and Ryan Lugalia-Hollon, writers and strategists.

STATEMENT: Chicago's Million Dollar Blocks is an interactive map showing spending on incarceration for every block in the city of Chicago, based on data obtained by the Chicago Justice Project and representing all adult convictions between 2005 and 2009. We obtained data on what each offense was, the length of the sentence, and the incarcerated person's residential address. From there, we calculated the total cost to imprison each person based on their minimum sentence.

This project draws from work by the Spatial Information Design Lab and the Justice Mapping Center, who have since coined the term *million dollar blocks* and helped reframe the public debate around community justice across the country. We were curious what such an analysis would show in Chicago. It revealed that the neighborhoods on the south and west sides are disproportionately affected by the criminal justice system. In one west side neighborhood alone, Austin, $290 million is being spent on nonviolent drug offenders.

PUBLICATION: *chicagosmilliondollarblocks. com* (July 21, 2015)

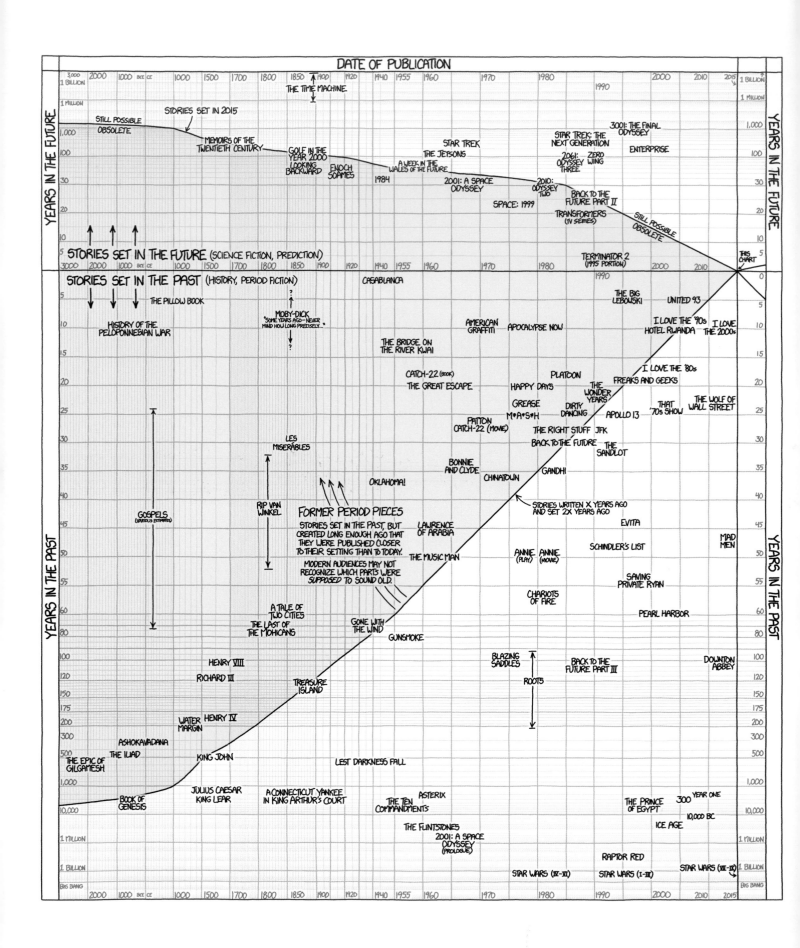

STORIES OF PAST AND FUTURE

Looking back at stories that looked backward and stories that looked forward.

ARTIST: Randall Munroe

STATEMENT: When *2001: A Space Odyssey* first came out, it was a story about the future, but now 2001 is well behind us. It has been made obsolete (or not, depending on your views on artificial intelligence). On this chart, stories are plotted by the date of publication and the time when the action takes place.

PUBLICATION: *xkcd.com* (February 25, 2015)

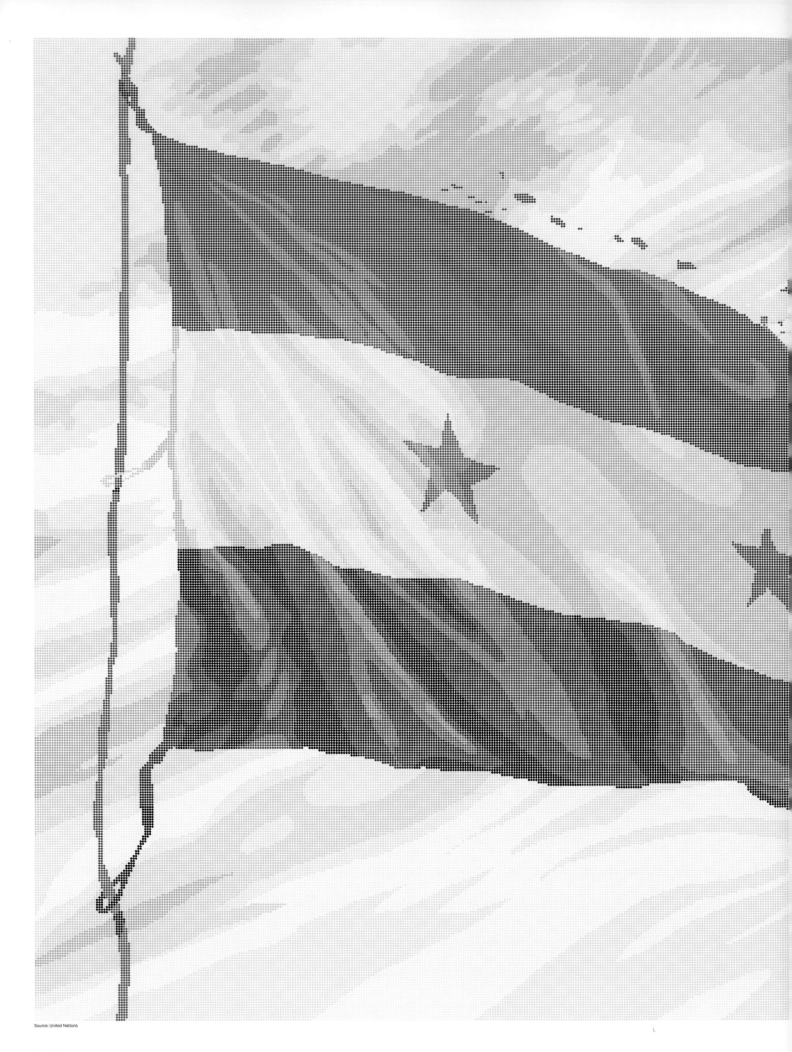

Source: United Nations

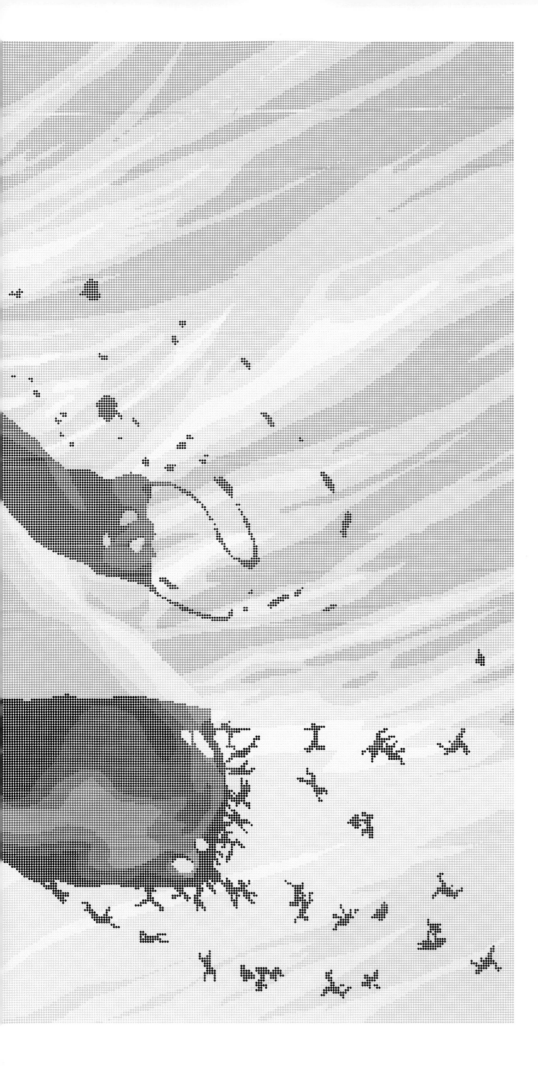

THE SYRIAN DEATH-TOLL FLAG

An image tries to capture the scale of the disaster.

ARTISTS: Richard Johnson, senior graphics editor, conception, research, creation, and writing; Tim Curran, weekend editor; Kevin Uhrmacher, graphic artist; Brian Cleveland, copy editor; Laris Karklis, graphics editor, at the *Washington Post.*

STATEMENT: On March 16, 2015, UN Secretary General Ban Ki-moon gave a speech marking the 70th anniversary of the United Nations, in which he said, "There is no more painful example of the failure of collective action of the United Nations than the conflict in Syria, now in its fifth year. More than 220,000 people have been killed."

To readers of a news story, 2,000 killed in Syria looks much like 22,000 killed, or 220,000 killed. This graphic was an attempt to overcome that, and to make each and every lost life visible. This dot screen image at first seems to be the whole message, but it subtly brings the reader to its true point: one single life snuffed out, 220,000 times over.

PUBLICATION: *Washington Post* (March 29, 2015)

WHERE THE PEOPLE ARE

Almost everyone is crowded onto one half of the planet.

ARTIST: Bill Rankin, historian, cartographer, and assistant professor of the history of science at Yale University.

STATEMENT: Out of the infinitely many hemispheres into which you could divide the world, which has the most people in it? These maps, which use data from the Global Rural-Urban Mapping Project (GRUMP) project at Columbia, show that what I call the "Human Hemisphere" is centered in western Switzerland. It contained 92.9 percent of the world's population in 2000. It looks like there might be some justification for Eurocentrism after all, at least geographically.

PUBLICATION: *www.radicalcartography.net* (September 12, 2015)

The World's Population by Latitude

(horizontal axis shows the sum of all population at each degree of latitude)

The World's Population by Longitude

(vertical axis shows the sum of all population at each degree of longitude)

93% of the world's population

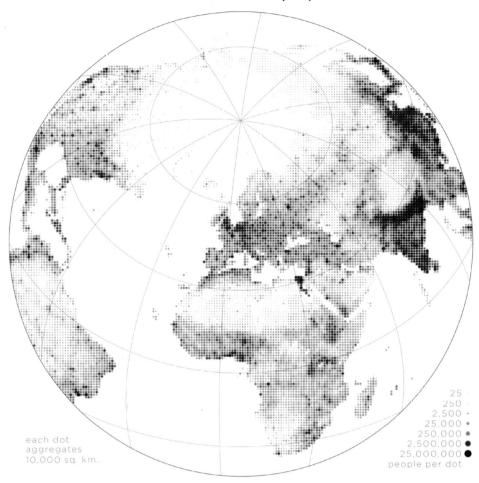

each dot
aggregates
10,000 sq. km.

25
250
2,500
25,000
250,000
2,500,000
25,000,000
people per dot

the other 7%

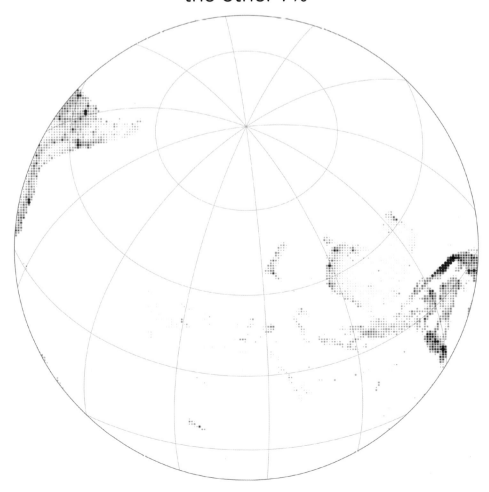

THE HUMAN TOLL OF WORLD WAR II

Sometimes the numbers are moving all by themselves.

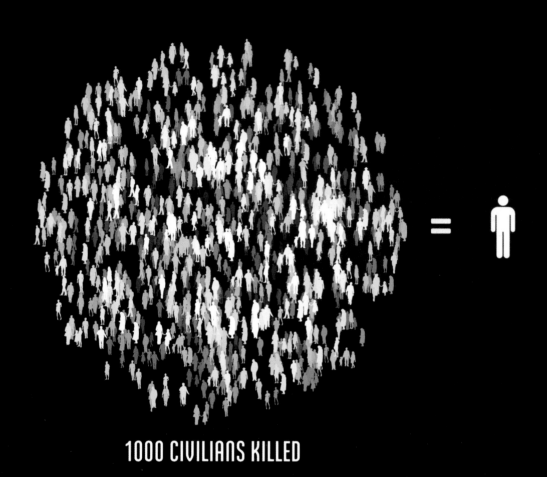

1000 CIVILIANS KILLED

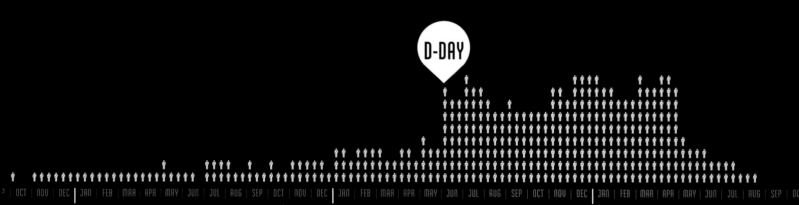

D-DAY

OCT | NOV | DEC | JAN | FEB | MAR | APR | MAY | JUN | JUL | AUG | SEP | OCT | NOV | DEC | JAN | FEB | MAR | APR | MAY | JUN | JUL | AUG | SEP | OCT | NOV | DEC | JAN | FEB | MAR | APR | MAY | JUN | JUL | AUG | SEP | OC

1943 1944 1945

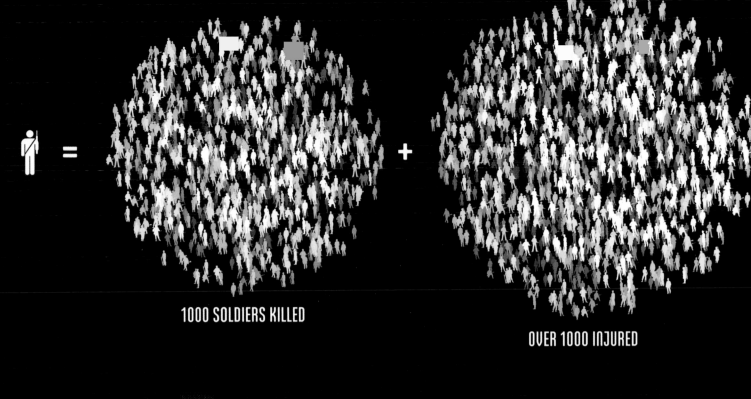

$\mathbf{\stackrel{\bullet}{i}} =$ 1000 SOLDIERS KILLED $+$ OVER 1000 INJURED

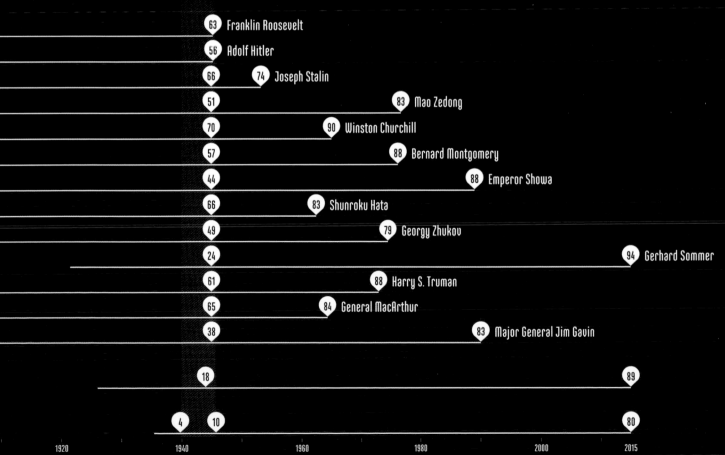

- (63) Franklin Roosevelt
- (56) Adolf Hitler
- (66) (74) Joseph Stalin
- (51) (83) Mao Zedong
- (70) (90) Winston Churchill
- (57) (88) Bernard Montgomery
- (44) (88) Emperor Showa
- (66) (83) Shunroku Hata
- (49) (79) Georgy Zhukov
- (24) (94) Gerhard Sommer
- (61) (88) Harry S. Truman
- (65) (84) General MacArthur
- (38) (83) Major General Jim Gavin
- (18) (89)
- (4) (10) (80)

1920 | 1940 | 1960 | 1980 | 2000 | 2015

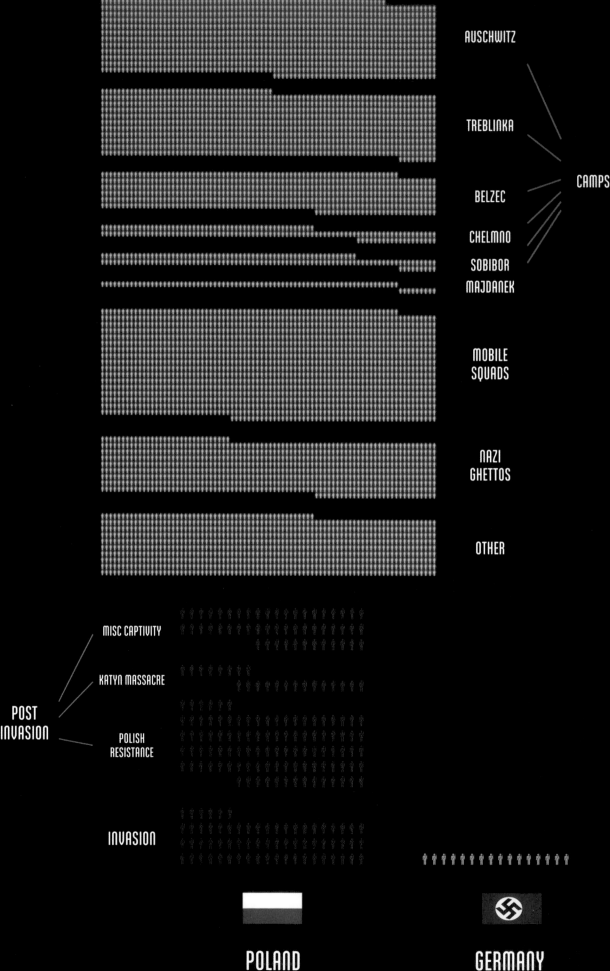

AUSCHWITZ

TREBLINKA

BELZEC

CHELMNO

SOBIBOR

MAJDANEK

CAMPS

MOBILE
SQUADS

NAZI
GHETTOS

OTHER

MISC CAPTIVITY

KATYN MASSACRE

POST
INVASION

POLISH
RESISTANCE

INVASION

POLAND

GERMANY

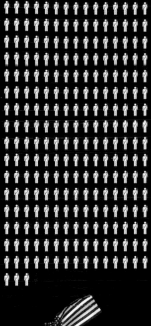

ARTISTS: Neil Halloran, direction, narration, coding of visuals; Andy Dollerson, music and sound design.

STATEMENT: *The Fallen of World War II* is an animated data-driven documentary about war and peace. Combining interactive charts with an 18-minute linear presentation, the film examines the human cost of the Second World War and compares it to that of other wars in history. Despite being exposed to countless movies, shows, documentaries, books, and video games about World War II, I never had a holistic picture of the scale of human loss. I created the film because I wanted to tell the story of World War II through the numbers, and hoped to create an emotional experience without relying on anecdotal content. I composed the animation with custom-built software that renders the visualization via a Web browser, which is an unusual and laborious method for creating film—but which allowed me to closely choreograph the movement of figures with the data, narration, and soundtrack.

PUBLICATION: *fallen.io* (Memorial Day, May 25, 2015)

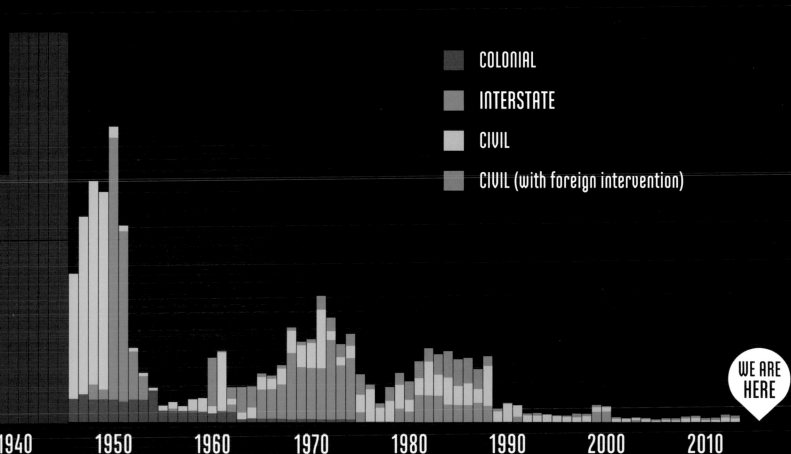

COLONIAL

INTERSTATE

CIVIL

CIVIL (with foreign intervention)

WE ARE HERE

1940 1950 1960 1970 1980 1990 2000 2010

How the key words in song titles have changed.

Decade	Word	Keyness	Maximum freq.	Contour (significant decade in red)
2010s	We	22	1.4%	
	Yeah	18	0.2%	
	Hell	18	0.3%	
	F**k	15	0.1%	
	Die	14	0.2%	
2000s	U	71	1.1%	
	Like	28	1.1%	
	Breathe	25	0.2%	
	It	24	2.4%	
	Ya	19	0.7%	
1990s	U	49	1.1%	
	You	28	5.1%	
	Up	21	1.0%	
	Get	20	1.0%	
	Thang	18	0.2%	
1980s	Love	48	3.8%	
	Fire	24	0.5%	
	Don't	20	1.6%	
	Rock	14	0.7%	
	On	14	3.2%	
1970s	Woman	33	0.6%	
	Disco	31	0.4%	
	Rock	24	0.7%	
	Music	24	0.6%	
	Dancin'	20	0.5%	
1960s	Baby	51	1.9%	
	Twist	24	0.7%	
	Little	16	4.0%	
	Twistin'	15	0.4%	
	Lonely	14	0.5%	
1950s	Christmas	31	0.8%	
	Penny	18	0.4%	
	Mambo	15	0.5%	
	Rednosed	15	0.3%	
	Three	15	0.5%	

ARTIST: David Taylor, data scientist in Saint-Lambert, Quebec.

STATEMENT: These are the words in *Billboard* magazine's top song titles that are most statistically overrepresented in each decade, with their "keyness" (the measure of statistical significance), the percentage of titles in which they appear, and a contour of how often each word appeared from 1890 to 2014. (Who knew *Billboard* song rankings went back to the 1890s?) You can track genres as they emerge among the words: "Rag" (1910s), "Blues" (1920s), "Swing" (1930s), "Boogie" and "Polka" (1940s), "Mambo" (1950s), "Twist" (1960s), "Disco" (1970s), and "Rock" (1970s and 1980s). After that, people realized you don't have to actually name the genre in the song title.

PUBLICATION: *Canadian Music Blog* (January 6, 2015)

Source: bullfrogspond.com

Methodology: A corpus of song title words was created, removing exact duplicate song titles in a given year, non-alphabetic characters, consecutive repeated words (e.g "Na na na na na na na") and the supplementary word "part" (e.g. "part one"). Keyness was determined by calculating the Dunning Log-Likelihood ratio between word frequency within each decade to the frequency of the same word in all other decades. Contour column plots are scaled from zero to maximum value for each word, where the maximum value is the percentage of song titles of that decade that contain that word.

Decade	Word	Keyness	Percentage
1940s	Polka	50	0.4%
	Serenade	35	0.7%
	Boogie	28	0.6%
	Blue	26	1.6%
	Christmas	22	0.8%
1930s	Moon	79	1.4%
	In	38	6.5%
	Swing	34	0.5%
	Sing	34	1.4%
	A	30	5.8%
1920s	Blues	153	3.1%
	Pal	42	0.9%
	Sweetheart	27	0.9%
	Rose	25	1.4%
	Mammy	23	1.0%
1910s	Gems	70	1.1%
	Rag	52	1.2%
	Home	43	2.9%
	Land	41	0.6%
	Old	38	3.7%
1900s	Uncle	58	4.5%
	Old	58	3.7%
	Josh	44	3.7%
	Reuben	38	1.4%
	When	33	3.8%
1890s	Uncle	59	4.5%
	Casey	54	3.3%
	Josh	53	3.7%
	Old	26	3.7%
	Michael	24	2.7%

Prostitution

THE HEIGHTS OF CRIME

San Francisco is hilly in another way as well.

ARTIST: Doug McCune, an artist, programmer, and amateur cartographer in Oakland.

STATEMENT: As a longtime resident of San Francisco, I'm fascinated by the incredible juxtapositions on this small chunk of land. The wealth and gaudiness of the Union Square shopping district are only a few short blocks from the stark poverty of the Tenderloin. Those contrasts are highlighted in the threatening peaks of these height maps, which show the relative density by location of three crimes: narcotics, prostitution, and vehicle theft.

Drug arrests occur throughout the city but are heavily concentrated in the Tenderloin and Mission neighborhoods. Prostitution shows a stark contrast, with nearly all arrests occurring along only a few streets. And vehicle theft occurs heavily across nearly all of San Francisco, showing that you can get your car stolen almost anywhere you park.

There is enormous complexity and bias embedded in arrest data. These maps are intended to raise more questions than answers.

PUBLICATION: Diode Gallery in Portland, Oregon, and *deviantcartography.com* (April 2015)

Narcotics

Vehicle theft

UBER FOR EVERYTHING

The on-demand service economy takes off.

ARTISTS: Kristin Lenz, art; Bobbie Gossage, editing, at *Inc.* magazine. Jennifer Alsever, reporting.

STATEMENT: Apps that allow you to order anything your heart desires, at the swipe of a finger, are more popular and better-funded than ever before, and Uber is the best-known startup in the on-demand economy. We wanted to look

at the on-demand sector's growth and its move to mobile. When you see the number of deals through the years and the amount of venture capital being pumped in, you do have a few moments of wondering, "Whoa, why didn't *we* think of that app?"

PUBLICATION: *Inc.* (February 2015)

THE UBER OF...

Now that Uber is one of the most valuable startups, dozens of similar app companies have launched to provide a variety of services.

TOTAL FUNDING RAISED ▶

MASSAGE
MORE THAN $5 MILLION

ZEEL
FOUNDED 2010
MARKETS 5

Use the app to order a licensed massage therapist to come to your home in as little as an hour.

CAR REPAIR
$12 MILLION

YOUR-MECHANIC
FOUNDED 2011
MARKETS 21

Enter your car type and service needs, and the app will send a mechanic to your home in one or two days.

BABYSITTING
$23 MILLION

URBAN-SITTER
FOUNDED 2011
MARKETS 60

Browse available local babysitters and schedule one to come to your home via the app.

LAUNDRY
MORE THAN $13 MILLION
WASHIO
FOUNDED 2012
MARKETS 6
Use the app to schedule a time, and a Washio "ninja" will come pick up (and deliver) your laundry and dry cleaning.

HOME REPAIRS
$42 MILLION

HANDY
FOUNDED 2012
MARKETS 28

Use the app to select what work you want done and schedule a plumber, electrician, handyman, or cleaner to come to your home.

PET SITTING
$47 MILLION

DOGVACAY
FOUNDED 2012
MARKETS NATIONWIDE (AND IN CANADA)

The app lets you book one of 20,000 dog sitters, on the basis of your pet's needs. You can also find a sitter for your cat, guinea pig, chicken, or snake.

VENTURE CAPITAL PER QUARTER

Total VC funding raised by on-demand mobile startups (not including Uber)

- $400,000
- $1.2 MILLION
- $3.7 MILLION
- $50.3 MILLION
- $57.5 MILLION
- $116.5 MILLION
- $141.8 MILLION
- $33.3 MILLION
- $26.6 MILLIO[N]

⊕ *Uber raises **$11 million** in Series A funding.*

⊕ *Uber raises **$37 million** in Series B funding.*

NUMBER OF DEALS

VC deals made with Uber-like companies per quarter

2010				2011				2012
Q1	Q2	Q3	Q4	Q1	Q2	Q3	Q4	Q1
3	1	4	4	6	12	7	6	9

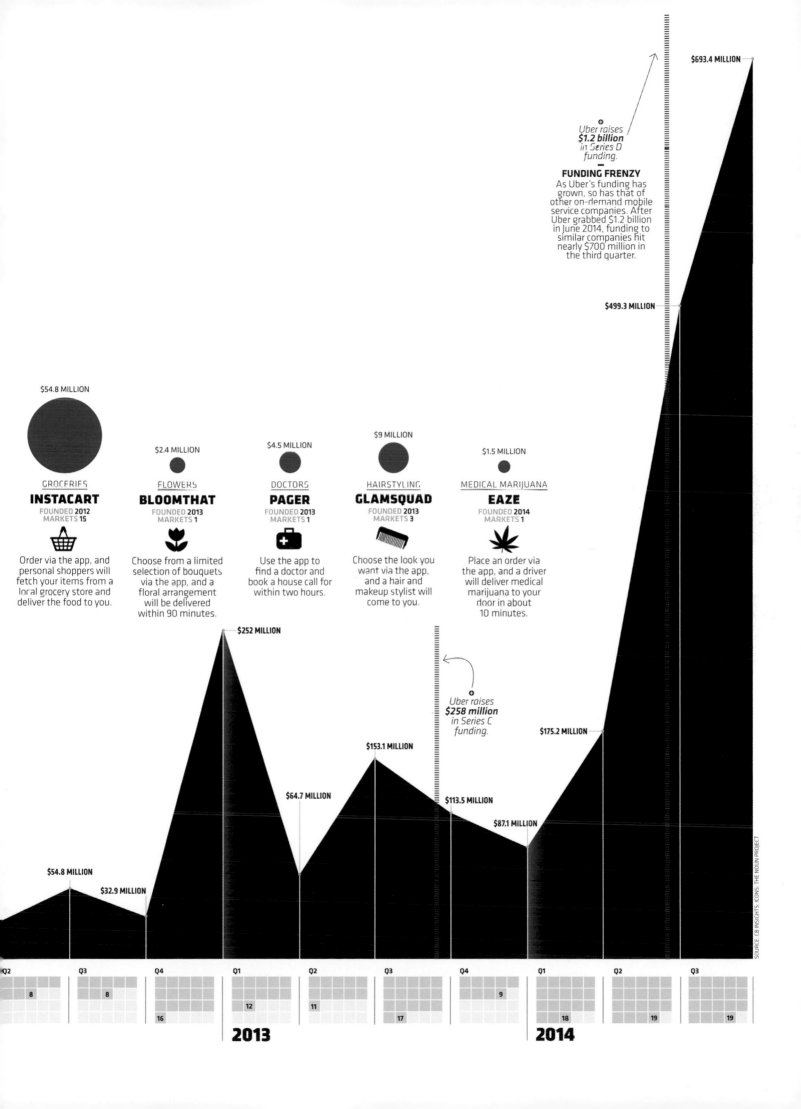

$693.4 MILLION

Uber raises
$1.2 billion
in Series D
funding.
—
FUNDING FRENZY
As Uber's funding has
grown, so has that of
other on-demand mobile
service companies. After
Uber grabbed $1.2 billion
in June 2014, funding to
similar companies hit
nearly $700 million in
the third quarter.

$499.3 MILLION

$54.8 MILLION

GROCERIES
INSTACART
FOUNDED **2012**
MARKETS **15**

Order via the app, and
personal shoppers will
fetch your items from a
local grocery store and
deliver the food to you.

$2.4 MILLION

FLOWERS
BLOOMTHAT
FOUNDED **2013**
MARKETS **1**

Choose from a limited
selection of bouquets
via the app, and a
floral arrangement
will be delivered
within 90 minutes.

$4.5 MILLION

DOCTORS
PAGER
FOUNDED **2013**
MARKETS **1**

Use the app to
find a doctor and
book a house call for
within two hours.

$9 MILLION

HAIRSTYLING
GLAMSQUAD
FOUNDED **2013**
MARKETS **3**

Choose the look you
want via the app,
and a hair and
makeup stylist will
come to you.

$1.5 MILLION

MEDICAL MARIJUANA
EAZE
FOUNDED **2014**
MARKETS **1**

Place an order via
the app, and a driver
will deliver medical
marijuana to your
door in about
10 minutes.

$252 MILLION

Uber raises
$258 million
in Series C
funding.

$175.2 MILLION

$153.1 MILLION

$64.7 MILLION

$113.5 MILLION

$87.1 MILLION

$54.8 MILLION

$32.9 MILLION

Q2	Q3	Q4	Q1	Q2	Q3	Q4	Q1	Q2	Q3
8	8	16	12	11	17	9	18	19	19

2013 **2014**

SOURCE: CB INSIGHTS. ICONS: THE NOUN PROJECT

URBAN POVERTY'S RISING TIDE

An analysis shows some gains, but more losses.

ARTIST: Justin Palmer, a cartographer who works on design and analytics at GitHub, Inc.

STATEMENT: Since the 1970s, poverty has risen sharply in America's largest cities. This graphic reveals urban census tracts where poverty has gone up (red) or fallen (green), with newly poor areas defined as a poverty rate that was below 30 percent in 1970 and 30 percent or more in 2010. At a glance, you can see the red indicating the almost universal increase of poverty in cities of the Rust Belt and the pockets of green in booming city centers like New York's, surrounded by increasingly poorer neighborhoods.

PUBLICATION: *labratrevenge.com* (August 3, 2015)

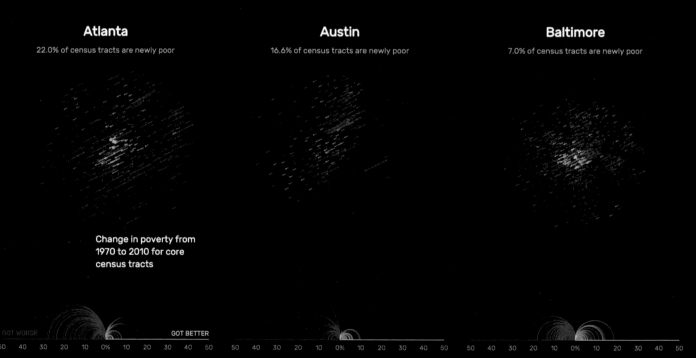

Atlanta
22.0% of census tracts are newly poor

Austin
16.6% of census tracts are newly poor

Baltimore
7.0% of census tracts are newly poor

Change in poverty from 1970 to 2010 for core census tracts

GOT WORSE · GOT BETTER

50 40 30 20 10 0% 10 20 30 40 50 50 40 30 20 10 0% 10 20 30 40 50 50 40 30 20 10 0% 10 20 30 40 50

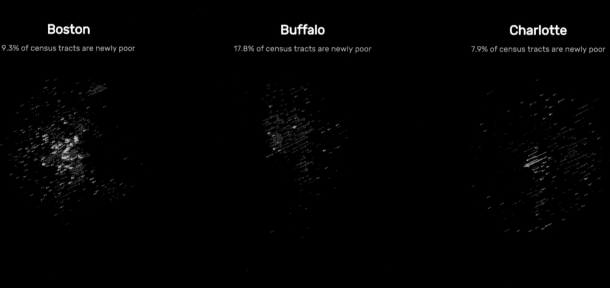

Boston
9.3% of census tracts are newly poor

Buffalo
17.8% of census tracts are newly poor

Charlotte
7.9% of census tracts are newly poor

50 40 30 20 10 0% 10 20 30 40 50 50 40 30 20 10 0% 10 20 30 40 50 50 40 30 20 10 0% 10 20 30 40 50

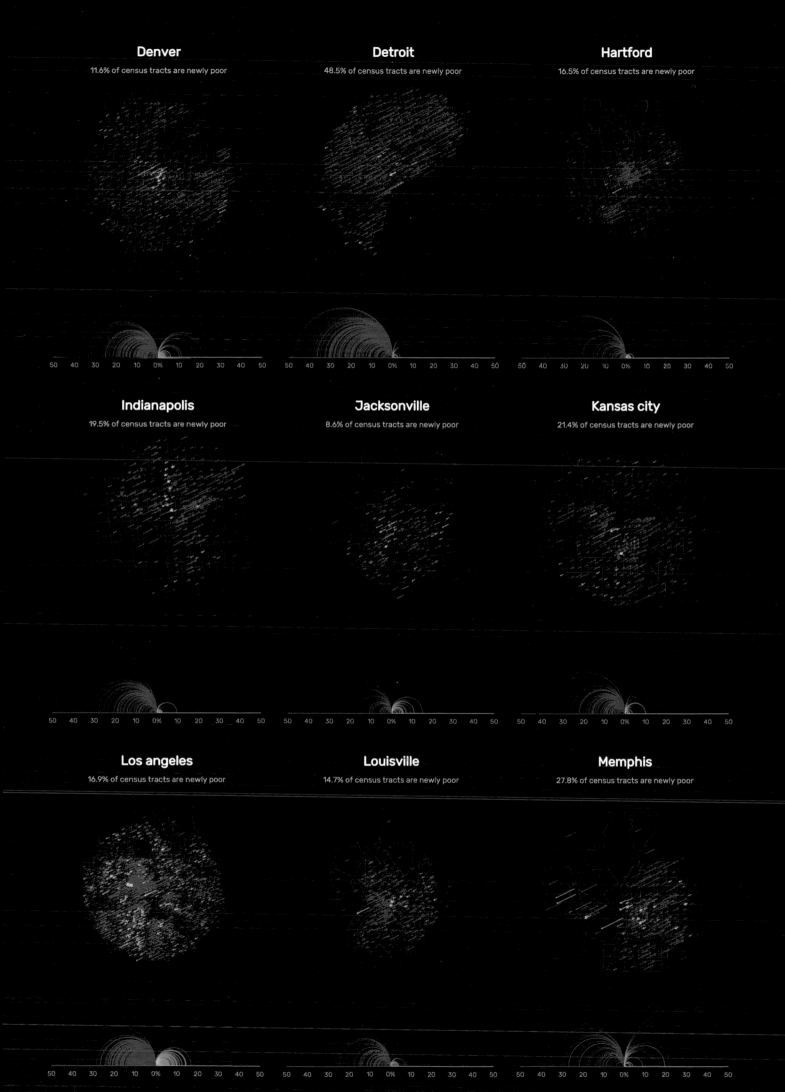

Who really gets credit in acceptance speeches?

Total
Acknowledgements
Combined

Family & Friends

Son	56	Husband	13
Daughter	50	Family	2
Wife	57	Grandmother	1
Father	46	Brother	10
Friend	34	Children	1
Mother	19	Ex-Partner	1
Niece	3	Girlfriend	1
Sister	12	Grandfather	1
Brother	11	Cousin	2
Boyfriend	1		

Misc.

Backer	11	Politician	1
Historical Figure	36	Brand	1
Celebrity	9	Character	12
Governor	1	Animal	1

Fashion/Beauty

Make-up Artist	20	Stylist	1
Hair Stylist	1		

Support Team

Lawyer	27	Driver	1
Therapist	2	Accountant	1
Assistant	2		

Talent Management

Agent	105	Manager	17
Publicist	31		

Visual Department

Art Director	6	Costume	
Cinematographer	47	Designer	13
Visual Effects		Production	
Artist	5	Designer	4
Art Department	2	Set Decorator	1

Writer

Author	35	Playwright	3
Writer	9	Poet	1

Sound Department

Sound		
Department	4	
Sound mixer	4	

Teacher/Coach

Trainer	8	Tutor	1
Acting teacher	9	Piano teacher	1

Misc. Crew

Production		Promoter	6
Manager	4	Researcher	1
Editor	26	Stuntman	5
Choreographer	4	Casting Director	1
Assistant Director	1		

Music

Composer	11	Musician	29

Producer	408
Organisation	354
Actor	364
Studio Exec.	115
Director	266
Actress	238
Screenwriter	121
Religion	73

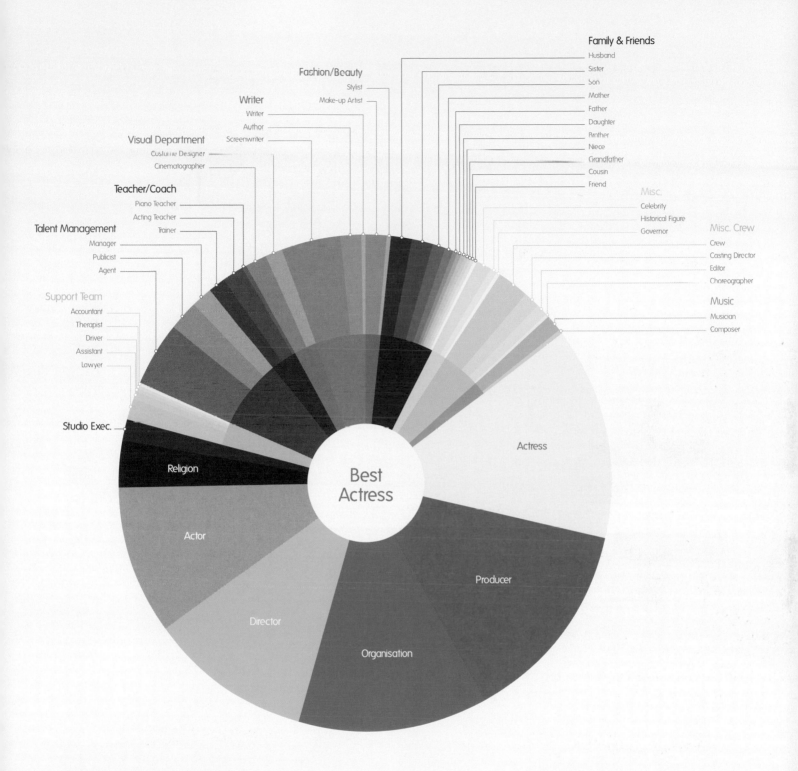

Family & Friends
- Husband
- Sister
- Son
- Mother
- Father
- Daughter
- Brother
- Niece
- Grandfather
- Cousin
- Friend

Misc.
- Celebrity
- Historical Figure
- Governor

Misc. Crew
- Crew
- Casting Director
- Editor
- Choreographer

Music
- Musician
- Composer

Fashion/Beauty
- Stylist
- Make-up Artist

Writer
- Writer
- Author
- Screenwriter

Visual Department
- Costume Designer
- Cinematographer

Teacher/Coach
- Piano Teacher
- Acting Teacher
- Trainer

Talent Management
- Manager
- Publicist
- Agent

Support Team
- Accountant
- Therapist
- Driver
- Assistant
- Lawyer

Studio Exec.

Best Actress

Religion

Actor

Director

Organisation

Producer

Actress

ARTISTS: Paul North, Chloe Williamson, and William Hughes of Big Group, creation and research; BakerWilcox, graphic design.

STATEMENT: Who gets thanked at the Academy Awards? This infographic looks at over 1,400 Oscar acceptance speeches, analyzing the categories of people who get mentioned by the winner and breaking them down by the six big awards: Best Actor, Best Actress, Best Supporting Actor, Best Supporting Actress, Best Film, and Best Director. We gathered data from the Academy archive and used a scraper to download the entire text of all the speeches. Many winners mention people by first name alone, so for every one we had to research whether that person was a sibling, agent, spouse, friend, business partner, and so on. In the course of our research, we also learned that three actresses used sign language in their speeches: Louise Fletcher (1975), Jane Fonda (1978), and Marlee Matlin (1986); five speeches employed just two simple words: "Thank you"; Anna Paquin is the only winner to thank an animal, the film's dog Beanie; and Jack Palance, at age 73, is the only winner to have performed one-armed push-ups as part of his acceptance.

PUBLICATION: *biggroup.co.uk* (February 20, 2015)

Chris Christie
GOV. OF NEW JERSEY

Andrew M. Cuomo
GOVERNOR OF NEW YORK

DuHaime tried to manage the scandal and determine what evidence Wildstein had on staff involvement.

In December, Christie and Cuomo vetoed bipartisan bills to reform the authority.

Showed Christie Sokolich's complaints: **minutes later, Christie told a news conference that staff didn't know of complaints.**

Many loyalists among at least 50 people recommended for jobs at …

The Governor's Staff

The Port Authority

POLITICAL STAFF

"FRONT OFFICE" STAFF

Christie: McKenna investigated closings in Oct. and concluded it was a traffic study. **McKenna: I first learned of study in Nov.**

Longtime Christie friend, confidant. Firm has millions in state business.

Top N.Y. appointee

Mike DuHaime
CHIEF POLITICAL STRATEGIST

Kevin O'Dowd
CHIEF OF STAFF

Charles McKenna
CHIEF COUNSEL

He about closing the lanes and that he all deleted, to Christie about the hearings.

Kim Guadagno
LT. GOV.

Christie loyalist; gave gifts of 9/11 wreckage to mayors being cultivated by Christie campaign.

David Samson
CHAIRMAN

Samson, furious at Foye for sending email about the lanes, warned: "he's playing in traffic, made a big mistake."

Patrick J. Foye
EXECUTIVE DIRECTOR

Consulted on Rockefeller's Hoboken development

Egea's boss

Kelly's boss

Christie ordered DuHaime to oust Stepien.

Stepien told Christie that Wildstein had approached him about closing the lanes and that he **Christie later said no one on his staff knew of the closings.** was involved in

Sent texts:

Regina Egea
TOP AIDE

Nicole Crifo
DEPUTY

Egea and Crifo,

the closings: "Nobody's reading this."

her deputy, edited a written version of Baroni's

Job as N.J.'s enforcer at the authority invented for Engineered union's endorsement Christie nominee rejected for N.J. Supreme Court Wildstein claims Christie knew of the closings

Samson knew of closings as they occurred.

Wildstein. He

Phillip Kwon
LAWYER

the closings were part of a traffic study, **later discredited.** testimony detailing the traffic study, **later discredited.**

as they were underway; Christie denies this.

Kwon coached Baroni's testimony.

Bill Baroni
DEPUTY EXECUTIVE DIRECTOR

Foye was not told of the closings. Later, Baroni told him they should avoid emailing about it.

Foye angrily ordered the lanes reopened, suggesting laws were broken.

Why was Stepien cut loose?

Stepien responded: "Take it to Trenton."

and DuHaime collaborated on races starting in 1997, including Baroni's N.J.

Paul Nunziato
HEAD OF P.A. POLICE UNION

Said he proposed a traffic study to Wildstein. After the study was debunked, **he recanted.**

and Christie attended high school together, and Christie attended his senate victory.

Close friends. "Trenton" was "VERY happy" with testimony, Wildstein said.

In an email to Drewniak, Wildstein called Foye "a piece of crap."

Bill Stepien
CAMPAIGN MANAGER
U.S.

Stepien and Wildstein traded emails.

Once Kelly's boss: she got his old job.

When did Christie, famous for being a hands-on manager, know about his staff's involvement?

A top culprit, Christie says: her department, which cultivated mayors,

Comella dismissed an early article about political motives in

Stepien

in which Stepien called Sokolich, the Fort Lee mayor, an "idiot"; Wildstein called him "this little Serbian." **(He is Croatian.)**

When did McKenna, Egea, Crifo and Kwon know that there had been no traffic study?
U.S.

Matt Mowers
AIDE

Mower's boss

Kelly asked Mowers if Sokolich would endorse Christie. Mowers: No. The next day she sent her infamous "traffic problems" email.

Bridget Anne Kelly
DEPUTY CHIEF OF STAFF
U.S.

was an "architect" of the closings; she said Kelly always sought approval from superiors.

Kelly: "Time for some traffic problems in Fort Lee." Wildstein: "Got it"

Both were panicky after Foye ordered the lanes reopened, but Wildstein assured Kelly that Samson was "helping us to retaliate."

What prompted Kelly to send this email?
U.S.

David Wildstein

Wildstein says "evidence exists" that Christie knew. If so, what is it?
U.S.

... and Renna told Kelly, who later passed it to O'Dowd. He showed it to the governor minutes before his news conference.

Remna disputed Christie's claims that Kelly

Maria Comella
COMMUNICATIONS DIRECTOR

Michael Drewniak
PRESS SEC'Y

Drewniak said

Drewniak, Kelly and Wildstein wrote a statement that the closings were part of a study. **They weren't.**

Drewniak and Wildstein, old friends, had dinner the night before Wildstein resigned. Drewniak wrote Wildstein's resignation announcement; Christie personally added praise of Wildstein. (Christie later said he barely knew him.)

Wildstein directed the closings. He and Baroni ordered bridge officials not to inform Fort Lee.

Access lanes closed for four days; the plan was to close them for a month.

Christina Renna
AIDE

During the closings, Ridley told Renna that Sokolich suspected it was a case of political retaliation …

PORT AUTHORITY ACTIONS:
George Washington Bridge

Staff members by law must respect a boundary between campaign activites and government business.

The work of cultivating mayors for endorsements was done by both political and non-political staff members in 2013 — Mowers, Kelly, Renna and Ridley among them.

Evan Ridley
AIDE

On Sokolich's distress over the traffic jam, Kelly emailed Wildstein: "Is it wrong that I am smiling?"

Did administration staff team with Wolff & Samson to strong-arm the Hoboken mayor?
U.S.

Did Samson steer work to his firm's clients?
U.S.

"Chairman's flight"
Newark to Columbia, S.C., Thursday evenings; returned Monday mornings

Did Samson pressure United to resume this little-used flight?
U.S.

Flight nicknamed for proximity to the Samsons' weekend home.

Wolff & Samson
LAW FIRM

Client of firm →

Atlantic City airport
Port Authority takeover from South Jersey Transportation Authority

Did a Wolff & Samson client benefit?
U.S.

S.J.T.A. was losing millions running the airport.

Richard E. Constable
COMMUNITY AFFAIRS

He replaced Grifa after she left for Samson's law firm.

Lori Grifa
WOLFF LAWYER

Clients awarded contracts on both bridge projects

New Goethals Bridge
Bayonne Bridge redesign

$1.5 billion cost.
D.A. $1.3 billion.
U.S.

Client

Rockefeller Group
DEVELOPER

Bayonne land deal

Did N.J. misuse authority funds to dodge a fiscal blow?

$235 million authority purchase in 2010 avoided a Bayonne bankruptcy and costly state bailout.

Former Christie aide: pressed Zimmer to meet with Rockefeller Group.

Pulaski Skyway repairs
(not a Port Authority property)

More than $1 billion. Redefined as access to the Lincoln Tunnel **(which is several miles away)**, shifting costs to the authority.

Seeking More Votes

The governor's office focused on 100 towns where Christie's 2013 margin of victory could be increased by courting mayors — especially Democrats — and other officials with favors and attention. Gifts included flags and steel from the wreckage of the World Trade Center provided by the authority.

The towns were ranked by electoral potential, 1 being the most promising:

Officials worked with Fulop until he endorsed Christie's opponent. Then they cut off contact.

Did Christie's staff display a pattern of political retribution?
U.S.

Zimmer accused Guadagno and Constable of threatening to withhold storm aid if a Rockefeller project wasn't approved.

Did this violate S.E.C. rules or break laws on bond issues?
S.E.C., D.A.

Baroni negotiated in secret

Steven M. Fulop
MAYOR, JERSEY CITY
RANK **34**

Mark Sokolich
MAYOR, FORT LEE
RANK **47**

DEMOCRATIC MAYORS

Dawn Zimmer
MAYOR, HOBOKEN
RANK **69**

Was Hoboken storm aid denied for political reasons?
U.S.

Sources: New York Times reporting; news reports

THE NEW YORK TIMES

CHRISTIE'S BRIDGEGATE

Political corruption so big it demanded a map of its own.

ARTIST: Bill Marsh, designer, based primarily on reporting by Kate Zernike, Marsh, and other reporters, at the *New York Times*.

STATEMENT: The drip-drip-drip of news—and occasional bombshell—about the George Washington Bridge lane-closing scandal involving New Jersey governor Chris Christie generated a bewilderingly long list of accusations and characters for readers to track. This full-page graphic plotted a diagram of connections encompassing 14 people in the political orbit of Governor Chris Christie; a half-dozen officials at the Port Authority, mostly Christie allies; three aggrieved New Jersey mayors; three investigating agencies; and 13 key questions about who knew what, still unanswered a year and a half after the lanes were blocked.

PUBLICATION: *New York Times* (April 8, 2015)

KEY Christie staff and allies at time of closings and their job status today:

● Fired or ties cut

● Scandal resignation

● Other resignation

● Still in office

Major unanswered questions

Bold text: assertions that contradict Christie or others; corrections of misstatements or claims

Investigations and reported areas of focus:

U.S. United States attorney for New Jersey
S.E.C. Securities and Exchange Commission
D.A. Manhattan district attorney

THE ATLANTIC SLAVE TRADE IN TWO MINUTES

A short animation depicts millions shipped abroad into captivity.

ARTISTS: Andrew Kahn, assistant interactives editor; Jamelle Bouie, chief political correspondent, at *Slate*. Background image by Flickr user Tim Jones.

STATEMENT: This fluid animation of over 20,000 slave ship voyages from Africa to the New World and Europe between the years 1545 and 1860 appeared as part of a series on *Slate* about American slavery. Each dot corresponds to a ship, and the size of a dot represents the number of enslaved people embarked at the port of purchase. The data comes from the Trans-Atlantic Slave Trade Database, a project with roots in academic research from the '70s and '80s.

The animation starts as a dribble of just a few ships and crescendos to a hemorrhagic flow, reaching its peak in the first half of the eighteenth century. A graph on the bottom tracks the total number of enslaved people carried to mainland North America, Brazil, and the Caribbean. Users can pause the animation and click on any ship for more information: its name, the number of enslaved people on board, the total number of enslaved people transported by the vessel over its life cycle. That granularity serves as a reminder that the slave trade was not some vague, involuntary evil, but the sum of thousands upon thousands of intentional, countable acts.

PUBLICATION: *Slate.com* (June 25, 2015)

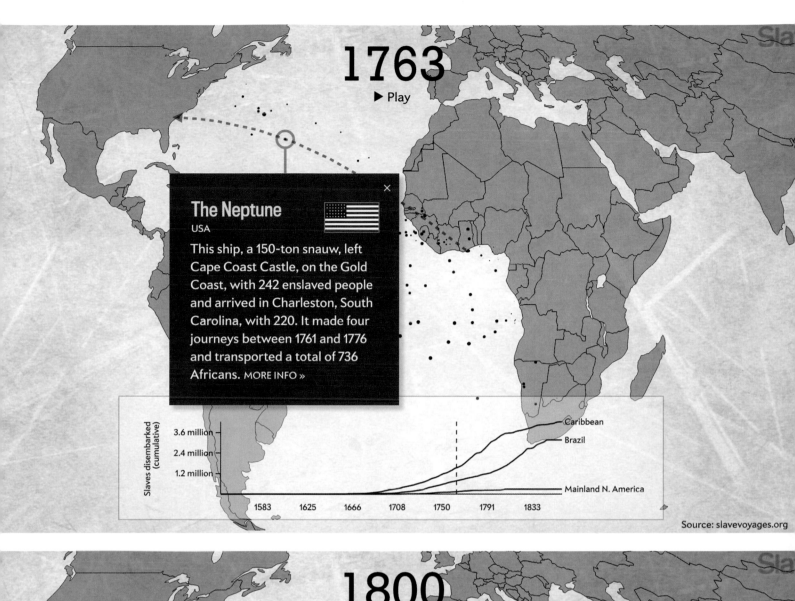

1763

▶ Play

The Neptune

USA

This ship, a 150-ton snauw, left Cape Coast Castle, on the Gold Coast, with 242 enslaved people and arrived in Charleston, South Carolina, with 220. It made four journeys between 1761 and 1776 and transported a total of 736 Africans. MORE INFO »

Slaves disembarked (cumulative)

3.6 million
2.4 million
1.2 million

1583 1625 1666 1708 1750 1791 1833

Caribbean
Brazil
Mainland N. America

Source: slavevoyages.org

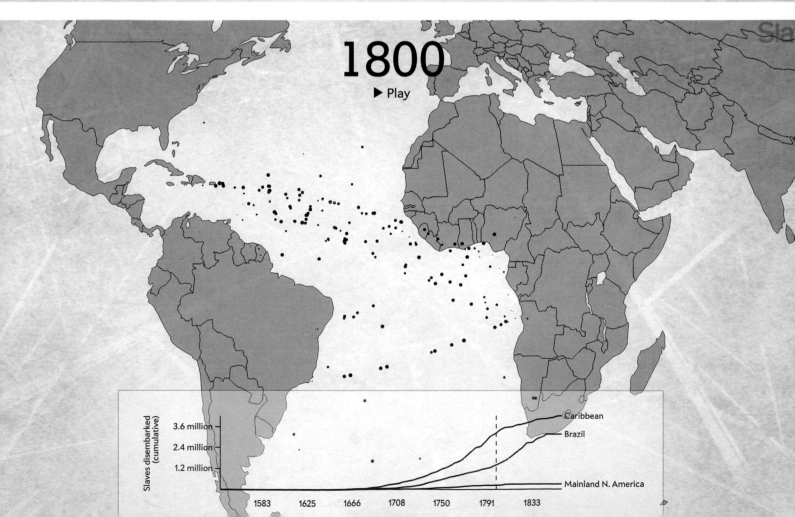

1800

▶ Play

Slaves disembarked (cumulative)

3.6 million
2.4 million
1.2 million

1583 1625 1666 1708 1750 1791 1833

Caribbean
Brazil
Mainland N. America

WHO'S FIGHTING WHOM IN SYRIA

Because it's so complicated that you may need a diagram.

ARTISTS: Derreck Johnson, designer; Joshua Keating, writer; Chris Kirk, interactives editor, at *Slate*.

STATEMENT: The web of friendships and rivalries in the Middle East is notoriously tangled and constantly changing. The Syrian civil war, like other conflicts in the area, can seem maddeningly intricate. With multiple factions vying for control, the war has more in common with *Game of Thrones* than anything in an American history textbook. To help our readers understand it better, we developed a simple interactive chart to explain the relationship between various parties in the conflict. A green face represents friendship; red, enmity; and yellow, "it's complicated." Clicking a face reveals a specific description of the relationship between the corresponding parties.

PUBLICATION: *Slate.com* (October 6, 2015)

Legend: Friends / Enemies / It's complicated

	Syrian Government	Syrian Rebels	ISIS	Jabhat al-Nusra	Kurds	U.S. and Allies	Iraq	Iran and Hezbollah	Russia	Saudi Arabia, Gulf States	Turkey
Syrian Government		Enemies	Enemies	Enemies	Complicated	Enemies	Friends	Friends	Friends	Enemies	Enemies
Syrian Rebels	Enemies		Enemies	Complicated	Complicated	Friends	Enemies	Enemies	Enemies	Friends	Friends
ISIS	Enemies	Enemies		Enemies	Enemies	Enemies	Enemies	Enemies	Enemies	Enemies	Enemies
Jabhat al-Nusra	Enemies	Complicated	Enemies		Enemies	Enemies	Enemies	Enemies	Enemies	Complicated	Complicated
Kurds	Complicated	Complicated	Enemies	Enemies		Friends	Enemies	Friends	Friends	Complicated	Enemies
U.S. and Allies	Enemies	Friends	Enemies	Enemies	Friends		Friends	Complicated	Complicated	Friends	Friends
Iraq	Friends	Enemies	Enemies	Enemies	Enemies	Friends		Friends	Enemies	Complicated	Complicated
Iran and Hezbollah	Friends	Enemies	Enemies	Enemies	Friends	Complicated	Friends		Friends	Enemies	Complicated
Russia	Friends	Enemies	Enemies	Enemies	Friends	Complicated	Friends	Friends		Enemies	Enemies
Saudi Arabia, Gulf States	Enemies	Friends	Enemies	Complicated	Complicated	Friends	Complicated	Enemies	Enemies		Friends
Turkey	Enemies	Friends	Enemies	Complicated	Enemies	Friends	Complicated	Complicated	Enemies	Friends	

HOW BASEBALL EVOLVED

The rise and fall of teams, players, and trends in the sport.

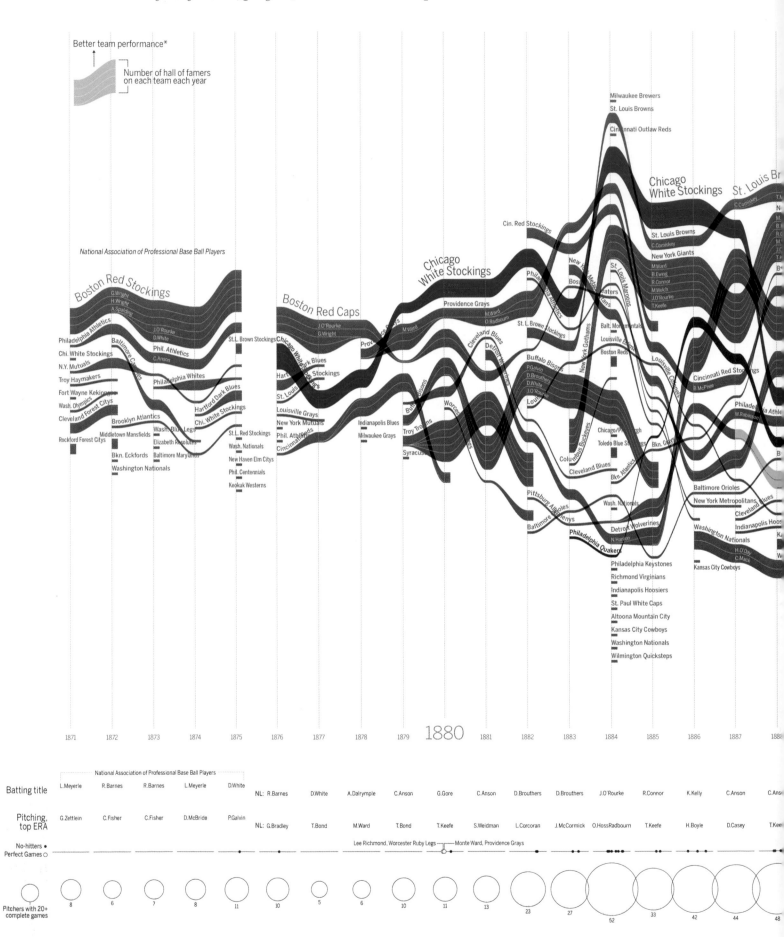

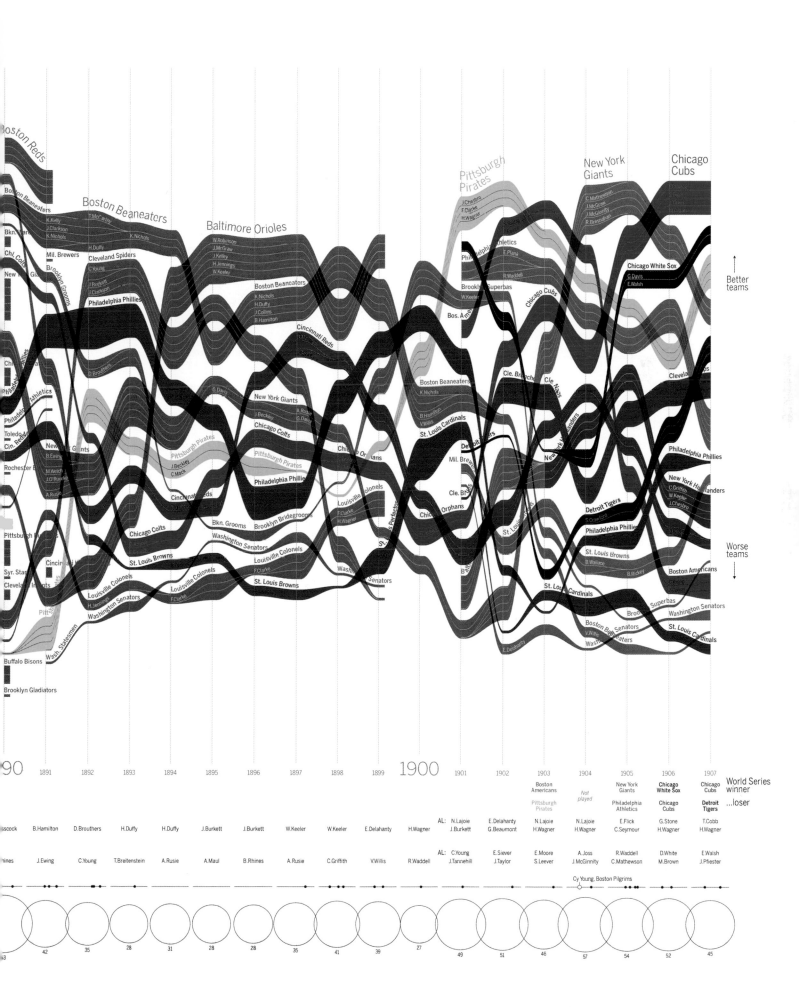

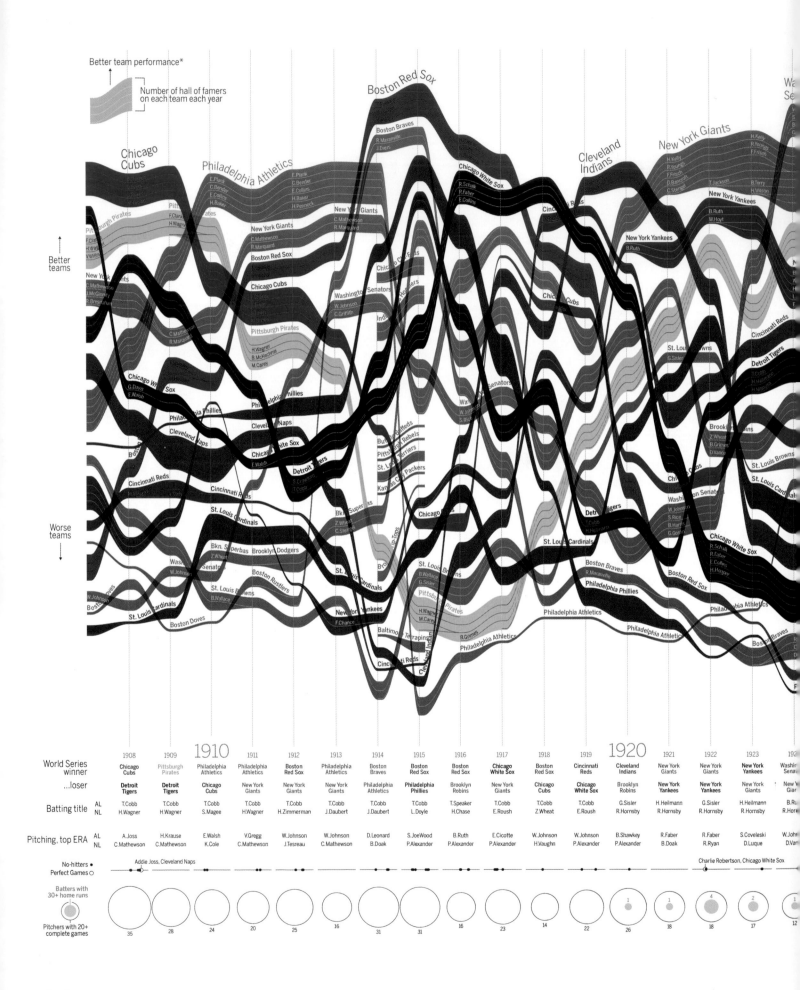

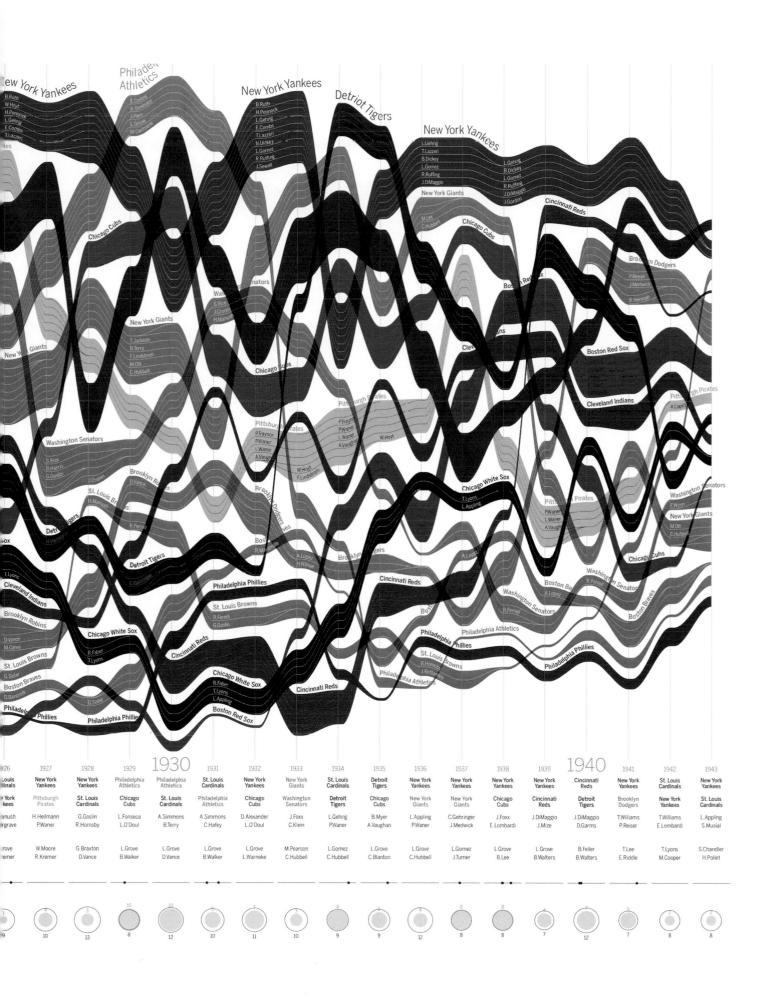

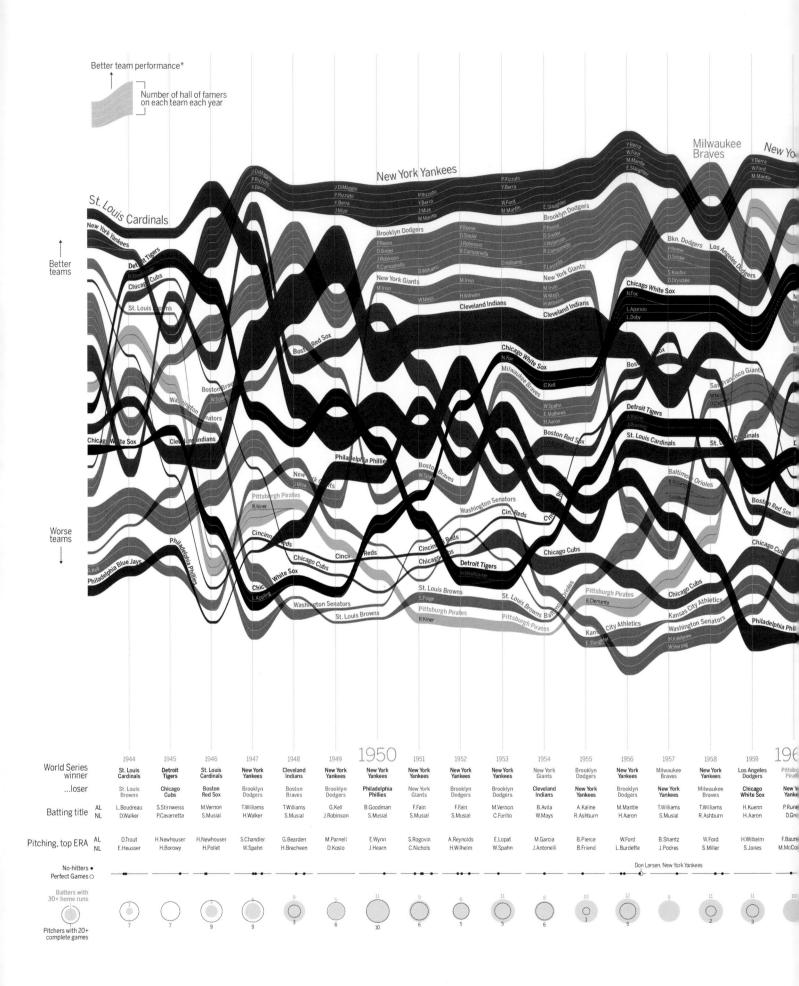

Better team performance*

Number of hall of famers on each team each year

Better teams ↑

Worse teams ↓

		1944	1945	1946	1947	1948	1949	1950	1951	1952	1953	1954	1955	1956	1957	1958	1959	196
World Series winner		St. Louis Cardinals	Detroit Tigers	St. Louis Cardinals	New York Yankees	Cleveland Indians	New York Yankees	New York Yankees	New York Yankees	New York Yankees	New York Yankees	New York Giants	Brooklyn Dodgers	New York Yankees	Milwaukee Braves	New York Yankees	Los Angeles Dodgers	Pittsb Pirat
...loser		St. Louis Browns	Chicago Cubs	Boston Red Sox	Brooklyn Dodgers	Boston Braves	Brooklyn Dodgers	Philadelphia Phillies	New York Giants	Brooklyn Dodgers	Brooklyn Dodgers	Cleveland Indians	New York Yankees	Brooklyn Dodgers	New York Yankees	Milwaukee Braves	Chicago White Sox	New Y Yanke
Batting title	AL	L.Boudreau	S.Stirnweiss	M.Vernon	T.Williams	T.Williams	G.Kell	B.Goodman	F.Fain	F.Fain	M.Vernon	B.Avila	A.Kaline	M.Mantle	T.Williams	T.Williams	H.Kuenn	P.Runne
	NL	D.Walker	P.Cavarretta	S.Musial	H.Walker	S.Musial	J.Robinson	S.Musial	S.Musial	S.Musial	C.Furillo	W.Mays	R.Ashburn	H.Aaron	S.Musial	R.Ashburn	H.Aaron	D.Gro
Pitching, top ERA	AL	D.Trout	H.Newhouser	H.Newhouser	S.Chandler	G.Bearden	M.Parnell	E.Wynn	S.Rogovin	A.Reynolds	E.Lopat	M.Garcia	B.Pierce	W.Ford	B.Shantz	W.Ford	H.Wilhelm	F.Baum
	NL	E.Heusser	H.Borowy	H.Pollet	W.Spahn	H.Brecheen	D.Koslo	J.Hearn	C.Nichols	H.Wilhelm	W.Spahn	J.Antonelli	B.Friend	L.Burdette	J.Podres	S.Miller	S.Jones	M.McCo

No-hitters ●
Perfect Games ○

Don Larsen, New York Yankees

Batters with 30+ home runs

Pitchers with 20+ complete games

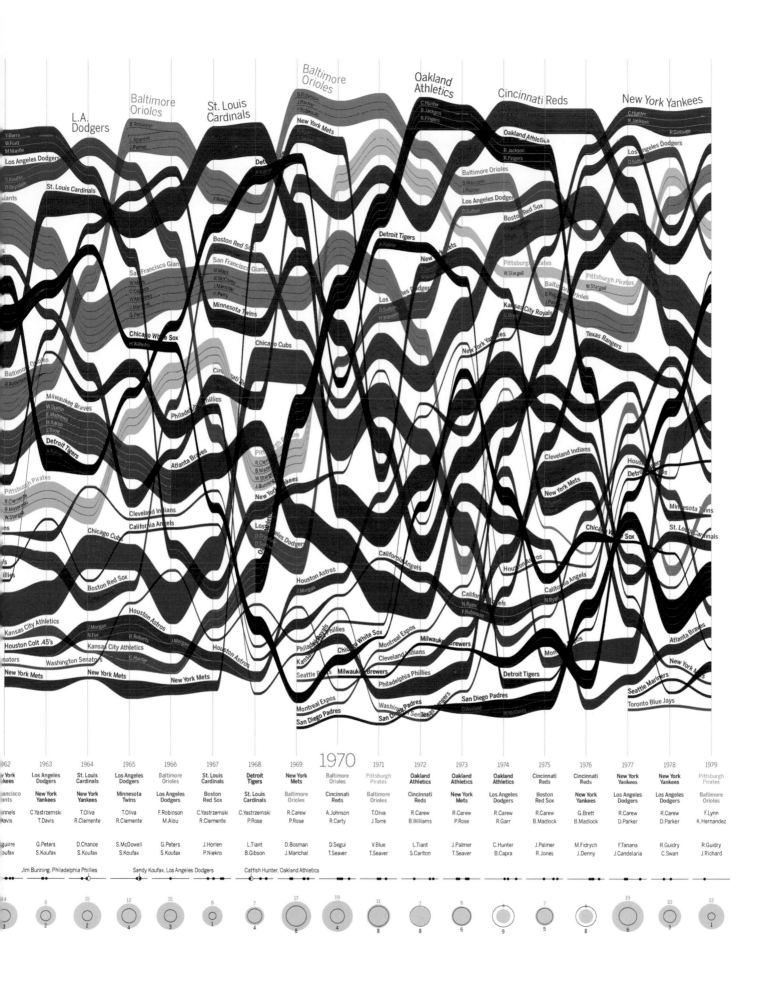

L.A.
Dodgers

Baltimore
Orioles

St. Louis
Cardinals

Baltimore
Orioles

Oakland
Athletics

Cincinnati Reds

New York Yankees

	1962	1963	1964	1965	1966	1967	1968	1969	1970	1971	1972	1973	1974	1975	1976	1977	1978	1979
	New York Yankees	Los Angeles Dodgers	St. Louis Cardinals	Los Angeles Dodgers	Baltimore Orioles	St. Louis Cardinals	Detroit Tigers	New York Mets		Pittsburgh Pirates	Oakland Athletics	Oakland Athletics	Oakland Athletics	Cincinnati Reds	Cincinnati Reds	New York Yankees	New York Yankees	Pittsburgh Pirates
	San Francisco Giants	New York Yankees	New York Yankees	Minnesota Twins	Los Angeles Dodgers	Boston Red Sox	St. Louis Cardinals	Baltimore Orioles		Baltimore Orioles	Cincinnati Reds	New York Mets	Los Angeles Dodgers	Boston Red Sox	New York Yankees	Los Angeles Dodgers	Los Angeles Dodgers	Baltimore Orioles
	C.Yastrzemski	C.Yastrzemski	T.Oliva	T.Oliva	F.Robinson	C.Yastrzemski	C.Yastrzemski	R.Carew	A.Johnson	T.Oliva	R.Carew	R.Carew	R.Carew	R.Carew	G.Brett	R.Carew	R.Carew	F.Lynn
	T.Davis	T.Davis	R.Clemente	R.Clemente	M.Alou	R.Clemente	P.Rose	P.Rose	R.Carty	T.Oliva	B.Williams	P.Rose	R.Garr	B.Madlock	B.Madlock	D.Parker	D.Parker	K.Hernandez
	Aguirre	G.Peters	D.Chance	S.McDowell	G.Peters	J.Horlen	L.Tiant	D.Bosman	D.Segui	V.Blue	L.Tiant	J.Palmer	C.Hunter	J.Palmer	M.Fidrych	F.Tanana	R.Guidry	R.Guidry
	Koufax	S.Koufax	S.Koufax	S.Koufax	S.Koufax	P.Niekro	B.Gibson	J.Marichal	T.Seaver	T.Seaver	S.Carlton	T.Seaver	B.Capra	R.Jones	J.Denny	J.Candelaria	C.Swan	J.Richard

Jim Bunning, Philadelphia Phillies Sandy Koufax, Los Angeles Dodgers Catfish Hunter, Oakland Athletics

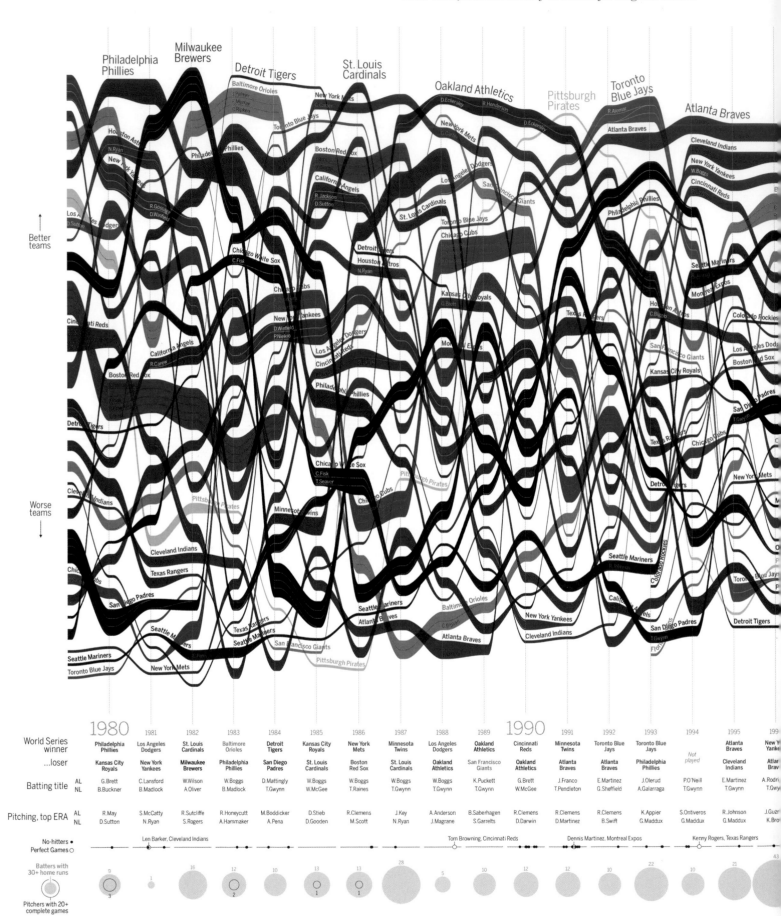

ARTIST: Andrew Garcia Phillips, designer at Chartball.

STATEMENT: This series of four prints, developed for an exhibit at the Baseball Hall of Fame in Cooperstown, New York, shows a history of the major leagues: which

↑ Better teams

↓ Worse teams

		1980	1981	1982	1983	1984	1985	1986	1987	1988	1989	1990	1991	1992	1993	1994	1995	199
World Series winner		Philadelphia Phillies	Los Angeles Dodgers	St. Louis Cardinals	Baltimore Orioles	Detroit Tigers	Kansas City Royals	New York Mets	Minnesota Twins	Los Angeles Dodgers	Oakland Athletics	Cincinnati Reds	Minnesota Twins	Toronto Blue Jays	Toronto Blue Jays	*Not played*	Atlanta Braves	New Yankee
...loser		Kansas City Royals	New York Yankees	Milwaukee Brewers	Philadelphia Phillies	San Diego Padres	St. Louis Cardinals	Boston Red Sox	St. Louis Cardinals	Oakland Athletics	San Francisco Giants	Oakland Athletics	Atlanta Braves	Atlanta Braves	Philadelphia Phillies		Cleveland Indians	Atlan Brav
Batting title	AL	G.Brett	C.Lansford	W.Wilson	W.Boggs	D.Mattingly	W.Boggs	W.Boggs	W.Boggs	W.Boggs	K.Puckett	G.Brett	J.Franco	E.Martinez	J.Olerud	P.O'Neill	E.Martinez	A.Rodri
	NL	B.Buckner	B.Madlock	A.Oliver	B.Madlock	T.Gwynn	W.McGee	T.Raines	T.Gwynn	T.Gwynn	T.Gwynn	W.McGee	T.Pendleton	G.Sheffield	A.Galarraga	T.Gwynn	T.Gwynn	T.Gwy
Pitching, top ERA	AL	R.May	S.McCatty	R.Sutcliffe	R.Honeycutt	M.Boddicker	D.Stieb	R.Clemens	J.Key	A.Anderson	B.Saberhagen	R.Clemens	R.Clemens	R.Clemens	K.Appier	S.Ontiveros	R.Johnson	J.Guzm
	NL	D.Sutton	N.Ryan	S.Rogers	A.Hammaker	A.Pena	D.Gooden	M.Scott	N.Ryan	J.Magrane	S.Garrelts	D.Darwin	D.Martinez	B.Swift	G.Maddux	G.Maddux	G.Maddux	K.Bro
No-hitters ● Perfect Games ○			Len Barker, Cleveland Indians							Tom Browning, Cincinnati Reds			Dennis Martinez, Montreal Expos			Kenny Rogers, Texas Rangers		

Batters with 30+ home runs

Pitchers with 20+ complete games

teams rose and fell over more than a century of baseball and which Hall of Fame players contributed to those teams. The series also shows macro trends in the sport, such as the slow shift from dominant pitchers to dominant hitters and the changes in team structure created by player free agency.

PUBLICATION: *chartball.com* (March 2015)

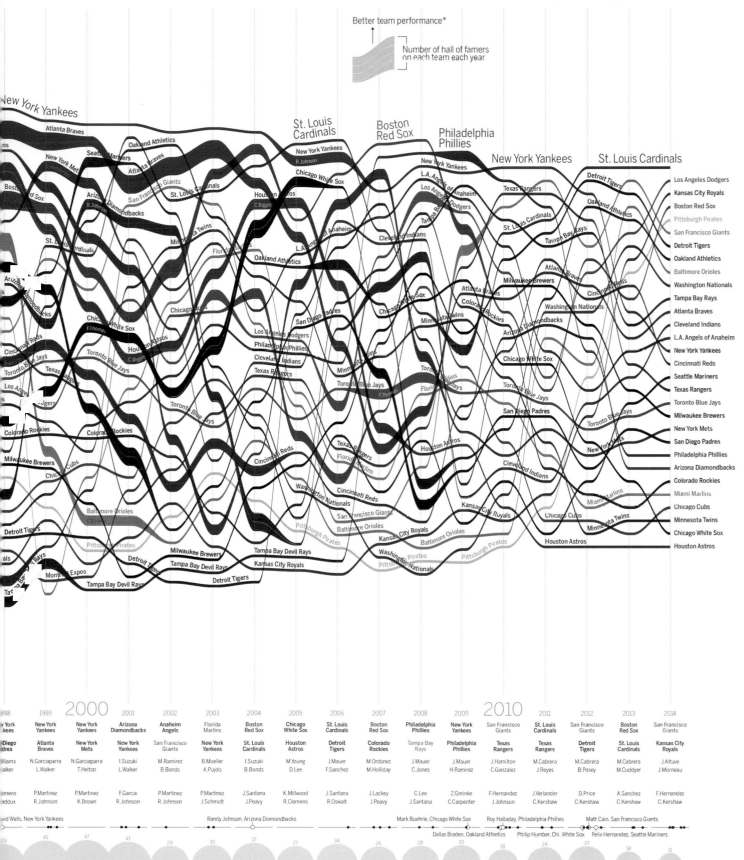

WHERE THEY SAW MARY

A historical and geographical map of miraculous sightings.

ARTISTS: Virginia W. Mason, senior graphics editor; Michael O'Neill, miraclehunter.com; Eve Conant, text; Victoria Sgarro, research, for *National Geographic*.

STATEMENT: In the mid-sixteenth century, the Roman Catholic Church's Council of Trent created an approval and vetting process for visions that may be considered miracles. This map, which accompanied a feature story on the Virgin Mary, shows the sightings of Mary since the Council.

PUBLICATION: *National Geographic* (December 2015)

SUPERNATURAL

The local bishop or the Vatican finds evidence of the supernatural (the occurrence of a miracle).

- Recognized by the Vatican after approval by local bishop
- Approved by local bishop
- ✝ Virgin Mary's appearance to future saint

EXPRESSION OF FAITH

- Visions are approved as worthy of faith expression but are not established as supernatural.

LOCAL TRADITION

- Visions are part of local traditions and saint biographies but are not formally investigated.
- ✝ Virgin Mary's appearance to future saint

UNCONFIRMED

- Apparitions are not supernatural, have not yet been investigated, or are under investigation.

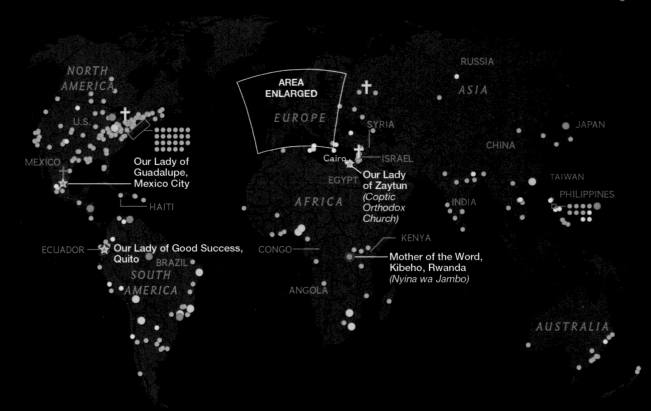

Centuries of Miracles

COUNCIL OF TRENT
One of the most important ecumenical councils in Roman Catholic Church history, it defined doctrine and an approval process for visions.

Each vertical segment represents the date of an apparition's first sighting.

| Recognized by the Vatican after approval by local bishop
| Approved by local bishop

| Expression of faith | Local tradition
| Unconfirmed

Our Lady of Guadalupe formally investigated, with positive verdict, in 1666

Council of Trent 1545-1563

Our Lady of Leżajsk

Our Lady of Šiluva

Our Lady of Happy Meetings

1531 1550 1600 1650 1700 1750

163 YEARS OF ATLANTIC HURRICANES

A map of storms that couldn't care less about your state lines.

ARTISTS: Valerio Pellegrini, artist; Raul Aguila, art director; Grace Dobush, writer; Sarah Fallon, editor.

STATEMENT: In this illustration of hurricanes in the Atlantic Basin since 1851, the challenge was to display 163 years of storm history on a single spread. A crucial first step was to define the background so the lines stood out properly. The artist omitted state names and used thin, bright borders between the states to highlight how this impressive natural phenomenon ignores these distinctions. For the hurricane paths, he experimented to determine the right color, thickness of the lines, and relationship between them. The result makes the power of this force of nature overwhelmingly clear.

PUBLICATION: *WIRED* (August 2015)

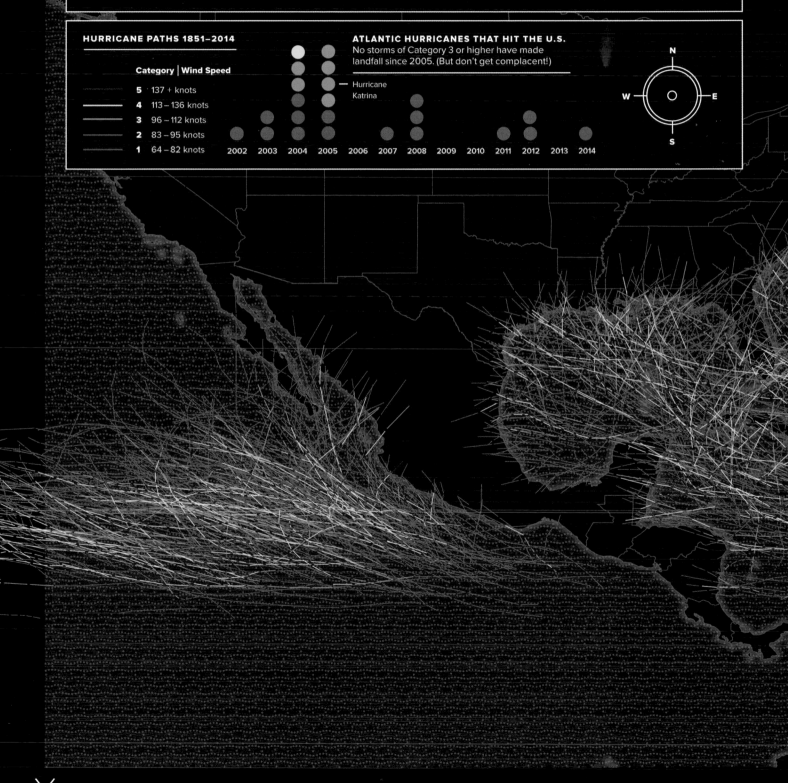

HURRICANE PATHS 1851–2014

Category	Wind Speed
5	137 + knots
4	113 – 136 knots
3	96 – 112 knots
2	83 – 95 knots
1	64 – 82 knots

ATLANTIC HURRICANES THAT HIT THE U.S.
No storms of Category 3 or higher have made landfall since 2005. (But don't get complacent!)

— Hurricane Katrina

2002 2003 2004 2005 2006 2007 2008 2009 2010 2011 2012 2013 2014

N
W ○ E
S

RIAL
RLD

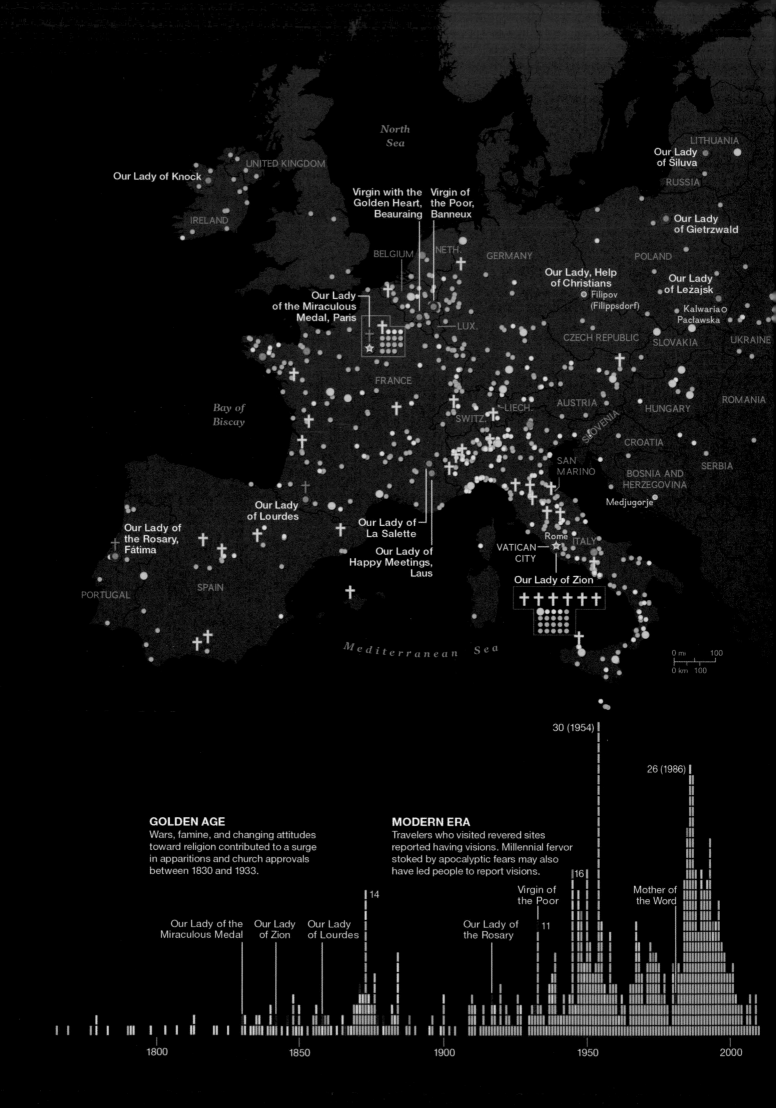

North
Sea

LITHUANIA
**Our Lady
of Šiluva**

UNITED KINGDOM

RUSSIA

IRELAND

Our Lady of Knock

**Virgin with the
Golden Heart,
Beauraing**

**Virgin of
the Poor,
Banneux**

**Our Lady
of Gietrzwald**

BELGIUM NETH.

GERMANY

POLAND

**Our Lady, Help
of Christians**

○ Filipov
(Filippsdorf)

**Our Lady
of Leżajsk**

**Our Lady
of the Miraculous
Medal, Paris**

LUX.

CZECH REPUBLIC

Kalwaria○
Pacławska

SLOVAKIA

UKRAINE

FRANCE

AUSTRIA

HUNGARY

ROMANIA

SWITZ. LIECH.

SLOVENIA

CROATIA

Bay of
Biscay

SAN
MARINO

SERBIA

BOSNIA AND
HERZEGOVINA

**Our Lady
of Lourdes**

Medjugorje

**Our Lady of
La Salette**

Rome
☆

ITALY

VATICAN
CITY

**Our Lady of
the Rosary,
Fátima**

**Our Lady of
Happy Meetings,
Laus**

Our Lady of Zion

† † † † † †
● ● ● ● ●
● ● ● ● ●
● ● ● ●

PORTUGAL SPAIN

M e d i t e r r a n e a n S e a

0 mi 100

0 km 100

30 (1954)

26 (1986)

GOLDEN AGE
Wars, famine, and changing attitudes
toward religion contributed to a surge
in apparitions and church approvals
between 1830 and 1933.

MODERN ERA
Travelers who visited revered sites
reported having visions. Millennial fervor
stoked by apocalyptic fears may also
have led people to report visions.

16

14

Virgin of
the Poor

Mother of
the Word

Our Lady of the
Miraculous Medal

Our Lady
of Zion

Our Lady
of Lourdes

Our Lady of
the Rosary

11

1800 1850 1900 1950 2000

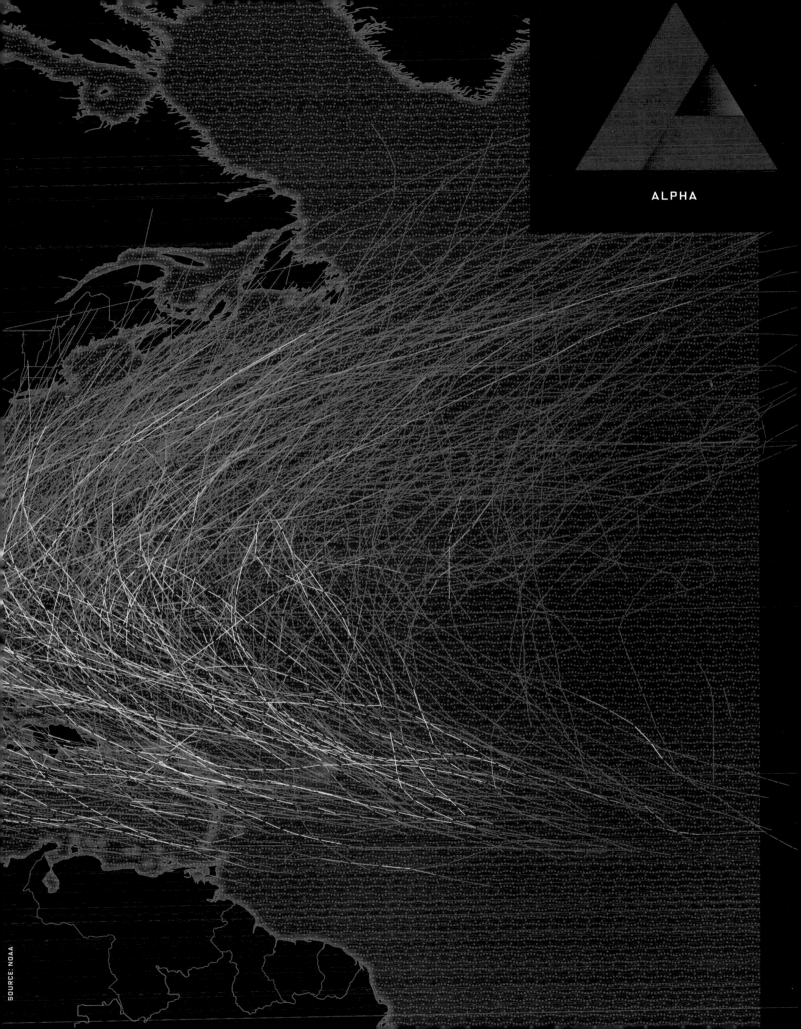

ALPHA

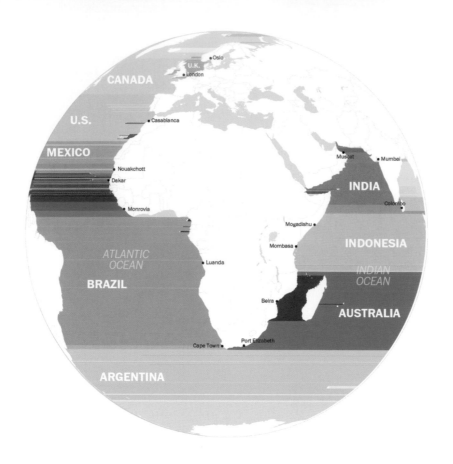

WHAT COUNTRY IS BEYOND THE HORIZON?

A key for ocean gazers.

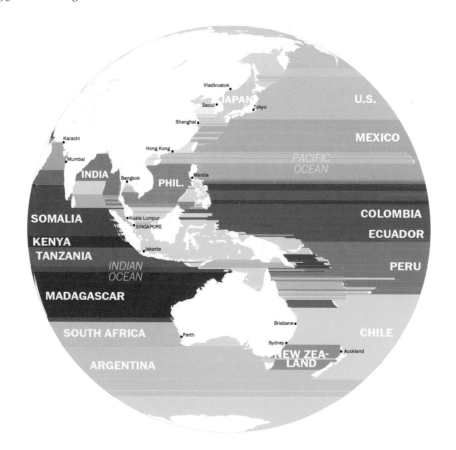

Legend by continent
- Africa
- Asia
- Europe
- North America
- Oceania
- South America

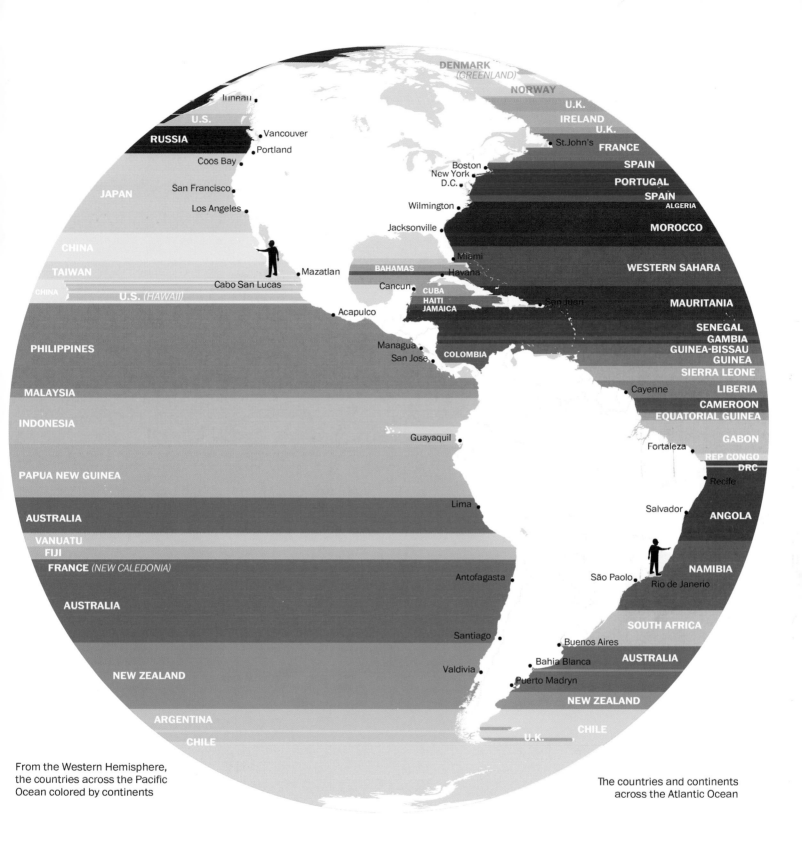

From the Western Hemisphere,
the countries across the Pacific
Ocean colored by continents

The countries and continents
across the Atlantic Ocean

ARTISTS: Weiyi Cai, designer; Laris Karklis, cartographer;
Ana Swanson, writer, at the *Washington Post*.

STATEMENT: Have you ever stood at the beach, gazed
toward the horizon, and wondered what's across the ocean?
Inspired by a map that considered this question for the east
and west coasts of the United States, we wanted to expand
the concept to the entire world. After experimenting with
various map projections, we decided to create three main
maps: for North and South America, Europe and Africa, and
Asia. We gave each continent a color theme, with different
tints designating various countries. The final presentation
included seven maps and close to 100 colors.

PUBLICATION: *Washington Post* (August 3, 2015)

HOW TO HACK SCIENCE

Want publishable results? Tweak the parameters till you get the answer you like.

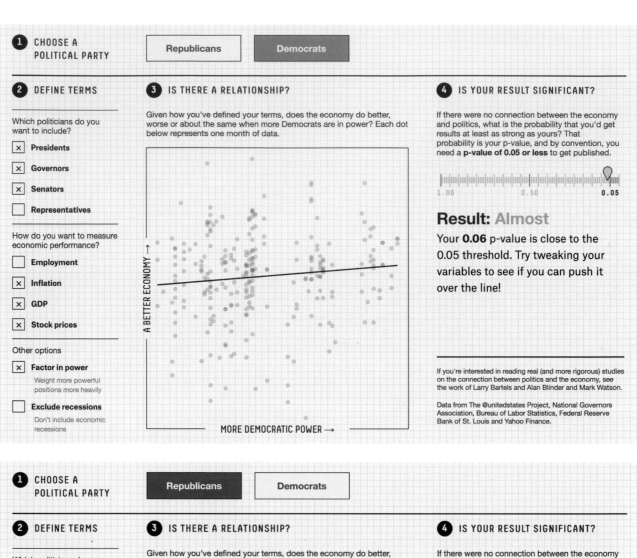

1 CHOOSE A POLITICAL PARTY

Republicans | **Democrats**

2 DEFINE TERMS

Which politicians do you want to include?

- [×] Presidents
- [×] Governors
- [×] Senators
- [] Representatives

How do you want to measure economic performance?

- [] Employment
- [×] Inflation
- [×] GDP
- [×] Stock prices

Other options

- [×] **Factor in power**
 Weight more powerful positions more heavily
- [] **Exclude recessions**
 Don't include economic recessions

3 IS THERE A RELATIONSHIP?

Given how you've defined your terms, does the economy do better, worse or about the same when more Democrats are in power? Each dot below represents one month of data.

↑ A BETTER ECONOMY

MORE DEMOCRATIC POWER →

4 IS YOUR RESULT SIGNIFICANT?

If there were no connection between the economy and politics, what is the probability that you'd get results at least as strong as yours? That probability is your p-value, and by convention, you need a **p-value of 0.05 or less** to get published.

1.00 0.50 **0.05**

Result: Almost

Your **0.06** p-value is close to the 0.05 threshold. Try tweaking your variables to see if you can push it over the line!

If you're interested in reading real (and more rigorous) studies on the connection between politics and the economy, see the work of Larry Bartels and Alan Blinder and Mark Watson.

Data from The @unitedstates Project, National Governors Association, Bureau of Labor Statistics, Federal Reserve Bank of St. Louis and Yahoo Finance.

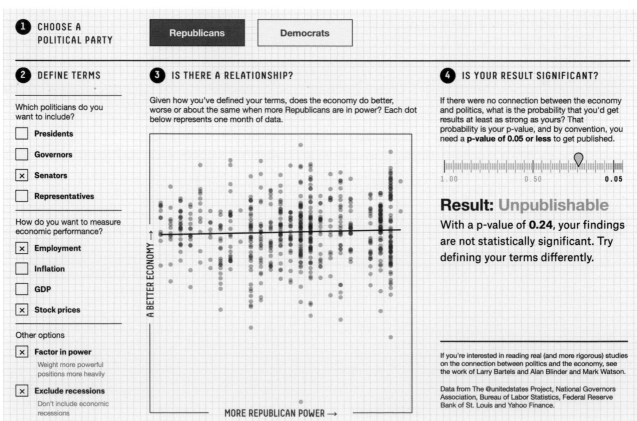

1 CHOOSE A POLITICAL PARTY

Republicans | Democrats

2 DEFINE TERMS

Which politicians do you want to include?

- [] Presidents
- [] Governors
- [×] Senators
- [] Representatives

How do you want to measure economic performance?

- [×] Employment
- [] Inflation
- [] GDP
- [×] Stock prices

Other options

- [×] **Factor in power**
 Weight more powerful positions more heavily
- [×] **Exclude recessions**
 Don't include economic recessions

3 IS THERE A RELATIONSHIP?

Given how you've defined your terms, does the economy do better, worse or about the same when more Republicans are in power? Each dot below represents one month of data.

↑ A BETTER ECONOMY

MORE REPUBLICAN POWER →

4 IS YOUR RESULT SIGNIFICANT?

If there were no connection between the economy and politics, what is the probability that you'd get results at least as strong as yours? That probability is your p-value, and by convention, you need a **p-value of 0.05 or less** to get published.

1.00 0.50 **0.05**

Result: Unpublishable

With a p-value of **0.24**, your findings are not statistically significant. Try defining your terms differently.

If you're interested in reading real (and more rigorous) studies on the connection between politics and the economy, see the work of Larry Bartels and Alan Blinder and Mark Watson.

Data from The @unitedstates Project, National Governors Association, Bureau of Labor Statistics, Federal Reserve Bank of St. Louis and Yahoo Finance.

ARTISTS: Ritchie King, senior visual journalist, art and text; Christie Aschwanden, lead writer for science, concept, at *FiveThirtyEight*.

STATEMENT: Using this interactive graphic, you can show both that Republicans are better for the economy and that Democrats are better for the economy. The point is to illustrate how easy it is for a scientist, especially a social scientist, to tweak the parameters of an experiment until she gets a statistically significant finding—a practice known as "p-hacking."

PUBLICATION: *FiveThirtyEight* (August 19, 2015)

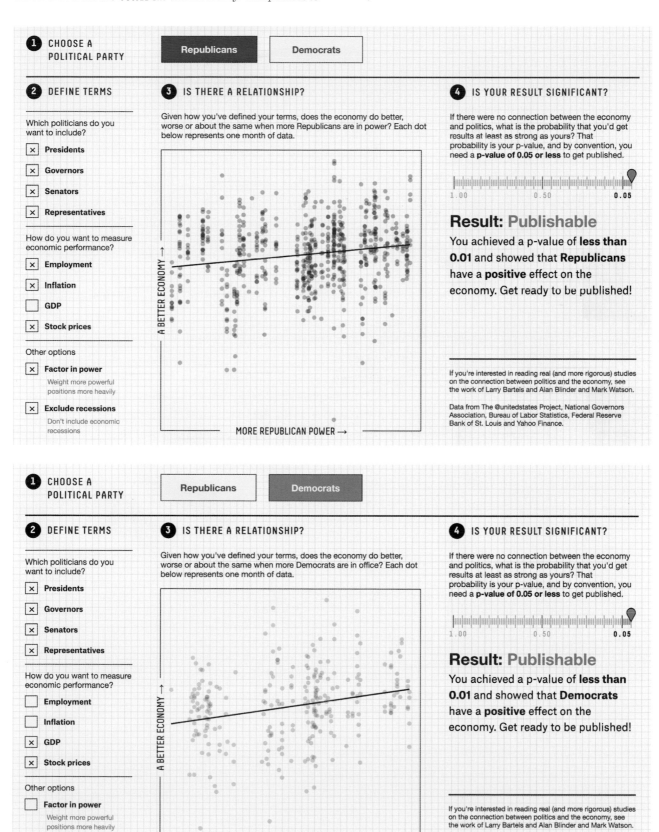

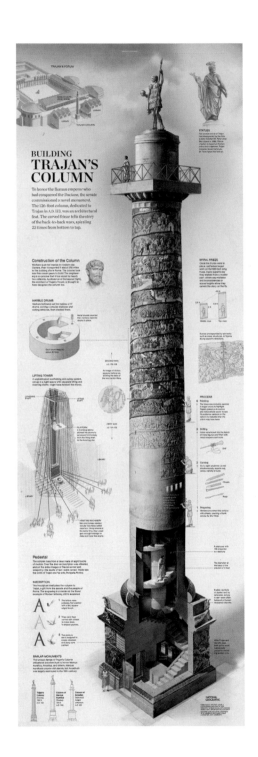

TRAJAN'S COLUMN

A Roman emperor's 126-foot commemoration.

ARTISTS: Fernando G. Baptista, senior graphics editor, main illustration and design; Daniela Santamarina and Emily Eng, graphic design specialists, secondary diagrams; Jeremy Berlin, staff writer, text, all at *National Geographic*. Samantha Welker, secondary diagrams; Amanda Hobbs, research; Kenneth Garrett, photography.

STATEMENT: Dedicated to the emperor Trajan in A.D. 113, this 126-foot Roman column commemorates the emperor's victory in Rome's wars against the Dacians. One graphic explains the likely construction method, including current theories about how the marble drums were hoisted, stacked, and carved. Another graphic shows the intricate frieze spiraling up the column, depicting thousands of individual figures involved in the two military campaigns against the Dacians. Included is a guide for "reading" or interpreting the column, offering a breakdown of the 155 scenes and pointing out Roman and Dacian forces in key panels of the frieze.

PUBLICATION: *National Geographic* (April 2015)

of the back-to-back wars, spiraling 23 times from bottom to top.

Construction of the Column

Workers quarried marble in modern-day Carrara, then transported it about 250 miles to the building site in Rome. The column took less than seven years to build. The engineering is so precise that it has stood for nearly two millennia. Apollodorus of Damascus (right), the architect of Trajan's Forum, is thought to have designed the column too.

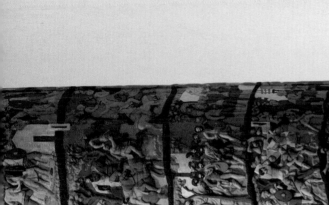

MARBLE DRUMS

Workers hollowed out the insides of 17 drums, carving a circular staircase and cutting windows, then stacked them.

Metal dowels inserted into mortises held the drums in place.

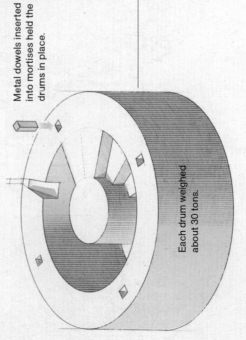

Each drum weighed about 30 tons.

LIFTING TOWER

A sophisticated scaffolding and pulley system, set up in a tight space with separate lifting and

SECOND WAR
A.D. 105-106

An image of Victory appears halfway up, dividing the tales of the two Dacian Wars.

SPIRAL FRIEZE

Once the drums were in place, craftsmen began work on the 656-foot-long frieze. Some experts say they worked from a master plan; others say mistakes and inconsistencies in scene heights show they carved the story on the fly.

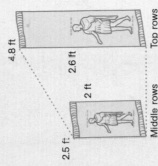

4.8 ft
2.6 ft
Top rows

2.5 ft
2 ft
Middle rows

Scenes are separated by elements such as trees, structures, or figures facing opposite directions.

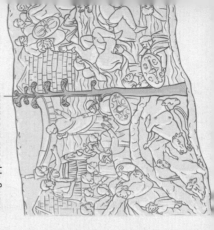

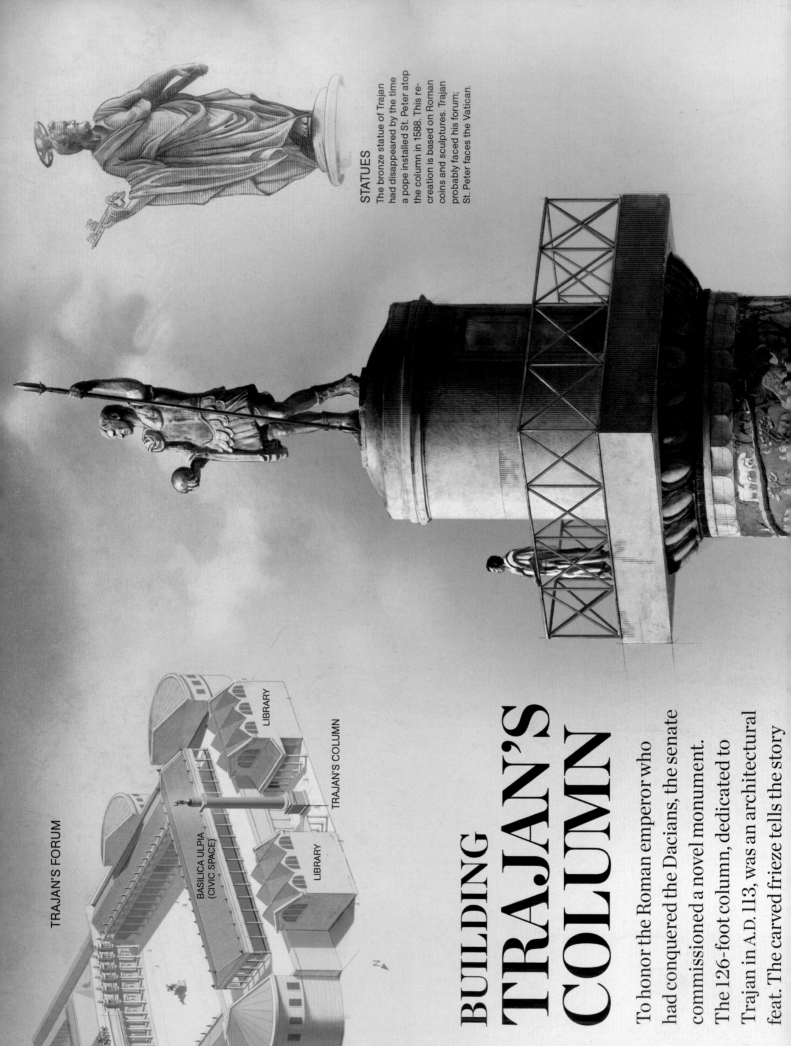

STATUES

The bronze statue of Trajan had disappeared by the time a pope installed St. Peter atop the column in 1588. This re-creation is based on Roman coins and sculptures. Trajan probably faced his forum; St. Peter faces the Vatican.

TRAJAN'S FORUM

LIBRARY

BASILICA ULPIA (CIVIC SPACE)

LIBRARY

TRAJAN'S COLUMN

N

BUILDING TRAJAN'S COLUMN

To honor the Roman emperor who had conquered the Dacians, the senate commissioned a novel monument. The 126-foot column, dedicated to Trajan in A.D. 113, was an architectural feat. The carved frieze tells the story

Pedestal

The column rises from a base made of eight blocks of marble. Over the door an inscription was chiseled, and on the sides images of Dacian armor and weaponry—the spoils of war—were carved. Inside was the tomb of Trajan and his wife, Pompeia Plotina.

The diameter at the base of the column is 12 feet.

Eagles—symbols of Jupiter and, by extension, victory in war—were often featured in Roman triumphal artworks.

After Trajan and his wife died, their ashes were purportedly placed in matching golden urns.

Funerary chamber

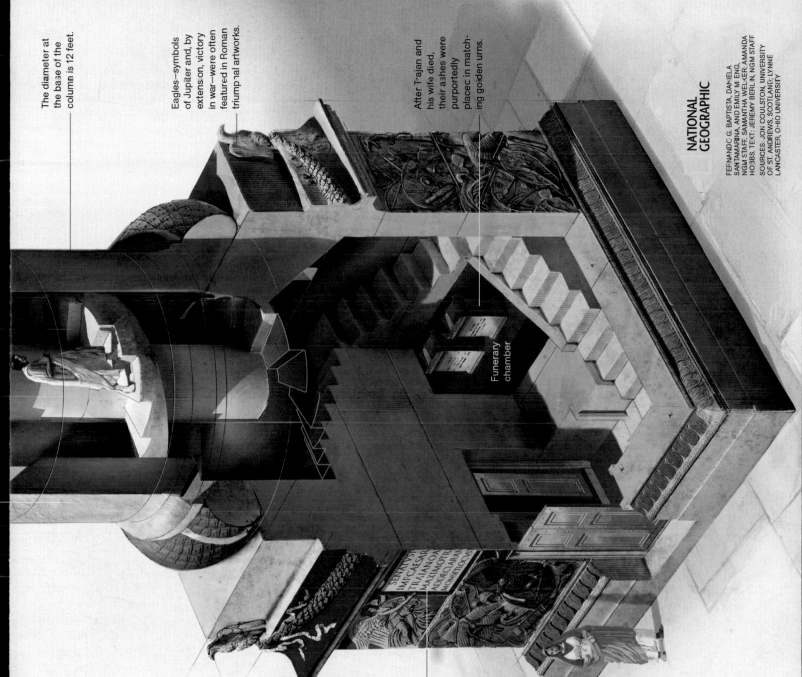

INSCRIPTION

The inscription dedicates the column to Trajan, a gift from the senate and the people of Rome. The engraving is considered the finest example of Roman lettering still in existence.

1 The letters were probably first painted with a flat, square-edged brush.

2 They were then carved with chisels to make deep, V-shaped grooves.

3 The grooves were designed to create shadows and likely were painted.

SIMILAR MONUMENTS

The unique design of Trajan's Column influenced columns built to honor Marcus Aurelius, Arcadius, and others. Marcus Aurelius's column still stands, but Arcadius's was largely destroyed in the 18th century.

Trajan's Column
(Rome)
126 ft
A.D. 113

Column of Marcus Aurelius
(Rome)
151 ft
A.D. 193

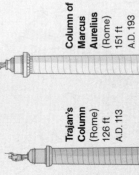

Column of Arcadius
(Istanbul)
height unknown
A.D. 421

NATIONAL GEOGRAPHIC

FERNANDO G. BAPTISTA, DANIELA SANTAMARINA, AND EMILY M. ENG, NGM STAFF. SAMANTHA WELKER, AMANDA HOBBS. TEXT: JEREMY BERLIN, NGM STAFF

SOURCES: JON COULSTON, UNIVERSITY OF ST. ANDREWS, SCOTLAND; LYNNE LANCASTER, OHIO UNIVERSITY

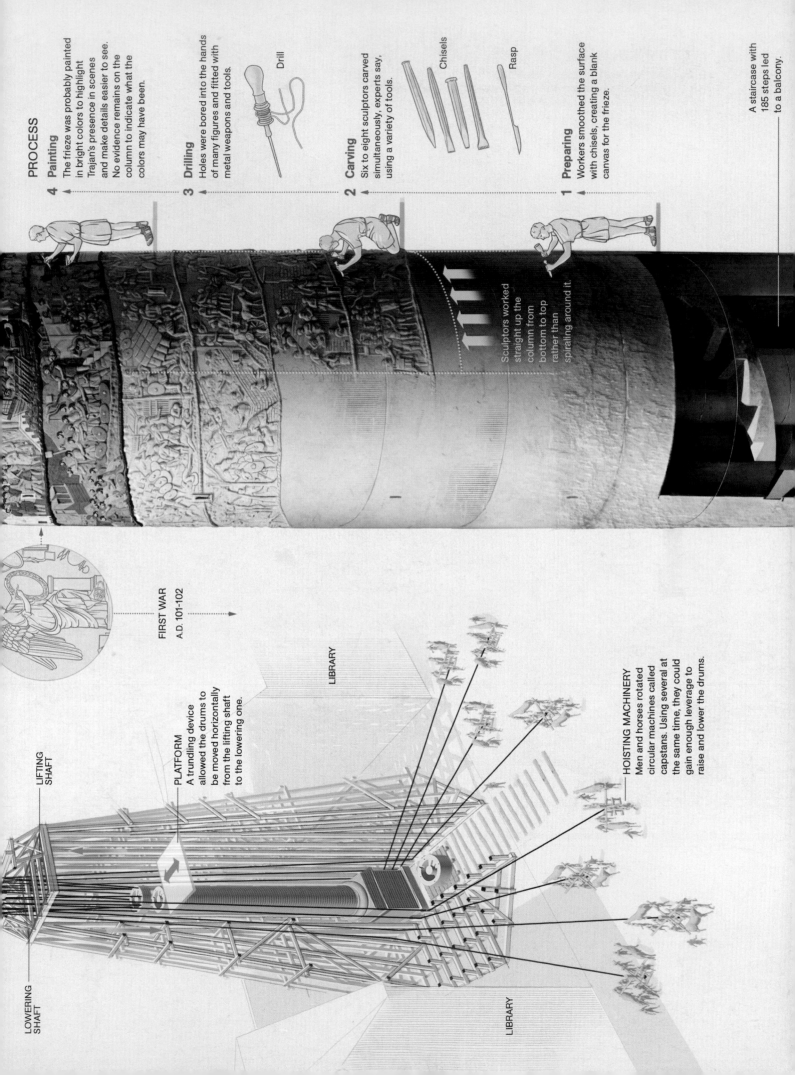

PROCESS

4 Painting
The frieze was probably painted in bright colors to highlight Trajan's presence in scenes and make details easier to see. No evidence remains on the column to indicate what the colors may have been.

3 Drilling
Holes were bored into the hands of many figures and fitted with metal weapons and tools.

Drill

2 Carving
Six to eight sculptors carved simultaneously, experts say, using a variety of tools.

Chisels

Rasp

1 Preparing
Workers smoothed the surface with chisels, creating a blank canvas for the frieze.

A staircase with 185 steps led to a balcony.

Sculptors worked straight up the column from bottom to top rather than spiraling around it.

FIRST WAR
A.D. 101–102

LOWERING SHAFT

LIFTING SHAFT

PLATFORM
A trundling device allowed the drums to be moved horizontally from the lifting shaft to the lowering one.

LIBRARY

LIBRARY

HOISTING MACHINERY
Men and horses rotated circular machines called capstans. Using several at the same time, they could gain enough leverage to raise and lower the drums.

THE ESSENCE OF A WESTERN

What you learn when you merge all of a movie's frames into one.

ARTIST: Kevin L. Ferguson, assistant professor, Queens College, City University of New York.

STATEMENT: My work at the intersection of digital humanities and media studies is inspired by the surrealists' interest in using automatic processes to generate new "irrational" knowledge. These images are each the "sum" of one film drawn from a corpus of 54 western films produced between 1939 and 2007. Using scientific image analysis software (ImageJ, created by Wayne Rasband at the US National Institutes of Health), I sampled one frame from every tenth second of the film, then added these together to create a new image.

These visualizations are a way to see what is in plain sight but also literally impossible to see without computer-assisted techniques. For example, with *The Assassination of Jesse James by the Coward Robert Ford,* we can see the vague impression of a face (with dark hair) in the center, showing that film's preference for centered close-ups. Compare this to *The Searchers,* whose composite image quite clearly shows the Monument Valley location where it was filmed.

PUBLICATION: *theouttake.net* (April 1, 2015)

Heaven's Gate (1980)

The Good, the Bad and the Ugly (1966)

The Assassination of Jesse James by the Coward Robert Ford (2007)

The Searchers (1956)

WHAT'S REALLY WARMING THE WORLD?

One way to rule things out.

ARTISTS: Eric Roston, journalist and reporter; Blacki Migliozzi, developer and data journalist, at *Bloomberg*.

STATEMENT: Some people still dismiss evidence that human activity drives global warming, embracing other explanations instead: It's the sun, for example, or volcanoes are adding more CO2. The climate always shifts with Earth's

Is It Volcanoes?

The data suggest no. Human industry emits about 100 times more CO_2 than volcanic activity, and eruptions release sulfate chemicals that can actually cool the atmosphere for a year or two.

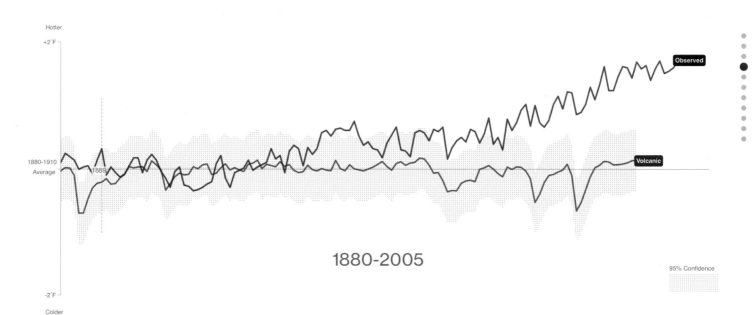

Hotter

+2˚F

1880-1910 Average

1889

1880-2005

Observed

Volcanic

95% Confidence

-2˚F

Colder

Is It the Earth's Orbit?

The Earth wobbles on its axis, and its tilt and orbit change over many thousands of years, pushing the climate into and out of ice ages. Yet the influence of orbital changes on the planet's temperature over 125 years has been negligible.

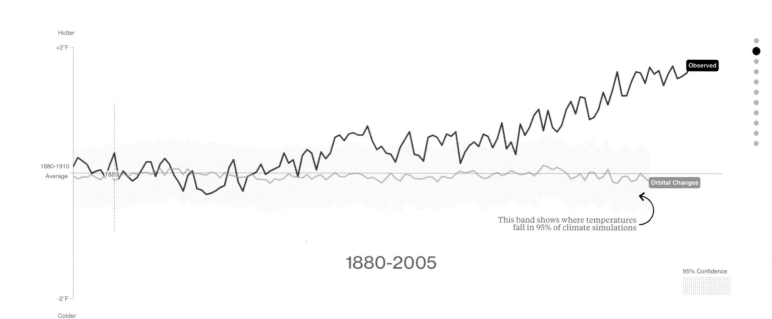

Hotter

+2˚F

1880-1910 Average

1889

1880-2005

Observed

Orbital Changes

This band shows where temperatures fall in 95% of climate simulations

95% Confidence

-2˚F

Colder

orbit. Unfortunately, these are incorrect, which we showed using data and model results from NASA's Goddard Institute for Space Studies. Our graphic uses NASA's ModelE2, a mathematical model of Earth's climate, to juxtapose various natural and manmade climate-change suspects with Earth's observed temperature record. These comparisons leave little doubt about the identity of the culprit: us.

PUBLICATION: *Bloomberg* (June 24, 2015)

No, It Really Is Greenhouse Gases.

Atmospheric CO_2 levels are 40 percent higher than they were in 1750. The green line shows the influence of greenhouse gas emissions. It's no contest.

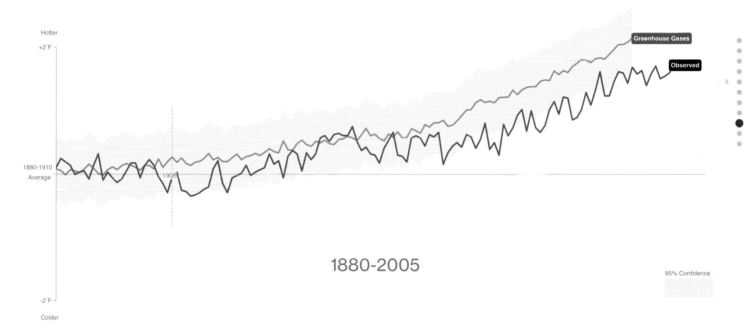

Compare and Contrast

Putting the possible natural and human causes of climate change alongside one another makes the dominant role of greenhouse gases even more plainly visible. The only real question is: What are we going to do about it?

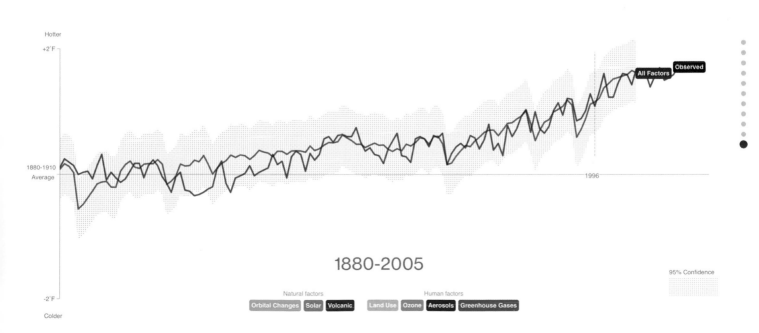

INSIDE THE DOLPHIN BRAIN

Big, sophisticated, and only sort of like the human one.

ARTISTS: Fernando G. Baptista, senior
graphics editor, main illustration and design;
Shizuka Aoki, freelance illustrator, illustra-
tions; Daniela Santamarina, graphic design
specialist, diagrams: Mesa Schumacher, free-
lance researcher; Rachel Hartigan Shea, text, at
National Geographic.

STATEMENT: Humans and dolphins have
evolved different physical forms in adapting to
two different environments, but both have large,
complicated brains. This graphic explains the
anatomy of human and dolphin brains and how
they process information in different ways. Also
explained is dolphin echolocation, a unique sen-
sory system that allows them to form mental
images of distant objects via reflected sound,
and some of dolphins' complex and variable
forms of social and hunting behavior.

PUBLICATION: *National Geographic* (May 2015)

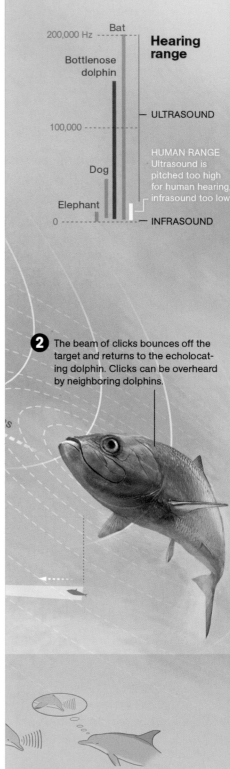

Sound

...ory system to detect
...echoes created by
...nes as fast in the

200,000 Hz — Bat

Bottlenose
dolphin

**Hearing
range**

— ULTRASOUND

100,000

Dog

HUMAN RANGE
Ultrasound is
pitched too high
for human hearing,
infrasound too low.

Elephant

0 — INFRASOUND

2 The beam of clicks bounces off the
target and returns to the echolocat-
ing dolphin. Clicks can be overheard
by neighboring dolphins.

...each other
...ize the signature whistles of
...aps even if the animals haven't
...ther for as long as 20 years.

RACICOT,

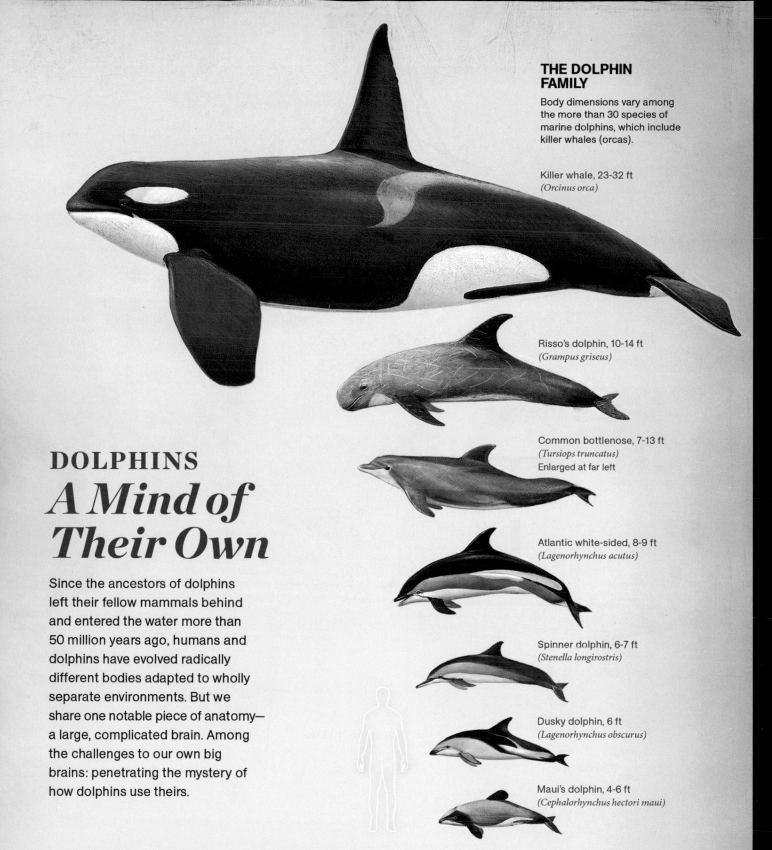

Body dimensions vary among
the more than 30 species of
marine dolphins, which include
killer whales (orcas).

Killer whale, 23-32 ft
(Orcinus orca)

Risso's dolphin, 10-14 ft
(Grampus griseus)

Common bottlenose, 7-13 ft
(Tursiops truncatus)
Enlarged at far left

Atlantic white-sided, 8-9 ft
(Lagenorhynchus acutus)

Spinner dolphin, 6-7 ft
(Stenella longirostris)

Dusky dolphin, 6 ft
(Lagenorhynchus obscurus)

Maui's dolphin, 4-6 ft
(Cephalorhynchus hectori maui)

DOLPHINS
A Mind of Their Own

Since the ancestors of dolphins
left their fellow mammals behind
and entered the water more than
50 million years ago, humans and
dolphins have evolved radically
different bodies adapted to wholly
separate environments. But we
share one notable piece of anatomy—
a large, complicated brain. Among
the challenges to our own big
brains: penetrating the mystery of
how dolphins use theirs.

BRAIN EVOLUTION

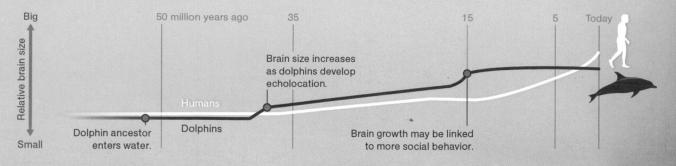

Big

Relative brain size

50 million years ago 35 15 5 Today

Brain size increases
as dolphins develop
echolocation.

Humans

Dolphins

Dolphin ancestor
enters water.

Brain growth may be linked
to more social behavior.

Small

THE GLOBE OF ECONOMIC COMPLEXITY

Bright fountains of multiple exports versus vivid-colored producers of a single good.

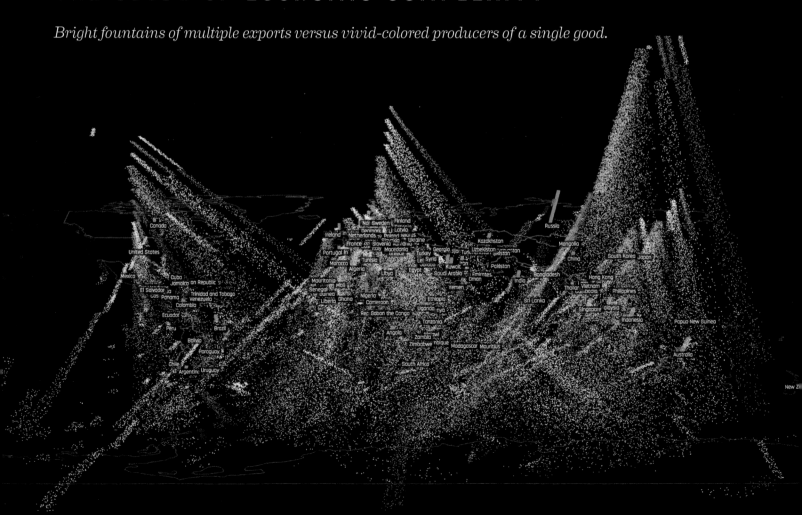

United States

Canada

Russia

Portugal
Ireland
Morocco in
 United Kingdom
Algeria France
 Belgium
 Netherlands
Switzerland
Tunisia Denmark Norway
 Germany
Italy ustria epublic Sweden
 Slovenia
Bosnia and Slovakia and Finland
Libya Albania Lit Latvia nia
 Macedonia
 Romania Belarus
 Bulgaria
 Moldova
 Ukraine
Egypt
 Turkey
Lebanon
 Syria
 Georgia

 Azerbaijan

Saudi Arabia
 Kuwait
Qatar an Turkmenistan Kazakhstan
United Arab Emirates Uzbekistan
 Oman
 Japan
 Tajikistan
Pakistan Kyrgyzstan South Korea

India Mongolia
 China
Bangladesh Hong Kong
 Laos

Foodstuffs | Mineral Products | Chemicals & Allied Industries | Plastics & Rubbers | Leathers and Furs | Wood & Wood Products | Textiles | Footwear & Headgear | Stone & Glass | Metals | Machinery & Elec

Foodstuffs | Mineral Products | Chemicals & Allied Industries | Plastics & Rubbers | Leathers and Furs | Wood & Wood Products | Textiles | Footwear & Headgear | Stone & Glass | Metals | Machinery & Electrical | Transporta

This is the world economy

Every pixel is a different product

ARTISTS: Romain Vuillemot, design, concept, and project supervision; Owen Cornec, design and execution.

STATEMENT: Why do some countries grow while others don't? One factor is the size and diversity of their export trade. "The Globe of Economic Complexity" is an interactive visualization of global world trade, showing each $100 million of exported products as a dot colored by category (textiles are green, cars are blue). Areas of the globe with more production become brighter; areas with a single area of specialty, such as southern Asia with textile products, show one distinctive color.

PUBLICATION: *globe.cid.harvard.edu* (August 24, 2015)

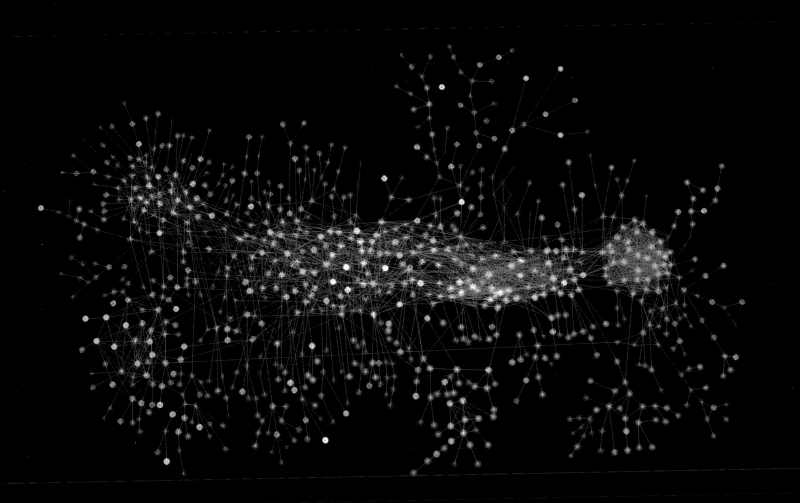

A gallery of popemobiles past and present.

ARTISTS: Kevin Uhrmacher and Richard Johnson, at the *Washington Post.*

STATEMENT: On the occasion of Pope Francis's first trip to America, our fascination with the Holy Father was rivaled

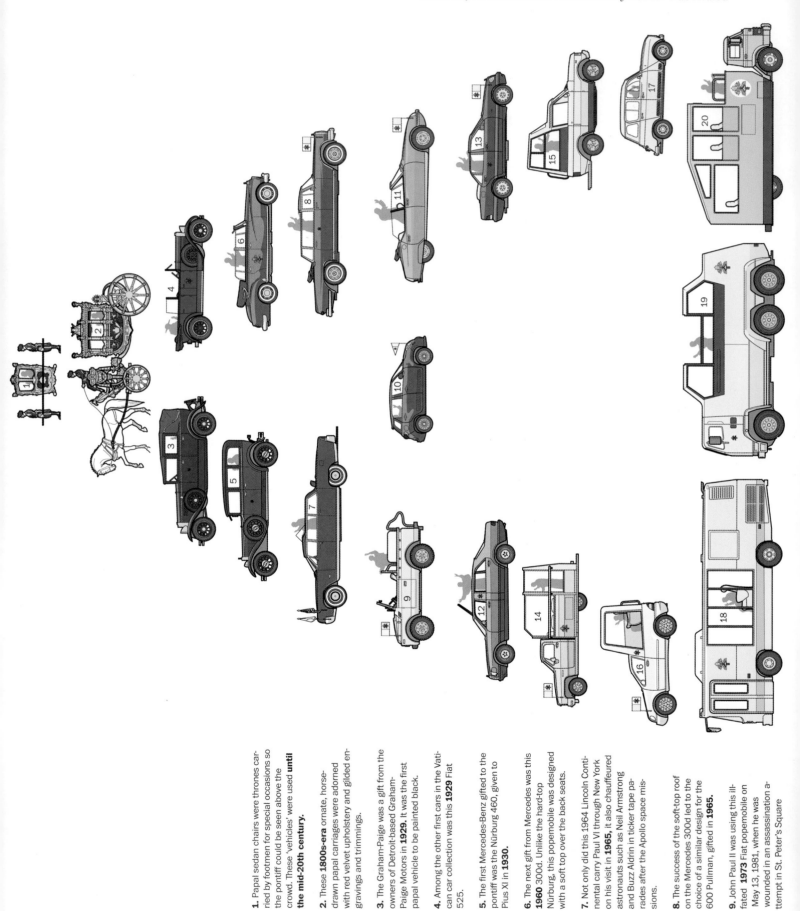

1. Papal sedan chairs were thrones carried by footmen for special occasions so the pontiff could be seen above the crowd. These 'vehicles' were used **until the mid-20th century.**

2. These **1800s-era** ornate, horse-drawn papal carriages were adorned with red velvet upholstery and gilded engravings and trimmings.

3. The Graham-Paige was a gift from the owners of Detroit-based Graham-Paige Motors in **1929.** It was the first papal vehicle to be painted black.

4. Among the other first cars in the Vatican car collection was this **1929** Fiat 525.

5. The first Mercedes-Benz gifted to the pontiff was the Nürburg 460, given to Pius XI in **1930.**

6. The next gift from Mercedes was this **1960** 300d. Unlike the hard-top Nürburg, this popemobile was designed with a soft top over the back seats.

7. Not only did this 1964 Lincoln Continental carry Paul VI through New York on his visit in **1965,** it also chauffeured astronauts such as Neil Armstrong and Buzz Aldrin in ticker tape parades after the Apollo space missions.

8. The success of the soft-top roof on the Mercedes 300d led to the choice of a similar design for the 600 Pullman, gifted in **1965.**

9. John Paul II was using this ill-fated **1973** Fiat popemobile on May 13, 1981, when he was wounded in an assassination attempt in St. Peter's Square

only by our fascination with the holy rollers that have transported him and other popes before him. The resulting graphic told the story not just of popemobiles through the ages but of the popes' different public personalities. It highlighted the sharp contrast Pope Francis has drawn by forging the security of enclosed luxury-brand vehicles and opting for open-air cars from such ordinary brands as Hyundai, Jeep, and Kia.

PUBLICATION: *Washington Post* (September 21, 2015)

In 1800, Pope-elect Pius VII, for the first time in the history of the church, came by carriage to Vatican City, not on horseback. Popes since then have never looked back.

Most of the blessed papal vehicles attempt to provide high visibility for the pontiff and for the crowds gathered for his blessing. Until an attempt on John Paul II's life in 1981 necessitated several other familiar features, including the bulletproof-glass-enclosed "pope box" design. You won't see any cars with that look on Francis's visit to the United States, though. For this week's trip, the pope has shunned what he calls a "sardine can" design in favor of an open-sided Jeep Wrangler. After arriving Tuesday, Francis rode in a Fiat 500L on his way to the Vatican's embassy.

10. A Fiat 500L took Francis to the Vatican's embassy in Washington after he arrived from Cuba on **Tuesday.** In response, the Italian company tweeted "#blessed."

11. A smiling John Paul II waved from a modified 1974 Citroën SM Presidentielle during a visit to Paris in **1980.**

12. Mercedes delivered this car to replace its 1965 papal limousine in **1985.** The car was outfitted with electric platforms in the floor that could elevate the pope.

13. This **1997** Mercedes was the third created in the convertible style. Its roof was raised slightly to help the pontiff get in and out of the vehicle more easily.

14. A GMC pickup truck was the foundation for this vehicle used on the pope's trip to Canada in **1984.**

15. This Range Rover popemobile was one of two cars outfitted for John Paul II's **1982** visit to Britain. It featured armored plating and bullet-resistant glass.

16. Several years of enclosed cupola designs led to this Mercedes M-Class in **2002.** The windows around the pope's chair were made from a special type of plastic, not bulletproof glass.

17. "A car is necessary to do a lot of work, but please, choose a more humble one," Francis said to young priests in 2013. Francis now drives himself around the Vatican in a **1984** Renault 4 with 186,000 miles on it.

18. Millions gathered along the streets of Mexico City to see John Paul II ride by in this bus in **1999.** After his death, it was turned into a mobile memorial and driven around the city.

19. This armored beast was another used on the British trip in **1982.** Weighing in at 24 tons, it was selected for its off-road capability and, if you can believe it, its acceleration in case an emergency arose.

20. This 15-seat chassis, originally on a Ford D-series, was used on the pope's **1979** visit to Ireland. It eventually had a second life as a party bus in Dublin.

21. This Mercedes box van was used on John Paul II's **1987** trip to military-controlled Chile, where he spoke out against President Augusto Pinochet.

22. This large truck, used by John Paul II during his visit to Poland in **1979,** was seen by some as a show of defiance against the Soviets who ruled Poland.

23. The **1980** Mercedes 230G introduced the now-famous design of the off-road popemobile with a raised, transparent compartment on the back to house the pontiff.

24. On a trip to the Philippines in **2014,** Francis used this jeepney, a common form of public transportation there.

25. Francis surprised South Koreans in **2015** when he rode in two cars by Kia, a South Korea-based company. He rode in a modified Kia Sedona as well as a black Kia Soul during his trip to the country.

26. The pope's choice of car for his trip to the United States will be a modified Jeep Wrangler similar to the one he used in Ecuador in **2015.**

27. Francis's trip to the Philippines in **2014** also featured this Isuzu with an Italian leather throne and rain shield. The D-Max was selected over a closed Volkswagen so Francis could be better seen by the faithful.

28. Francis rode through St. Peter's Square in a modest Hyundai Santa Fe popemobile in **2014.**

29. The Peugeot 504 ferried John Paul II in Paraguay in **1988,** and Francis reused it when he visited the nation this summer.

30. In **1988,** while visiting the Ferrari factory in Maranello, Italy, the pope skipped the normal popemobile parade, opting instead for a brand new convertible Ferrari Mondial Cabriolet.

31. This SEAT Panda is the rare small popemobile from this period. John Paul II used it on his first visit to Spain in **1982.**

32. Responding to a request for an open popemobile to use in good weather, Mercedes delivered this G-Class vehicle in **2007**

Corn
Cornfields of America

Deciduous
Deciduous Forests of America

SINGLE=MINDED MAPS

What you learn when you visualize just one crop across the United States.

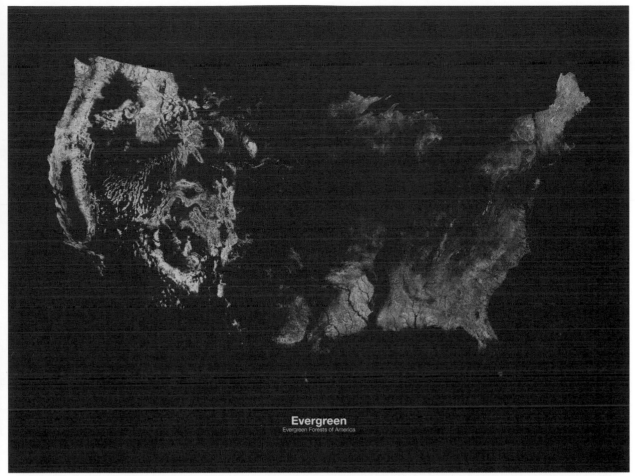

Evergreen
Evergreen Forests of America

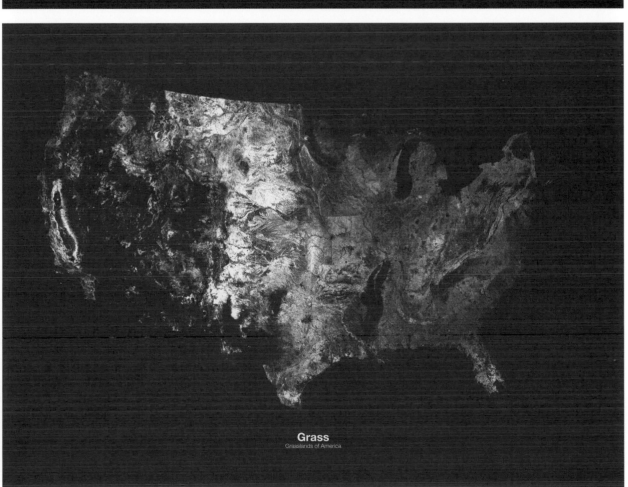

Grass
Grasslands of America

ARTIST: Studio Forage, an interdisciplinary design studio led by Michael Pecirno.

STATEMENT: Borrowing data from the USDA, these detailed single-subject maps isolate a single crop or plant and reveal its presence throughout the country. Compared to the physical and political maps that are now ubiquitous, thanks to Google and global satellite photography, these maps allow us to focus purely on what it looks like, for instance, for cornfields to take up a staggering 4.83 percent of the contiguous United States.

PUBLICATION: *www.michaelpecirno.com* (2015)

AN IMPOSSIBLE MAP
OF ELECTRICITY

Could a surrealist diagram be a useful mnemonic?

ARTIST: Pierluigi Scotolati, a graphic designer in Schio, Vicenza, Italy.

STATEMENT: I created this visual cheat sheet as a personal project, expressing the most important formulas of electricity with an analogy to an impossible water circuit. It depicts the movement of electric charge as water, including electrical resistance (ohms); the flow (amps); and a difference, or "drop," in charge (volts).

PUBLICATION: *visual.ly/electricity* (February 13, 2015)

-ELECTRICITY-

Ampere
electric current
$A = C / S$

Ohm
electric resistance
$\Omega = \rho \bullet (l / a)$

l

a

Coulomb
electric charge

Volt
electric potential
$V = \Omega \bullet A$

Watt
electric power
$W = A \bullet V$

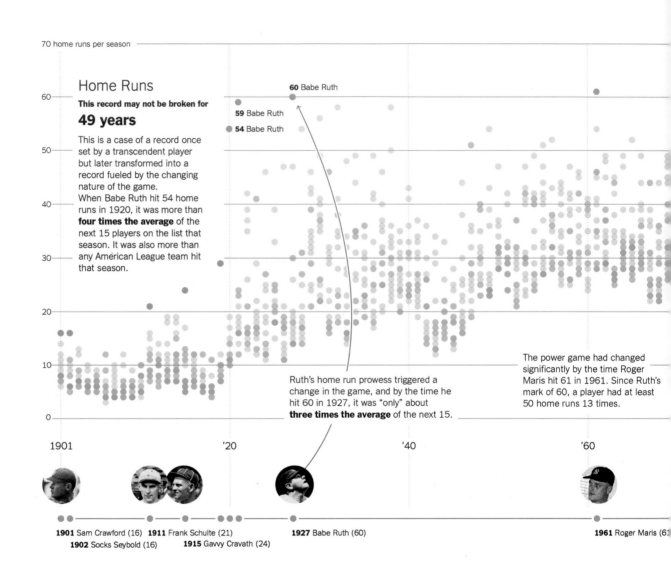

70 home runs per season

Home Runs

This record may not be broken for

49 years

This is a case of a record once set by a transcendent player but later transformed into a record fueled by the changing nature of the game.
When Babe Ruth hit 54 home runs in 1920, it was more than **four times the average** of the next 15 players on the list that season. It was also more than any American League team hit that season.

60 Babe Ruth

59 Babe Ruth

54 Babe Ruth

Ruth's home run prowess triggered a change in the game, and by the time he hit 60 in 1927, it was "only" about **three times the average** of the next 15.

The power game had changed significantly by the time Roger Maris hit 61 in 1961. Since Ruth's mark of 60, a player had at least 50 home runs 13 times.

1901 '20 '40 '60

1901 Sam Crawford (16) **1911** Frank Schulte (21)
1902 Socks Seybold (16) **1915** Gavvy Cravath (24)

1927 Babe Ruth (60)

1961 Roger Maris (61

HOW LONG WILL THIS BASEBALL RECORD LAST?

A predictive tool allows you to make a decent guess.

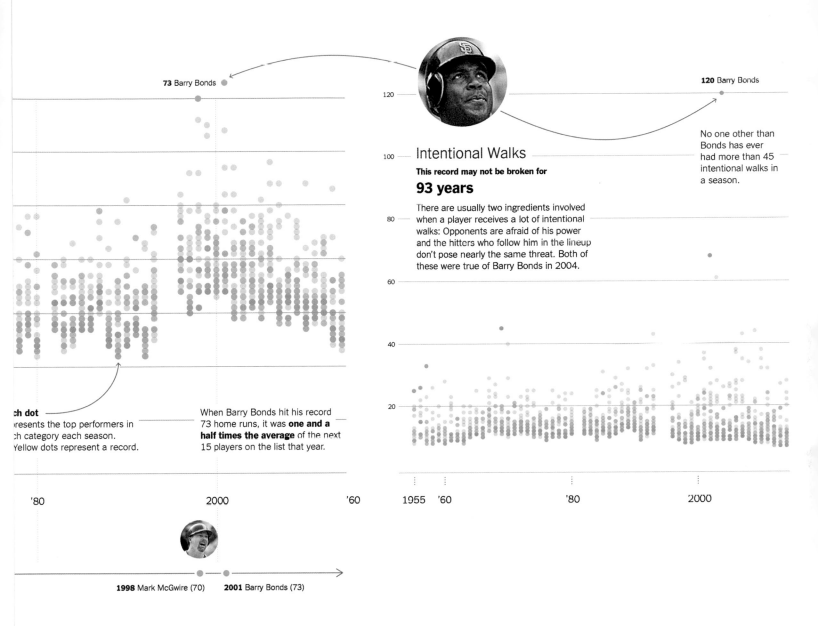

73 Barry Bonds

120 Barry Bonds

120

No one other than Bonds has ever had more than 45 intentional walks in a season.

Intentional Walks

This record may not be broken for

93 years

100

There are usually two ingredients involved when a player receives a lot of intentional walks: Opponents are afraid of his power and the hitters who follow him in the lineup don't pose nearly the same threat. Both of these were true of Barry Bonds in 2004.

80

60

40

h dot resents the top performers in ch category each season. Yellow dots represent a record.

When Barry Bonds hit his record 73 home runs, it was **one and a half times the average** of the next 15 players on the list that year.

20

'80

2000

'60

1955 '60

'80

2000

1998 Mark McGwire (70) **2001** Barry Bonds (73)

ARTISTS: Joe Ward, sports graphics editor, and Josh Katz, graphics editor, research, text, and design; Larry Buchanan, graphics editor, design, at the *New York Times*.

STATEMENT: In baseball, records are the thread that ties together generations of players and fans. Some records fall at a fairly regular clip, while others seem destined never to be broken. We made this graphic to explore the mechanics of those trends, and used a modeling strategy called extreme value theory to approximate how many seasons it would take to reach a 50 percent chance of breaking some single-season records.

PUBLICATION: *New York Times* (April 5, 2015)

THE PATH TO PLUTO
When it began its journey, New Horizons was the fastest spacecraft ever launched.

Sun

Earth

Jupiter

Saturn orbit

Uranus orbit

Neptune orbit

Pluto orbit

JANUARY 2006
Launch at Cape Canaveral.

FEBRUARY 2007
Slingshot boost from Jupiter's gravity.

2007–14
Hibernation.

DECEMBER 2014
New Horizons awakens.

JULY 2015 ▶
Fly-by of Pluto and its moon Charon.

N

ONE DAY WITH A DWARF PLANET

A high speed flyby.

ARTISTS: Alexandra Witze, reporting; Lauren Morello, editing; Jasiek Krzysztofiak, design and illustration; Kelly Krause, art direction; Wesley Fernandes, art direction, at *Nature*.

STATEMENT: On July 14, 2015, after a journey of more than nine years, NASA's *New Horizons* spacecraft approached the dwarf planet Pluto for humanity's first ever flyby. Johns Hopkins University provided 3D illustrations of the space probe and the dwarf planet, which meant we could spend more time creating our own explanatory diagrams and illustrations. One of the main challenges of space travel graphics is that planets rotate, with spacecraft and other objects simultaneously moving in three-dimensional space—which is hard to depict on a still, flat page. Another is scale: with space there are enormous distances and great differences in sizes. In this case, Pluto's moon Styx turned out to be so small compared to Pluto that we had to enlarge it in order to be able to see it on the page.

PUBLICATION: *Nature* (July 2015)

New Horizons spacecraft

THE DWARF PLANET

SURFACE
Pluto is covered with several types of ice, including methane, nitrogen and carbon monoxide. Its reddish surface is one of the most strongly mottled in the Solar System, and New Horizons should reveal the identities of these light and dark patches. Its closest analogue in the Solar System may be Neptune's icy moon Triton, which is thought to have been captured from the Kuiper belt.

ATMOSPHERE
Pluto has a thin atmosphere generated by ices sublimating from its surface. Since its discovery in 1988, the atmosphere has mysteriously expanded — even though Pluto is getting farther from the Sun.

Ocean?

Rocky core?

Icy surface and mantle

PLUTO/ARTWORKS/TRAJECTORIES: NASA/JHU APL/SWRI

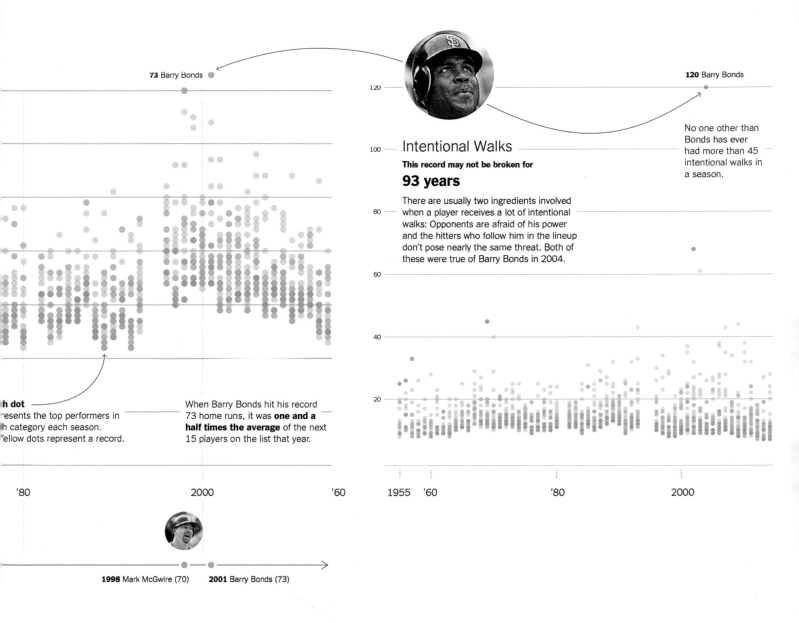

73 Barry Bonds

120 Barry Bonds

120

No one other than Bonds has ever had more than 45 intentional walks in a season.

100

Intentional Walks

This record may not be broken for

93 years

80

There are usually two ingredients involved when a player receives a lot of intentional walks: Opponents are afraid of his power and the hitters who follow him in the lineup don't pose nearly the same threat. Both of these were true of Barry Bonds in 2004.

60

h dot
esents the top performers in
h category each season.
ellow dots represent a record.

When Barry Bonds hit his record 73 home runs, it was **one and a half times the average** of the next 15 players on the list that year.

40

20

'80 — 2000 — '60

1955 '60 — '80 — 2000

1998 Mark McGwire (70) — **2001** Barry Bonds (73)

ARTISTS: Joe Ward, sports graphics editor, and Josh Katz, graphics editor, research, text, and design; Larry Buchanan, graphics editor, design, at the *New York Times*.

STATEMENT: In baseball, records are the thread that ties together generations of players and fans. Some records fall at a fairly regular clip, while others seem destined never to

be broken. We made this graphic to explore the mechanics of those trends, and used a modeling strategy called extreme value theory to approximate how many seasons it would take to reach a 50 percent chance of breaking some single-season records.

PUBLICATION: *New York Times* (April 5, 2015)

.426 Nap Lajoie, 1901

Ted Williams (.406) was
the last player to hit .400.

.400 batting average

.350

.300

1900 '20 '40 '60 '80 2000

191 Hack Wilson, 1930

Last season's major league
leader, Adrian Gonzalez, had
116, which ranks 575th on
the single-season R.B.I. list.

180 R.B.I.

160

140

120

100

80

60

1900 '20 '40 '60 '80 2000

223 Mark Reynolds, 2009

200 strikeouts

When Mark Reynolds set the mark in 2009, he hit a home
run every 13 at-bats and struck out every two and a half
at-bats. At least he was not hitting into double plays.

150

100

50

1900 '20 '40 '60 '80 2000

48 Jack Chesbro, 1904

40 complete games

30

20

10

0

1900　'20　'40　'60　'80　2000

Completing more than even 10 games these days is a rarity. Clayton Kershaw was the league leader last season.

Of his 48 complete games, 41 were wins (out of the 92 the Highlanders had that season).

6 Clayton Kershaw, 2014

62 Francisco Rodriguez, 2008

60 saves

50

40

30

20

10

0

1900　'20　'40　'60　'80　2000

It is no longer unusual for a closer to appear in more than 70 games.

130 Rickey Henderson, 1982

120 stolen bases

100

118 Lou Brock, 1974

80

60

40

20

1900　'20　'40　'60　'80　2000

Henderson stole more bases in 1982 than 28 entire teams stole in 2014. More than half of the teams last season didn't even attempt 130 steals.

Shortened seasons in 1981, 1994 and 1995 are omitted. The number of top performers shown in each season is the same as the number of teams.

Sources: Baseball-Reference.com; Baseball-Almanac.com

THE PATH TO PLUTO
When it began its journey, New Horizons was the fastest spacecraft ever launched.

Sun

Earth

Jupiter

Saturn orbit

Uranus orbit

Neptune orbit

Pluto orbit

JANUARY 2006
Launch at Cape Canaveral.

FEBRUARY 2007
Slingshot boost from Jupiter's gravity.

2007–14
Hibernation.

DECEMBER 2014
New Horizons awakens.

JULY 2015
Fly-by of Pluto and its moon Charon.

New Horizons spacecraft

ONE DAY WITH A DWARF PLANET

A high speed flyby.

ARTISTS: Alexandra Witze, reporting; Lauren Morello, editing; Jasiek Krzysztofiak, design and illustration; Kelly Krause, art direction; Wesley Fernandes, art direction, at *Nature*.

STATEMENT: On July 14, 2015, after a journey of more than nine years, NASA's *New Horizons* spacecraft approached the dwarf planet Pluto for humanity's first ever flyby. Johns Hopkins University provided 3D illustrations of the space probe and the dwarf planet, which meant we could spend more time creating our own explanatory diagrams and illustrations. One of the main challenges of space travel graphics is that planets rotate, with spacecraft and other objects simultaneously moving in three-dimensional space—which is hard to depict on a still, flat page. Another is scale: with space there are enormous distances and great differences in sizes. In this case, Pluto's moon Styx turned out to be so small compared to Pluto that we had to enlarge it in order to be able to see it on the page.

PUBLICATION: *Nature* (July 2015)

THE DWARF PLANET

SURFACE
Pluto is covered with several types of ice, including methane, nitrogen and carbon monoxide. Its reddish surface is one of the most strongly mottled in the Solar System, and New Horizons should reveal the identities of these light and dark patches. Its closest analogue in the Solar System may be Neptune's icy moon Triton, which is thought to have been captured from the Kuiper belt.

ATMOSPHERE
Pluto has a thin atmosphere generated by ices sublimating from its surface. Since its discovery in 1988, the atmosphere has mysteriously expanded — even though Pluto is getting farther from the Sun.

Ocean?

Rocky core?

Icy surface and mantle

PLUTO/ARTWORKS/TRAJECTORIES: NASA/JHU APL/SWRI

THE FLY-BY

Up to and including 12 JULY
New Horizons will map the surface and study the atmosphere, looking for clouds and haze on Pluto, as well as rings and moons beyond the five known (Charon, Styx, Nix, Kerberos and Hydra).

13 JULY
Limited initial observations will be sent back to Earth in case the spacecraft does not survive the encounter.

14 JULY
New Horizons will remain radio silent for much of the day so that it can concentrate on gathering data at Pluto and Charon. It will collect colour images of Pluto at a resolution of 0.5 kilometres per pixel, and black-and-white ones (in a narrow band across the dwarf planet's centre) at resolutions as high as 100 metres per pixel.

15 JULY
Close-up images of Pluto and Charon, along with scientific data, will start to be sent to Earth over a 26-month period. New Horizons' transmission rate is limited by its communications time with NASA's Deep Space Network and the sheer quantity of data that it will collect during the intense, close encounter. The highest-resolution images of Pluto that will be available from the encounter will be transmitted on 15 July, with those for Charon following the day after.

14 JULY

7:50 a.m.
Eastern Daylight Time
Closest approach to Pluto, 12,500 kilometres. Images taken in both visible and near-infrared wavelengths.

8:04 a.m.
Closest approach to Charon, at 28,800 kilometres. Because this is more than twice the distance of the closest approach to Pluto, the best pictures of Charon will be roughly twice as coarse as those of Pluto.

8:51 a.m.
Passes through Pluto's shadow, allowing it to probe Pluto's atmosphere.

10:18 a.m.
Passes through Charon's shadow, allowing it to search for an atmosphere on Charon.

9:02 p.m.
Mission team on Earth should receive a preprogrammed 'phone home' signal which, if all went well, will indicate the spacecraft survived the encounter.

THE MOONS

FORMATION
Early in the Solar System's history, a proto-Charon probably walloped into a proto-Pluto, sending debris cascading out into space. Much of that may have condensed to form Pluto's four smaller moons.

Proto-Charon

Proto-Pluto

BINARY SYSTEM
Pluto and Charon are locked in an intricate orbital dance. Because Charon is so large relative to Pluto — at one-eighth its mass — the two actually orbit a mutual centre of gravity that is located in space. They also both rotate on their axes once every 6.4 Earth days. Analyses of the shapes of Pluto and Charon could reveal whether one or both of them ever harboured an underground ocean, kept liquid by subterranean heat.

THE SMALLER MOONS
Nix and Hydra tumble chaotically on their axes, but Nix, Styx and Hydra are locked in an orbital resonance that has them travelling around Pluto in synchrony. Kerberos is surprisingly dark in colour, possibly reflecting a piece of the original impactor that formed the Pluto–Charon system. Of the small known moons, New Horizons will get the best view of Nix. It may also discover more moons, or dust rings, somewhere in the system.

Pluto

Styx

Charon

Kerberos

Hydra

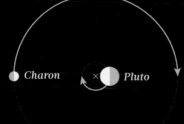

Charon × *Pluto*

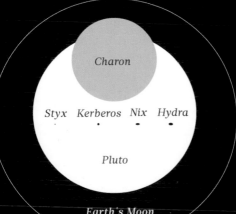

Charon

Styx Kerberos Nix Hydra

Pluto

Earth's Moon

MOON DATA: NASA/ESA/M. SHOWALTER (SETI INSTITUTE)

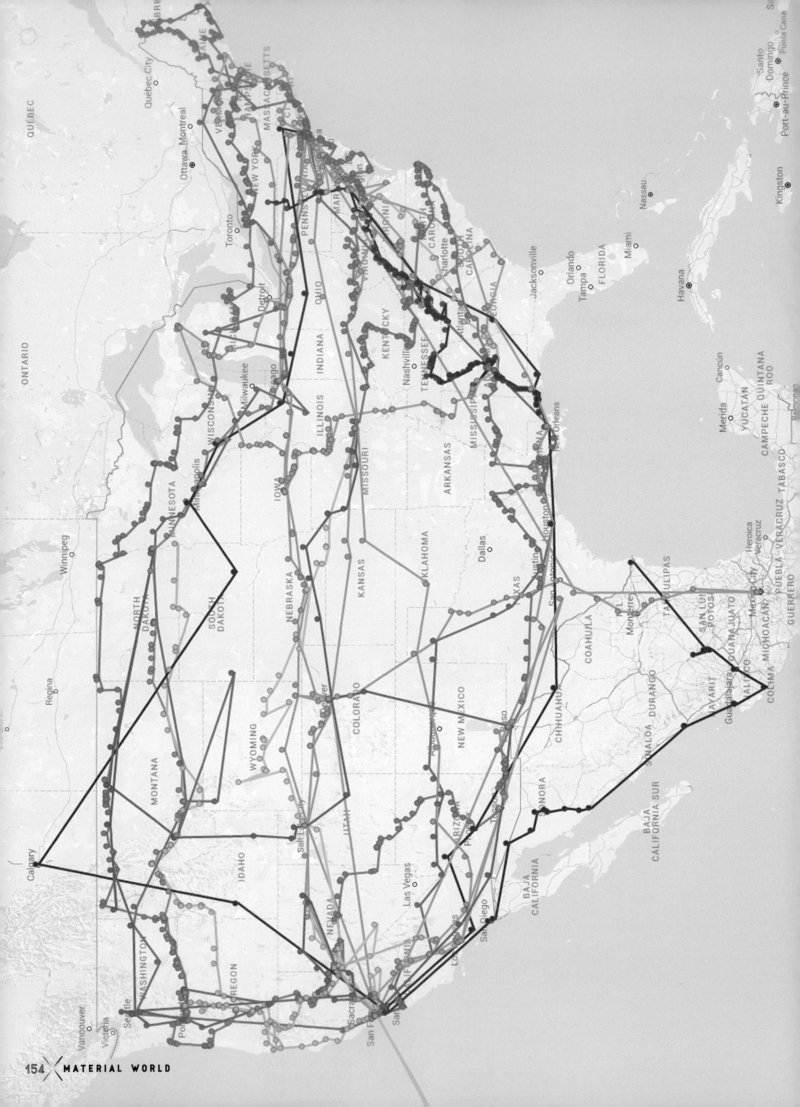

Flatbush Avenue, New York

BLUE HIGHWAYS
BY WILLIAM LEAST HEAT-MOON

"The Belt Roadway showed the backsides of suburbs and miles of carpet sample, unclaimed freight, factory outlet, ad furniture warehouse stores—half of them gone under, the others with windows blocked by giant prices. Things raced past like the jump images of a nickelodeon: abandoned and stripped cars on the shoulders, two hitchhiking females that nobody could stop to pick up, a billboard that said EAT SAUSAGE AND BE HAPPY, low-flying jumbos into Kennedy international, the racetrack at Ozone Park, bulldozed piles of dirt to fill the marsh at Jamaica Bay, long and straight Flatbush Avenue, Sheepshead Bay, Coney Island, the World Trade Center like stumps in the yellow velvet sky."

BUY ON AMAZON

Wild
The Cruise of the Rolling Junk
Rolling Nowhere
A Walk Across America
Cross Country
The Lost Continent
Blue Highways
On the Road
Roughing It
Zen and the Art of Motorcycle Maintenance
Travels with Charley
The Electric Kool-Aid Acid Test

A LITERARY ROAD MAP

Tracing the path of famous books about American journeys.

ARTISTS: Richard Kreitner, concept and writing; Steven Melendez, data.

STATEMENT: This interactive map is a visualization of the routes taken in 12 of the most famous US road-trip books. By clicking the dots, users can read what each author said about places they visited or passed through. We hope the map prompts Americans to rediscover the vast extent of their own country, and perhaps to find what *On the Road's* Sal Paradise does in San Francisco: "Here I was at the end of America—no more land—and now there was nowhere to go but back."

PUBLICATION: *Atlas Obscura* (July 20, 2015)

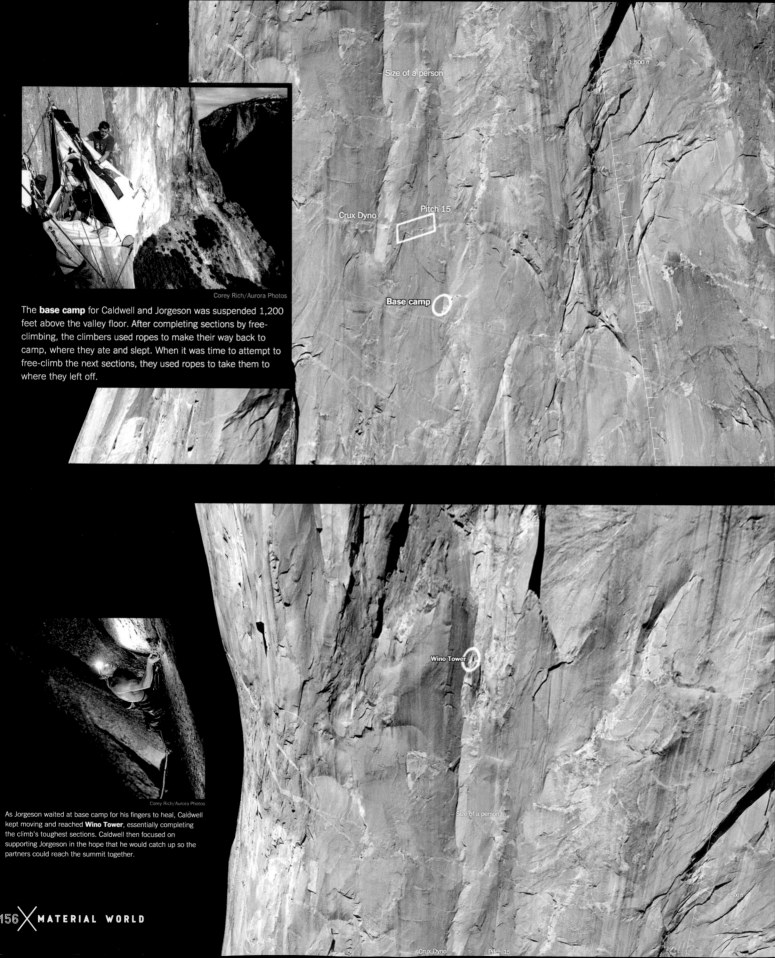

Size of a person

1,500 ft

Crux Dyno Pitch 15

Base camp

Corey Rich/Aurora Photos

The **base camp** for Caldwell and Jorgeson was suspended 1,200 feet above the valley floor. After completing sections by free-climbing, the climbers used ropes to make their way back to camp, where they ate and slept. When it was time to attempt to free-climb the next sections, they used ropes to take them to where they left off.

Wino Tower

Size of a person

Corey Rich/Aurora Photos

As Jorgeson waited at base camp for his fingers to heal, Caldwell kept moving and reached **Wino Tower**, essentially completing the climb's toughest sections. Caldwell then focused on supporting Jorgeson in the hope that he would catch up so the partners could reach the summit together.

Crux Dyno Pitch 15

Two images combine to give readers a glimpse of a shocking climb.

ARTISTS: Shan Carter, Wilson Andrews, Derek Watkins, and Joe Ward, graphics editors at the *New York Times*.

STATEMENT: While reporting the story of Tommy Caldwell and Kevin Jorgeson's climb up the Dawn Wall of El Capitan, we tracked down two useful images. The first was an extremely high fidelity, three-dimensional scan of El Capitan by researchers from the University of Lausanne, which we used to create a 3D file small enough to load in a browser. Second was a very high resolution photograph of El Capitan that showed the climbing route perfectly. We merged the two assets, meticulously matched the 3D model to the same vantage point as the photograph, and then draped the image over the model, effectively allowing us to rotate around the original photograph.

This combination of a highly accurate 3D model of the granite face and an actual photograph proved ideal. Not only could we show close-up details of the rock face, but with the underlying 3D model we were able to allow our viewers to dynamically change their perspective and get several vertigo-inducing views of this amazing wall of granite, giving them a visceral sense of the two climbers' incredible feat.

PUBLICATION: *New York Times* (January 9, 2015)

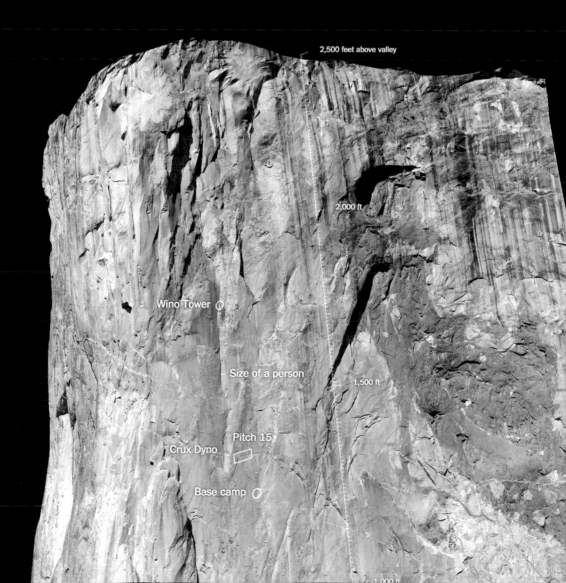

2,500 feet above valley

2,000 ft

Wino Tower

Size of a person

1,500 ft

Pitch 15

Crux Dyno

Base camp

1,000 ft

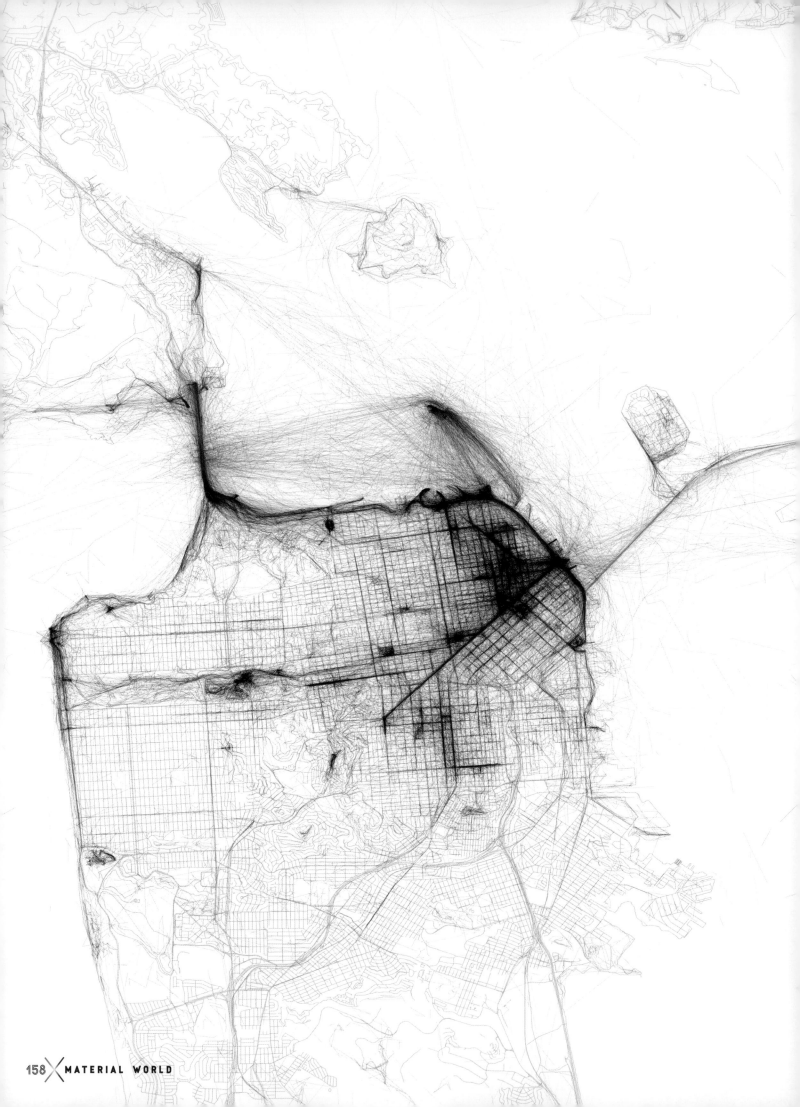

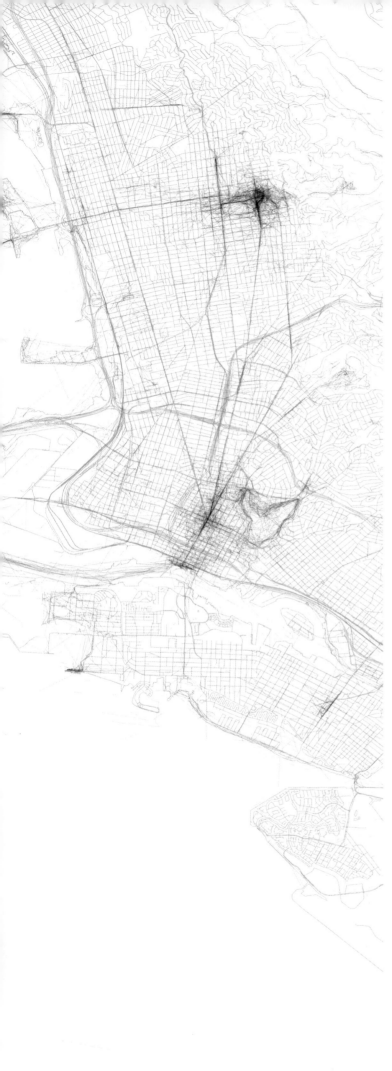

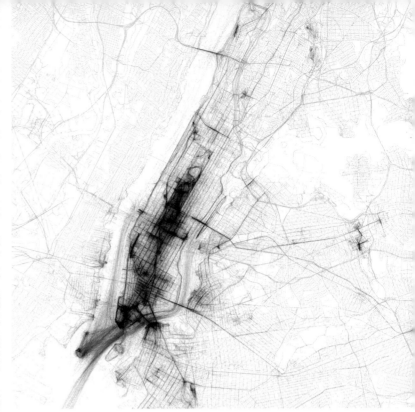

THE SCENIC ROUTE

What geotagged photos reveal about cities.

ARTIST: Eric Fischer, data artist and software developer at Mapbox.

STATEMENT: The Geotaggers' World Atlas is my long-term project to discover the world's most interesting places and the routes that people follow between them. Thanks to Flickr's API, it exposes over 10 years of photo locations. A cluster of geotagged photos is a good indicator of the interestingness of a place because it signifies that people went there in the first place, saw something worth taking a picture of, and put the effort into posting it for others to appreciate. A sequence of photos along a route is even more significant, because it indicates that someone sustained their interest over distance and time rather than taking one picture and turning back. The project has been full of surprises, making me aware of streets, neighborhoods, and whole cities I knew nothing about before. The separate paths of thousands of individuals combine to give the appearance of a sketch. The red lines on the map (which show where a photographer traveled between photo sites at a speed between 7 and 19 miles per hour, based on the time stamps and locations of the pictures) that I had hoped would identify favorite bike routes turned out instead to reveal scenic ferries.

PUBLICATION: *mapbox.com/blog/* (April 28, 2015)

OUR AVIAN FUTURE

How climate change will change the birder's world.

ARTISTS: Tiffany Farrant-Gonzalez, data visualization; Breanna Draxler, writing; and Katie Peek, art direction, at *Popular Science* magazine.

STATEMENT: This graphic showcases the avian winners and losers of climate change, based on models of the United States in 2075. It's not all bad news for US birds. Some, like the Gambel's quail (pictured), will see their range expand, in part because they're a southern species that does well in close proximity to people. Others will see their ranges shrink—either because they'll be pushed north into Canada, or because their preferred environment will disappear altogether. Each of the 50 species in the journal article appear as a bar in the chart, with the most imperiled species on the left. The bars are color-coded by the region of the country the bird currently favors, making it clear at a glance that, in general, northern species will ebb while southern species grow.

PUBLICATION: *Popular Science* (April 2015)

Quails in the Southwest have a taste for suburban life. As Phoenix and Tucson swell, these birds will likely settle in.

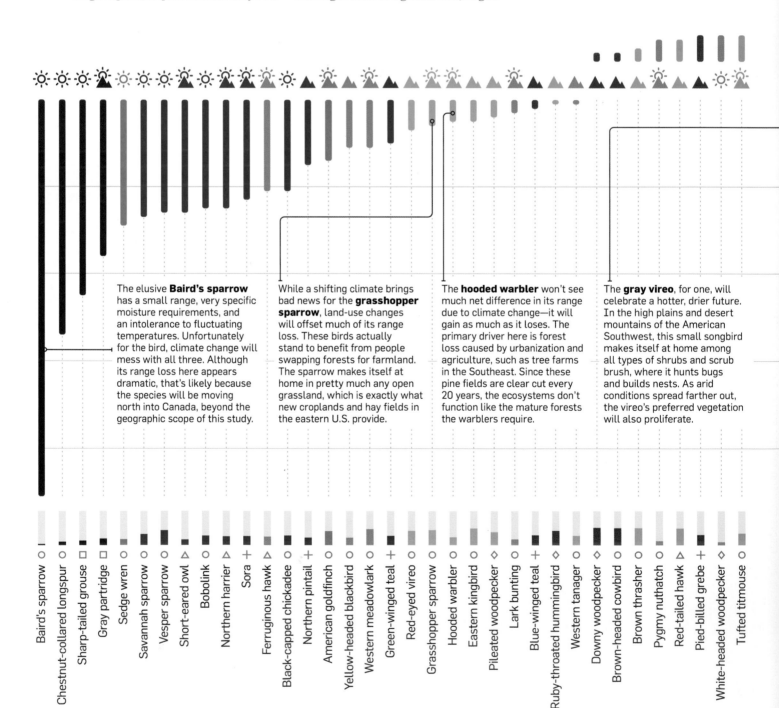

The elusive **Baird's sparrow** has a small range, very specific moisture requirements, and an intolerance to fluctuating temperatures. Unfortunately for the bird, climate change will mess with all three. Although its range loss here appears dramatic, that's likely because the species will be moving north into Canada, beyond the geographic scope of this study.

While a shifting climate brings bad news for the **grasshopper sparrow**, land-use changes will offset much of its range loss. These birds actually stand to benefit from people swapping forests for farmland. The sparrow makes itself at home in pretty much any open grassland, which is exactly what new croplands and hay fields in the eastern U.S. provide.

The **hooded warbler** won't see much net difference in its range due to climate change—it will gain as much as it loses. The primary driver here is forest loss caused by urbanization and agriculture, such as tree farms in the Southeast. Since these pine fields are clear cut every 20 years, the ecosystems don't function like the mature forests the warblers require.

The **gray vireo**, for one, will celebrate a hotter, drier future. In the high plains and desert mountains of the American Southwest, this small songbird makes itself at home among all types of shrubs and scrub brush, where it hunts bugs and builds nests. As arid conditions spread farther out, the vireo's preferred vegetation will also proliferate.

Baird's sparrow · Chestnut-collared longspur · Sharp-tailed grouse · Gray partridge · Sedge wren · Savannah sparrow · Vesper sparrow · Short-eared owl · Bobolink · Northern harrier · Sora · Ferruginous hawk · Black-capped chickadee · Northern pintail · American goldfinch · Yellow-headed blackbird · Western meadowlark · Green-winged teal · Red-eyed vireo · Grasshopper sparrow · Hooded warbler · Eastern kingbird · Pileated woodpecker · Lark bunting · Blue-winged teal · Ruby-throated hummingbird · Western tanager · Downy woodpecker · Brown-headed cowbird · Brown thrasher · Pygmy nuthatch · Red-tailed hawk · Pied-billed grebe · White-headed woodpecker · Tufted titmouse

37,579,297

Number of U.S. bird observations entered into the eBird citizen science database in 2014. (Cornell's Sohl sifted through 2,319,910 of them to make his models for this study.)

60%

40%

20%

0%

GAINS GROUND

0%

LOSES GROUND

20%

40%

60%

80%

CHANGE IN BIRD RANGE BY 2075

HOW TO READ THIS VISUALIZATION

The graph shows how a bird's range—in the U.S. only—will likely change over the next 60 years. Color denotes the region a species calls home.

| NW | N | NE | E | SE | S | SW | W |

Range extends throughout continental U.S.

Symbols in the middle pinpoint the factor most responsible for the species' fate.

▲ Land use and land cover ☼ Climate change ⛰ Both equal

Bars along the bottom show the percentage of land in the lower 48 that is suitable habitat for each species.

Symbols at the bottom show bird type.
- ○ Perching birds
- □ Pigeons, grouse, and quail
- △ Preying birds
- + Water birds
- ◇ Hummingbirds and woodpeckers

Great blue heron +
Orchard oriole ○
Western kingbird ○
Dickcissel ○
Carolina wren ○
Red-headed woodpecker ◇
Great horned owl △
Lark sparrow ○
Band-tailed pigeon □
Anna's hummingbird ◇
Painted bunting ○
Gray vireo ○
Scissor-tailed flycatcher ○
Cactus wren ○
Gambel's quail □

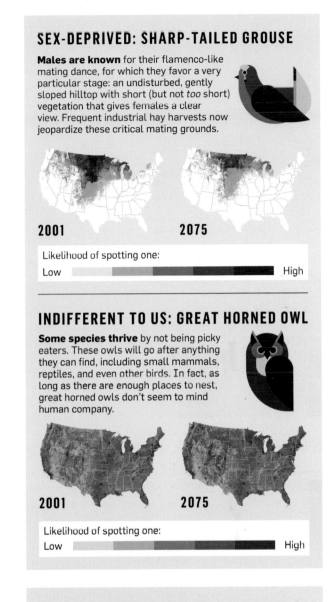

SEX-DEPRIVED: SHARP-TAILED GROUSE

Males are known for their flamenco-like mating dance, for which they favor a very particular stage: an undisturbed, gently sloped hilltop with short (but not *too* short) vegetation that gives females a clear view. Frequent industrial hay harvests now jeopardize these critical mating grounds.

2001 **2075**

Likelihood of spotting one:
Low ———— High

INDIFFERENT TO US: GREAT HORNED OWL

Some species thrive by not being picky eaters. These owls will go after anything they can find, including small mammals, reptiles, and even other birds. In fact, as long as there are enough places to nest, great horned owls don't seem to mind human company.

2001 **2075**

Likelihood of spotting one:
Low ———— High

NEW SURVIVAL TACTICS

As species move into different regions, they'll have to interact with new neighbors. In South Dakota, for example, northern mockingbirds are encroaching on brown thrasher territory. Soon they'll be competing for the same resources. Timing is an issue too. A European bird study found that species that began migrating earlier enjoyed stable or growing populations, while birds that stuck to the usual timetable saw declines. But the early birds face risks too. In response to warming temperatures, a species called the great tit has started laying its eggs sooner. Chicks hatch about 10 days before their primary food source, caterpillars, emerge. That's a problem. For the nonmigrators, behaviors may need tweaking. A study of the grey shrikethrush in southeastern Australia found that the roadside-dwelling bird chirps at a higher frequency amid cars to ensure that its mating song can be heard over traffic.

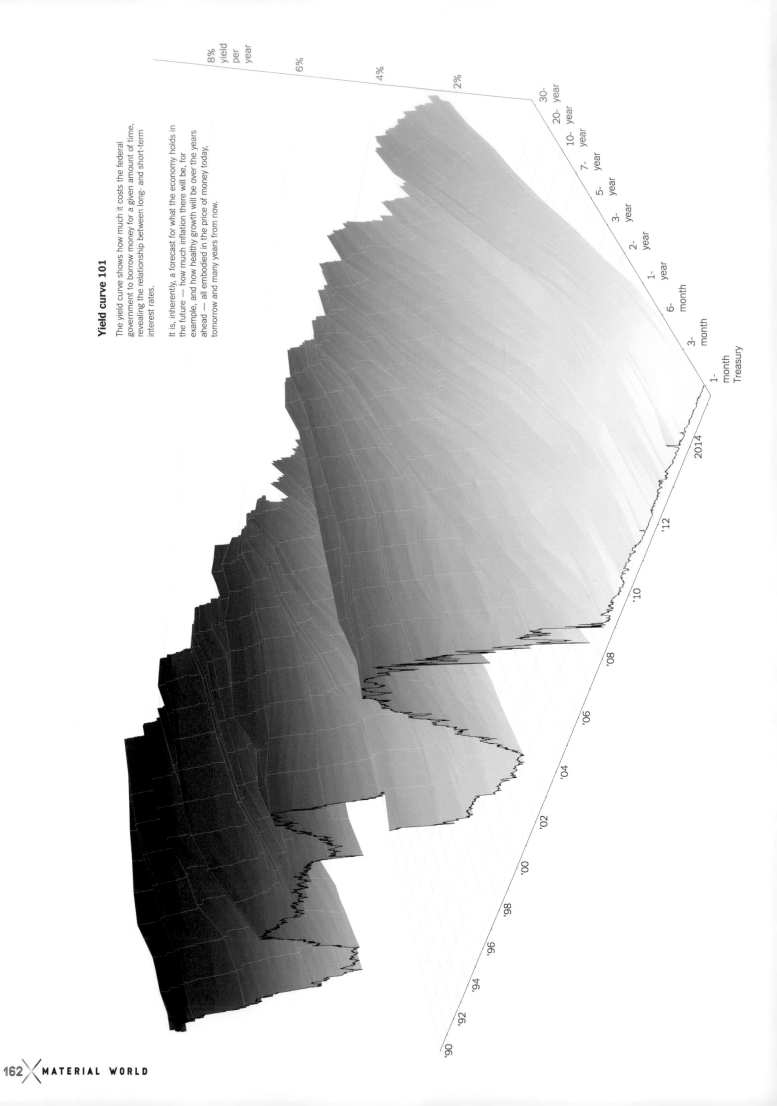

Yield curve 101

The yield curve shows how much it costs the federal government to borrow money for a given amount of time, revealing the relationship between long- and short-term interest rates.

It is, inherently, a forecast for what the economy holds in the future — how much inflation there will be, for example, and how healthy growth will be over the years ahead — all embodied in the price of money today, tomorrow and many years from now.

8% yield per year

6%

4%

2%

30-year
20-year
10-year
7-year
5-year
3-year
2-year
1-year
6-month
3-month
1-month Treasury

2014
'12
'10
'08
'06
'04
'02
'00
'98
'96
'94
'92
'90

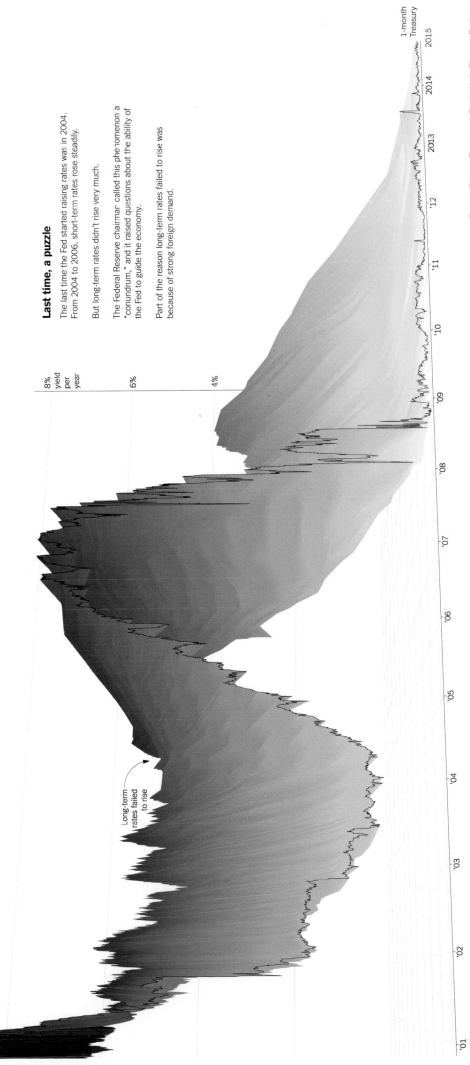

THE FUTURE OF BONDS, IN 3D

Mountains and valleys of yield.

Last time, a puzzle

The last time the Fed started raising rates was in 2004. From 2004 to 2006, short-term rates rose steadily.

But long-term rates didn't rise very much.

The Federal Reserve chairman called this phenomenon a "conundrum," and it raised questions about the ability of the Fed to guide the economy.

Part of the reason long-term rates failed to rise was because of strong foreign demand.

Long-term rates failed to rise

8% yield per year

6%

4%

'01 '02 '03 '04 '05 '06 '07 '08 '09 '10 '11 '12 2013 2014 2015

1-month Treasury

Sources: Treasury Department; Bundesbank; Thomson Reuters

ARTISTS: Gregor Aisch and Amanda Cox, *New York Times*

STATEMENT: The bond market doesn't capture the popular imagination the way the stock market does. Bond data are usually charted in one of two ways: either the yield on a single security over time, or the shape of the yield curve for a select number of days. By using 3D, the *Times* achieved both at once. The final product takes readers on a tour of the "conundrum" the Fed faced when it raised rates in the mid-2000s and the once-unthinkable rates in Europe in 2015. It borrows tricks from Alfred Hitchcock to switch perspective between views.

PUBLICATION: *nytimes.com* (March 19, 2015)

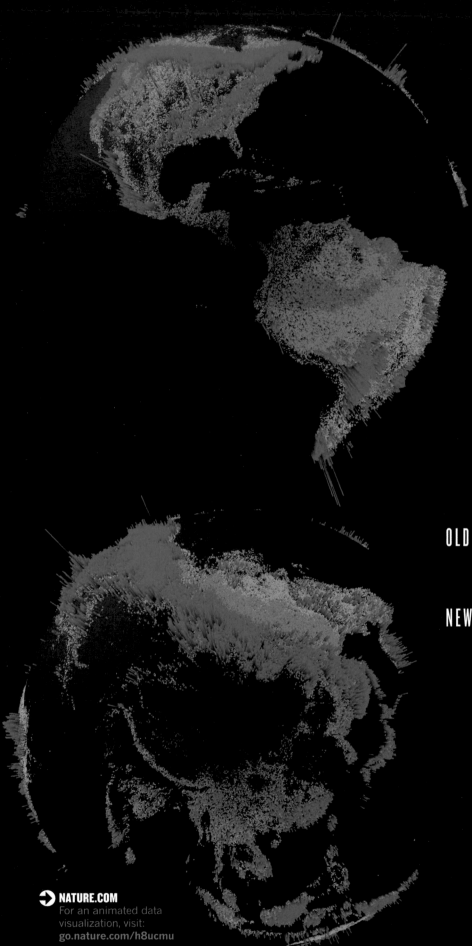

A GALAXY OF TREES

There are more than we thought, but the world's forests are under attack.

ARTISTS: Jasiek Krzysztofiak, design; Kelly Krause, design and art direction; Wesley Fernandes, art direction; Matt Crenson, text and editing, all at *Nature* magazine. Jan Willem Tulp, data visualization; Rachel Ehrenberg, reporting and text.

STATEMENT: In September 2015 *Nature* published the first-ever comprehensive map of the world's trees. Previously it was thought that there were 4 billion trees on earth, but it turns out there are just over 3 trillion trees on earth, more than the number of stars in the Milky Way. Data visualization expert Jan Willem Tulp used both line height (height represents forest density in one square kilometer) and color to represent tree density across the globe. Vertical lines are not only an intuitive way to show density, but they also mimic the appearance of forests.

PUBLICATION: *Nature* (September 9, 2015)

OLD ESTIMATE 400 BILLION

NEW ESTIMATE 3.04 TRILLION

▲ = 10 billion trees

NATURE.COM
For an animated data visualization, visit:
go.nature.com/h8ucmu

Line height represents forest density in 1 km²

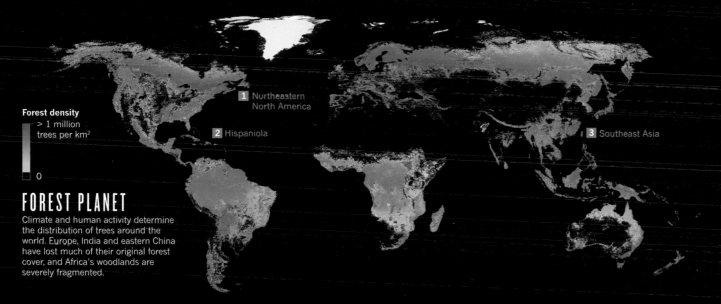

Forest density

> 1 million
trees per km²

0

1 Northeastern
North America

2 Hispaniola

3 Southeast Asia

FOREST PLANET

Climate and human activity determine
the distribution of trees around the
world. Europe, India and eastern China
have lost much of their original forest
cover, and Africa's woodlands are
severely fragmented.

1. NORTHEASTERN NORTH AMERICA

Farms, orchards and sheep took over the landscape of
northeastern North America in the 1800s, when much
the region's forest was harvested for timber. Today, the
six US states of New England are more than 80%
forested — but suburban sprawl and other factors
present new threats.

New England

Atlantic
Ocean

2. HISPANIOLA

The effects of deforestation are stark on the
Caribbean island of Hispaniola. The Dominican
Republic, on the eastern side of the island, has tree
cover that is four times denser than that in
neighbouring Haiti, which has been forced to cut
down trees for fuel.

Atlantic Ocean

Dominican
Haiti Republic

Cuba

Jamaica **Hispaniola**

Caribbean Sea

3. SOUTHEAST ASIA

Forests in southeast Asia have changed drastically
since the 1970s. From 1973 to 2009, Thailand and
Vietnam lost 43% of their forest cover; Cambodia and
Laos lost 22% and 24%, respectively. If current trends
continue, more than 30% of the region's remaining
forest will be cleared by 2030.

Bay of
Bengal

China

Vietnam

Thailand South
China Sea

LAY OF THE LAND

Despite deforestation caused by farming, ranching, mining and logging, tropical
areas still contain an astounding 43% of the planet's trees. Tree densities are
greatest in the northern boreal and tundra forests, which can contain more than
1,000 trees per hectare. (Percentages are rounded.)

Tropical moist
26% of total forest cover

Temperate
broadleaf
12%

Tropical dry
5%

Temperate
conifer
5%

Boreal forests
24%

Tropical
grasslands
11%

Temperate
grasslands
5%

Tundra
3%

Flooded
grasslands
2%

Montane
grasslands
2%

Mediterranean
forests
1.8%

Deserts
1.8%

Tropical
coniferous
0.7%

Mangroves
0.3%

LEAF OF NATIONS

The tropics host many densely forested countries, but
nations with boreal forest, such as Finland, have the
highest tree densities. At the other extreme are desert
and island nations, and some impoverished countries.

Finland **72,644**
trees per km²

Slovenia **71,131**

Sweden **69,161**

Brazil **35,288**

Canada **32,055**

United Kingdom
12,264

Haiti **5,467**

Kazakhstan
2,245

Bermuda **708**

● = 1,000 trees

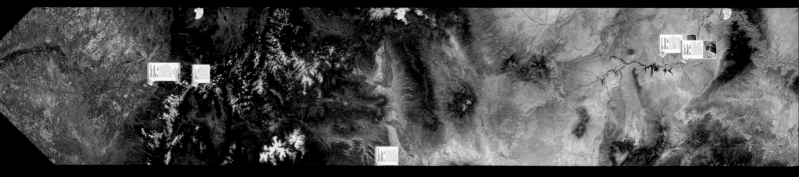

DRAINING THE COLORADO

The engineering marvels that have gradually sapped a great water source.

ARTISTS: Abrahm Lustgarten, senior reporter; Al Shaw, news applications developer; Jeff Larson, data editor; Amanda Zamora, senior engagement editor; and Lauren Kirchner, senior research fellow, at ProPublica; John Grimwade, illustrator. ProPublica is a nonprofit, investigative newsroom based in New York.

STATEMENT: For a century, seven states have defied all natural limitations to wring ever more water from the Colorado River, the most important water source for 40 million people in the West. This interactive map traces artificial engineering projects along the Colorado over time and space, and shows how they have combined to contribute to the drought crisis.

PUBLICATION: *ProPublica* (May 26, 2015)

DRONE WORK AROUND THE WORLD

What are different regions using them for?

ARTISTS: Caleb Bennett and Christy Sheppard Knell, art direction; Francesco Muzzi, illustration; Lauren Smiley, text; Sarah Fallon, editing.

STATEMENT: Drones are being used for delivery around the world, for purposes from pizza delivery in Moscow to saliva samples for tuberculosis testing in Papua New Guinea. In this graphic, schematic illustrations show the drones' relative sizes, along with information about their speed and maximum payload.

PUBLICATION: *WIRED* (February 2015)

1
DHL PARCELCOPTER

Max payload
2.6 pounds
Max range
7.5 miles
Width 40.6 in

2
COPTER EXPRESS OCTOCOPTER

Max payload
6.6 pounds
Max range
1.7 miles
Width About 30 in

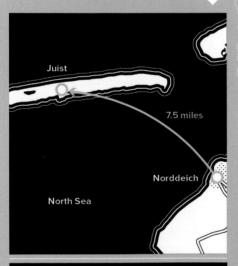

Juist

7.5 miles

Norddeich

North Sea

Dodo Pizza

Jigme Dorji Wangchuck National Referral Hospital

Thimphu

5.8 miles

Chamgang Basic Health Unit

The North Sea

Payload: Medicines like painkillers or anticoagulants
Method: Automated (but a pilot monitors the flight)
Status: A local ferry service makes daily runs to the island of Juist, but the drone is for urgent orders; the flight takes a mere **17 minutes**.

Syktyvkar, Russia

Payload: Pizza
Method: Preprogrammed via GPS and equipped with cameras monitored from the pizza shop; the pie is dropped down to the customer on a cable.
Status: If you're in Syktyvkar, just call Dodo Pizza and order Одну большую пиццу пожалуйста.

Bhutan

Payload: Antibiotics from the hospital in the Himalayan capital of Thimphu, at 7,710 feet above sea level, up to a remote mountain health clinic
Method: Automated (after operators program in the destination)
Status: Tests ran in August 2014, and a rollout is planned for 2015.

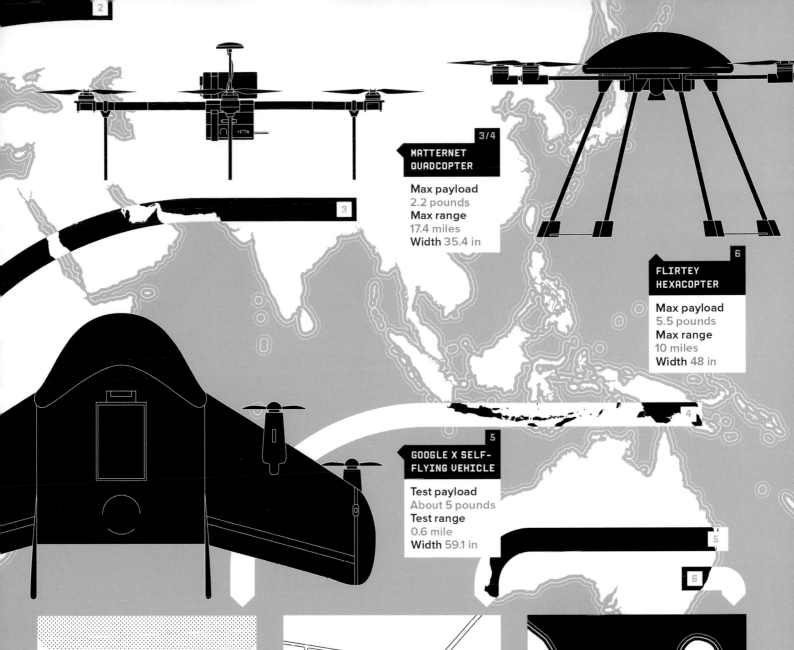

MATTERNET QUADCOPTER

Max payload
2.2 pounds
Max range
17.4 miles
Width 35.4 in

3

FLIRTEY HEXACOPTER

Max payload
5.5 pounds
Max range
10 miles
Width 48 in

GOOGLE X SELF-FLYING VEHICLE

Test payload
About 5 pounds
Test range
0.6 mile
Width 59.1 in

4

5

6

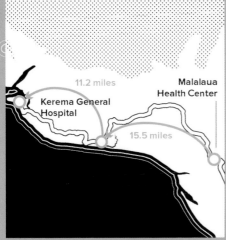

11.2 miles
Malalaua
Health Center
Kerema General
Hospital
15.5 miles

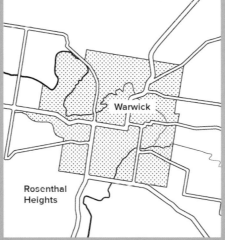

Warwick
Rosenthal
Heights

Farm Cove
0.25 mile
Royal
Botanical
Gardens
Woolloomooloo
Bay

Papua New Guinea

Payload: Saliva samples for tuberculosis testing, from Malalaua to the Kerema hospital; the drone shortens what can be a days-long overland trip to one hour.
Method: Automated
Status: Tests ran in September 2014 in anticipation of a 2015 rollout.

Queensland, Australia

Payload: Dog treats, cattle vaccines, and a first-aid kit for farmers
Method: Will be preprogrammed; once in position, it lowers the package on a line and a bundle of sensors detect when the package has hit the ground.
Status: It's still in the research stages.

Sydney

Payload: Physics and law textbooks to University of Sydney students
Method: Automated
Status: More testing is ongoing at the University of Nevada, Reno.

BEST AMERICAN INFOGRAPHICS BRAIN TRUST

THOMAS ALBERTY became the design director at New York magazine in 2012, after eight years on staff at GQ. His work has been recognized by the Society of Publication Designers and the Type Directors Club, and New York has won the American Society of Magazine Editors' award for design twice since his arrival, in 2014 and 2015. He lives in Brooklyn.

SAMUEL ARBESMAN is a complexity scientist and scientist in residence at Lux Capital. He is also a senior adjunct fellow of the Silicon Flatirons Center for Law, Technology, and Entrepreneurship at the University of Colorado and a research fellow at the Long Now Foundation. He is the author of The Half-Life of Facts.

ALBERTO CAIRO teaches infographics and data visualization at the University of Miami, where he is Knight Chair in Visual Journalism and director of the visualization program at the Center for Computational Science. He is the author of the books The Functional Art: An Introduction to Information Graphics and Visualization (2012) and The Truthful Art: Data, Charts, and Maps for Communication (2016).

JEN CHRISTIANSEN is senior graphics editor at Scientific American. She has art-directed and produced illustrated graphics and data visualizations for publications including Scientific American, National Geographic, McGraw Hill science textbooks, and Modernist Cuisine. She completed her undergraduate studies in geology and art at Smith College, and her graduate studies in science illustration at the University of California, Santa Cruz.

AMANDA COX joined the New York Times graphics desk in 2005.

She holds a master's degree in statistics from the University of Washington.

CARL DETORRES is a multidisciplinary graphic designer operating at the intersection of design, illustration, and information graphics. He is a longtime contributor to publications such as Nature, WIRED, Fortune, Time, and the New York Times and regularly partners with corporations and institutions like IBM, Visa, Facebook, and the Gates Foundation. He has recently partnered with Jeffrey O'Brien to create StoryTK, a hybrid design and storytelling agency.

MARIETTE DICHRISTINA is editor-in-chief and senior vice president of Scientific American, which includes oversight of the magazine as well as ScientificAmerican.com, Scientific American Mind, and all newsstand special editions. She is also director of editorial and publishing, magazines, for the Nature Research Group, and is a fellow of the American Association for the Advancement of Science.

JOHN GRIMWADE has his own information graphics business (johngrimwade.com). He has produced infographics for many magazines, newspapers, books, and corporate clients. Before moving to the United States, he worked for 14 years in newspapers in London, including 6 years as head of graphics at the Times. He cohosts the annual Malofiej "Show, Don't Tell!" infographics workshop in Pamplona, Spain, and teaches information graphics at Ohio University's School of Visual Communication.

KARL GUDE is the former director of information graphics at Newsweek and the Associated Press. Karl left Newsweek after a decade to spearhead the first information

graphics program at Michigan State University's School of Journalism. Karl also teaches a class on creative problem-solving and the creative process.

NIGEL HOLMES is the founder of Explanation Graphics, a design company that helps people to understand complex processes and statistics. He was graphics director for Time from 1978 to 1994. The Society for News Design gave him a Lifetime Achievement Award in 2009, and an exhibition of fifty years of his work was shown at QVIG in Munich in February 2016. His most recent book, Odd, was published by Taschen in 2016. With his son, Rowland, he makes short infographic videos.

ANDY KIRK is a UK-based data visualization specialist and editor of the award-winning site visualisingdata.com. He is a globe-trotting freelance design consultant, researcher, and provider of training workshops, as well as a visiting lecturer at Maryland Institute College of Art (MICA) and Imperial College in London. Andy is a two-time author, with his latest book published by Sage and titled Data Visualisation: A Handbook for Data Driven Design. He is on Twitter as @visualisingdata.

GEOFF MCGHEE develops interactive media at the Bill Lane Center for the American West at Stanford University. Previously, he spent a decade doing infographics, multimedia, and video at the New York Times, ABC News, and France's Le Monde. In 2009–2010, he was a John S. Knight Journalism Fellow at Stanford University studying data visualization, which resulted in the Web documentary Journalism in the Age of Data.

JOHN NELSON is a friendly cartographer and information designer who works with social and natural data to create stirring illustrations of Earth's systems, including us. He is a product engineer for Esri, where he develops software user experiences and advocates for the fetching use of open data. He researches, creates, and occasionally speaks on the intersection of aesthetics, usability, and mapping. Before joining Esri, John was the director of visualization for IDV Solutions. His background is in geography, social science, and usability. You can find him on Twitter at @John_M_Nelson.

HANSPETER PFISTER is An Wang Professor of Computer Science and director of the Institute for Applied Computational Science at the Harvard School of Engineering and Applied Sciences. His research in visual computing lies at the intersection of visualization, computer graphics, and computer vision. He has a PhD in computer science from the State University of New York at Stony Brook and an MS in electrical engineering from ETH Zurich, Switzerland. Before joining Harvard, he worked at Mitsubishi Electric Research Laboratories where he was associate director and senior research scientist.

KIM REES is cofounder of Periscopic, a socially conscious data visualization and strategy firm.

ERIC RODENBECK came to San Francisco from New York City in 1994. Twenty-two years later, Eric's passion for cities, design, and technology has made him both a local and international leader at the intersection of all three. In 2001 Rodenbeck founded the data visualization design studio Stamen, where he is creative director and CEO. The company's high bar for elegant, data-driven design has brought many brilliant data artists, designers, and technologists through its doors. In 2007, Eric joined the board of the Kenneth Rainin Foundation (KRF), an organization whose mission is to bring innovative thinking to medicine, education, and the arts. Through this work, Eric fulfills his mission of connecting design with civic duty, people with place, and passion with data, with delight.

SIMON ROGERS is data editor at Google in California and was formerly data editor at Twitter and founding editor of the Guardian's Datablog and Data Store. Director of the Data Journalism Awards, he has also won the Royal Statistical Society award for statistical excellence in journalism.

DREW SKAU is a product manager at Visually, an on-demand creative services platform connecting marketing professionals with premium creative talent. He is pursuing a PhD in computer science at the University of North Carolina at Charlotte with a focus on evaluating the perceptual impact of designers' modifications to charts.

JOHN TOMANIO joined National Geographic in 2009 and is currently senior editor for art and graphics. Before that he spent 10 years at Fortune magazine as a graphics editor. His work has been recognized by the Society for News Design (SND), its Spanish chapter (SNDe), the Cartography and Geographic Information Society (CaGIS), and the Society of Publication Designers (SPD).

ANDREW VANDE Moere is an associate professor at KU Leuven University in Belgium. He is also the author behind the blog Information Aesthetics (infosthetics.com), on which he showcases a collection of compelling data visualization examples, ranging from data art to scientific data analytics.

FERNANDA B. VIÉGAS is a computational designer whose work focuses on the social, collaborative, and artistic aspects of information visualization. She is a co-leader, with Martin Wattenberg, of Google's "Big Picture" data visualization group in Cambridge, MA.

MARTIN WATTENBERG is a computer scientist and artist whose work focuses on visual explorations of culturally significant data. With Fernanda Viégas he leads Google's "Big Picture" visualization research group. A particular interest is using visual tools to foster collaboration and collective discovery.

BANG WONG is the creative director of the Broad Institute of MIT and Harvard and an adjunct assistant professor in the Department of Art as Applied to Medicine at the Johns Hopkins University School of Medicine. His work focuses on developing strategies to meet the analytical challenges posed by the unprecedented volume, resolution, and variety of data in biomedical research.

NATHAN YAU has a PhD in statistics from the University of California, Los Angeles, and is the author of Visualize This and Data Points. He writes about visualization and statistics at FlowingData.com.

DAN ZEDEK is the assistant managing editor for design at the Boston Globe, where he leads the design and infographics teams in print and online. In 2012, BostonGlobe.com was named the world's best-designed website by the Society for News Design.

CREDITS

THE BEST AMERICAN INFOGRAPHICS

2015

GUEST INTRODUCER: Maria Popova.

SERIES EDITOR: Gareth Cook.

THE BEST AMERICAN INFOGRAPHICS

2014

GUEST INTRODUCER: Nate Silver.

SERIES EDITOR: Gareth Cook.

THE BEST AMERICAN SERIES®

FIRST, BEST, AND BEST-SELLING

The Best American Comics

The Best American Essays

The Best American Infographics

The Best American Mystery Stories

The Best American Nonrequired Reading

The Best American Science and Nature Writing

The Best American Science Fiction and Fantasy

The Best American Short Stories

The Best American Sports Writing

The Best American Travel Writing

AVAILABLE in print and e-book wherever books are sold.

VISIT our website: *www.hmhco.com/bestamerican*

THE BEST
AMERICAN
INFO-
GRAPHICS
2016

✕